DESIGNING WILDLIFE PHOTOGRAPHS

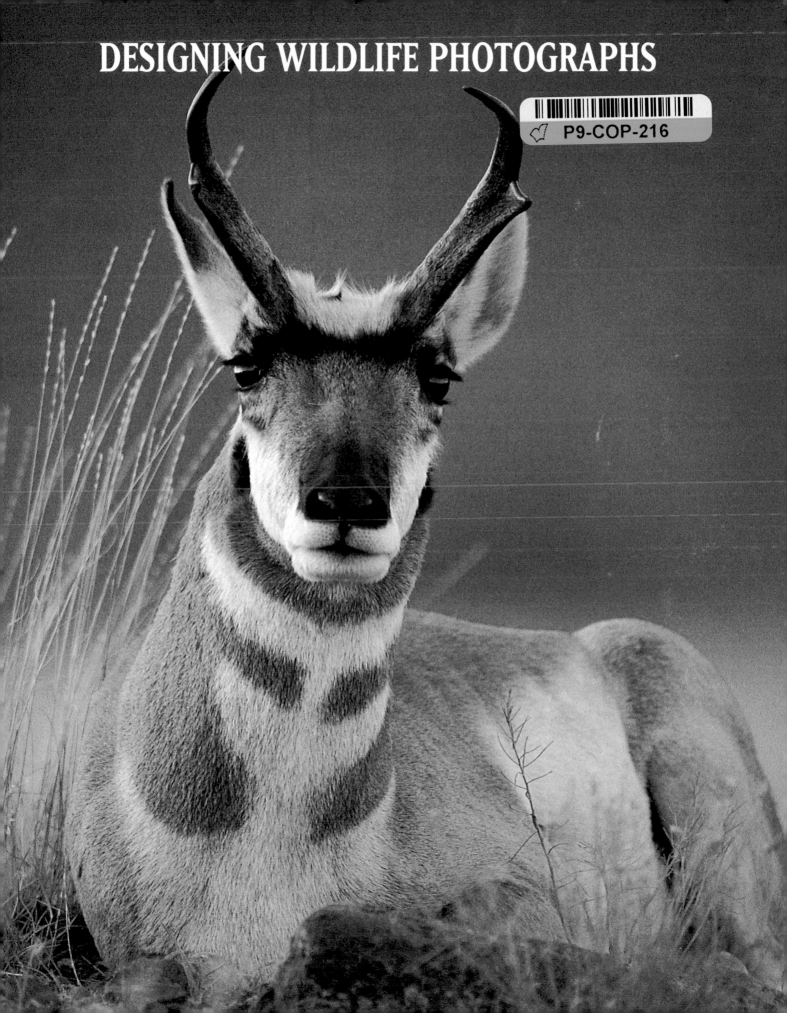

DESIGNING WILDLIFE PHOTOGRAPHS

JOE McDONALD

AMPHOTO
An imprint of Watson-Guptill Publications/New York

PICTURE INFORMATION:

Page 1. PRONGHORN. Yellowstone National Park, WY. 600mm F4 lens.
1/125 sec. at f/4. Kodachrome 200.

Pages 2–3. GRIZZLY BEAR AT SUNSET. Wild Eyes, MT. 500mm F4 lens.
1/125 sec. at f/4. Fujichrome 100.

Page 5. SCREECH OWLS IN FLIGHT. Hoot Hollow, McClure, PA.
80–200mm F2.8 zoom lens. Bulb at f/16. Four flash units. Fuji Velvia
at ISO 40.

Page 6. TIMBER WOLF WITH DEER. Wild Eyes, MT. 300mm F4 lens.
1/250 sec. at f/6.3. Kodachrome 64.

Pages 12–13. PAPER WASP. Hoot Hollow, McClure, PA. 100mm F2.8 lens.
1/250 sec. at f/16. Three manual flash units. Fuji Velvia at ISO 40.

Pages 54–55. WESTERN NEWT. Muir Woods, CA. 105mm F2.8 macro lens.
1/125 sec. at f/16. One manual flash unit.

Pages 68–69. SONORAN WHIPSNAKE. Southeastern Arizona.
200mm F4 macro lens. 1/125 sec. at f/16. Fujichrome 100.

Pages 82–83. GREEN-BACKED HERON. Anhinga Trail, Everglades National
Park, FL. 500mm F4 lens. 1/250 sec. at f/5.6. Kodachrome 64.

Pages 120–121. COUGAR. Wild Eyes, MT. 300mm F4 lens.
1/1000 sec. at f/5.6. Fuji Velvia 50 at ISO 100.

Editorial concept by Robin Simmen
Edited by Liz Harvey
Designed by Areta Buk
Graphic production by Ellen Greene

Copyright © 1994 by Joe McDonald
First published 1994 in New York by Amphoto,
an imprint of Watson-Guptill Publications,
a division of BPI Communications,
1515 Broadway, New York, NY 10036

Library of Congress Cataloging-in-Publication Data

McDonald, Joe.
 Designing wildlife photographs: professional field techniques for
composing great pictures / by Joe McDonald.
 p. cm.
 Includes index.
 ISBN 0-8174-3781-9 (pbk.)
 1. Wildlife photography. I. Title.
TR729.W54M333 1994 94-16283
778.9'32—dc20 CIP

Manufactured in Hong Kong

1 2 3 4 5 6 7 8 9 / 02 01 00 99 98 97 96 95 94

PHOTOGRAPH BY MARY ANN MCDONALD

Joe McDonald is a professional wildlife
photographer and zoologist. For nearly 30
weeks each year, he and Mary Ann, his wife,
conduct wildlife photographic tours and
workshops throughout the United states and
in foreign destinations. His photographs have
appeared in a variety of nature publications,
including *National and International Wildlife,
Natural History, Ranger Rick,* and *Birder's World,*
as well as in numerous calendars and books.
McDonald is also the author of a best-selling
Amphoto title, *The Complete Guide to Wildlife
Photography* (1992).

ACKNOWLEDGMENTS
This book divulges a number of wonderful
"secrets" that will help you photograph wildlife
more effectively. Some of these methods I've
developed, and some I've adapted or modified
after working with good friends and other
photographers. I'd like to extend special thanks
to these people: Chuck Bentivegna, the insect
consultant; Derrick Hamrick, the high-speed-
flash tester; Paul Forster, the equipment adapter;
Bryan Geyer, the Arca-plate man; Sam Maglione,
the equipment guru; Bill Sailer, my scout;
Mike Walz and Gary Lee, my herp suppliers;
and Ray Davis, my mentor.

 I'd also like to thank the hundreds of people
who have shared in the field experiences Mary
Ann and I have had on workshops and photo
tours. Without them, our trips would have been
far less interesting!

CONTENTS

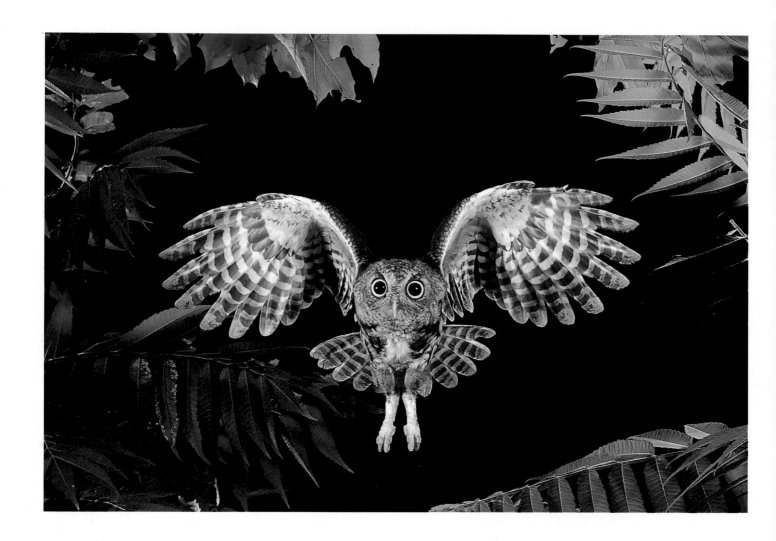

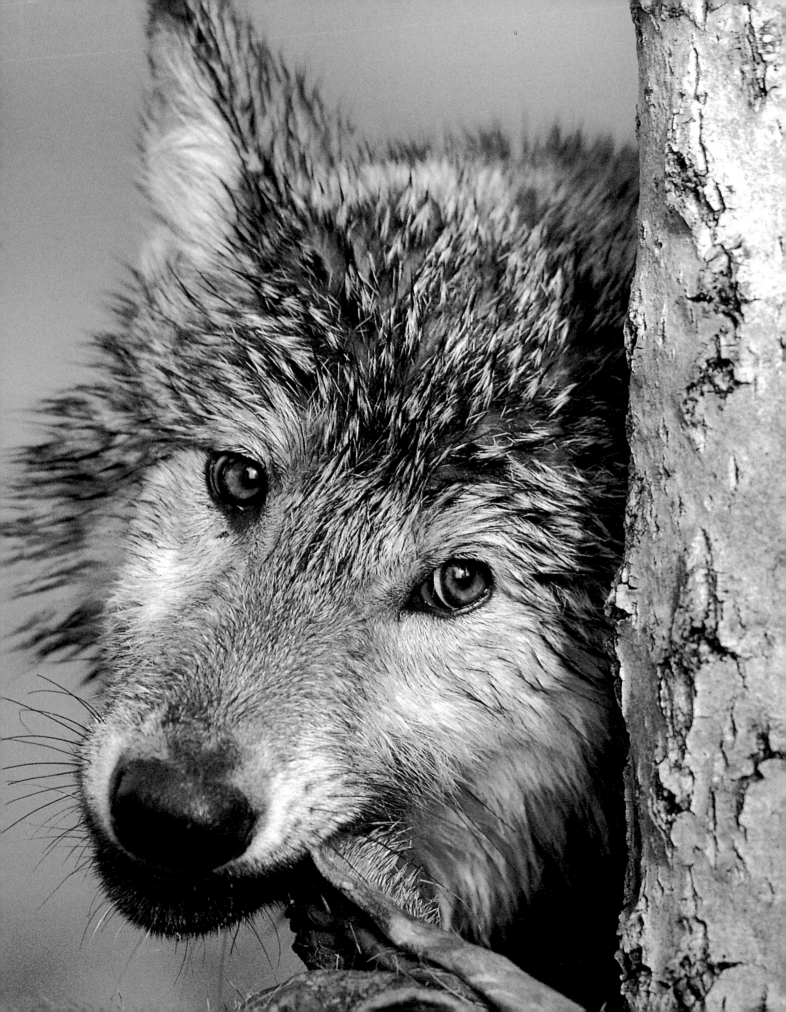

INTRODUCTION

GRIZZLY BEAR. Denali National Park, AK. 75–300mm F4.5–5.6 lens. 1/125 sec. at ƒ/8. Fuji Velvia at ISO 40.

The vibrant fall color on Alaska's tundra is stunning, and a closeup of this backlit grizzly bear would have completely ignored the beauty of this scene. By setting a relatively short focal length on my zoom lens, I was able to incorporate the bear as a small point of interest in what is essentially a shot of this magnificent landscape.

Many of the people I meet on my photography tours or in my workshops have a basic, and sometimes even a thorough, knowledge of photography. They are familiar with exposure and how a meter reads light; they understand the principles behind lens length, magnification, and angle of view; and they comprehend the limitations color-slide film has in handling contrast. The participants know all this, but some still feel that their photographs lack something. Then when we review their material together, they see how such seemingly minor changes as shifting their perspective, obtaining a larger image size, or varying the contrast could have improved their images. Yet in the field, when it counted, that information escaped them, and they didn't make the most of their photographic opportunities.

I believe the success of a great image lies with three interrelated elements. First, you must have an attractive subject. Second, you must compose the picture in a pleasing, intriguing, or interesting manner.

Finally, the finished photograph either must be technically correct or must just "look right," with all the pieces falling into place.

This last element is subtle. Having a great image should imply sharpness, although it doesn't necessarily demand it. Most good shots are properly exposed; however, on rare occasions, an image that is under- or overexposed produces a striking photograph. In short, what works and what is technically correct can differ—but this is the exception, not the rule. You must pay attention to other details as well, such as keeping horizon lines level and removing foreground distractions. But it is the way you put together all of these elements while your subject is before you that determines if an image works.

In wildlife photography all of this ultimately depends upon finding a subject. Photographing a wide variety of animal subjects requires an extensive background in natural history, which is something you can't acquire in

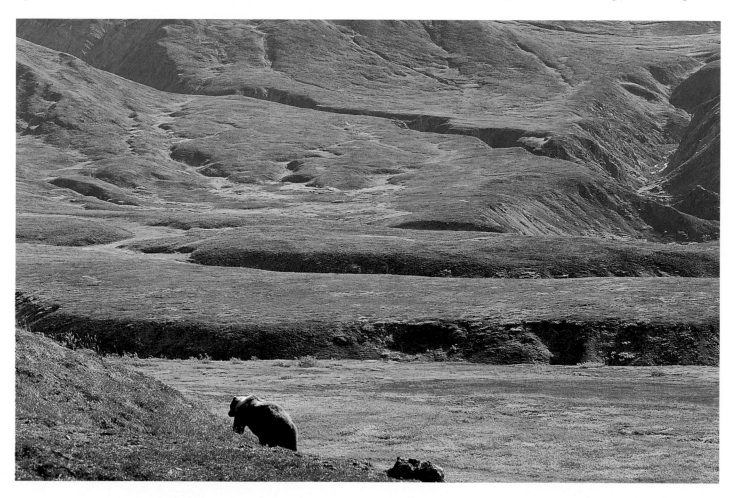

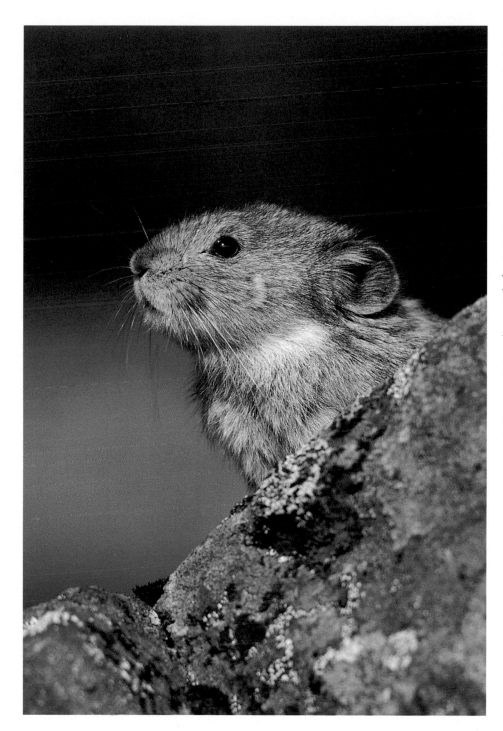

COLLARED PIKA. Denali National Park, AK. 600mm F4 lens. 1/250 sec. at *f*/8. Kodachrome 64

I spent nearly the entire day working with and habituating this collared pika in Denali National Park's marmot valley. Twenty minutes before I had to leave to meet my ride back to camp, I decided to shoot this rock, which the pika frequented, from a different angle. Just two minutes before I absolutely had to leave, the pika popped up on the rock. Twenty frames later, I checked my watch and discovered that I was only eight seconds behind schedule. Luck was on my side that day.

a weekend or a week-long course or in a single book. It is no secret that most good wildlife photographers are also good naturalists, or at least they are knowledgeable about the subjects they like to capture on film. If you don't know your subject, you'll have to rely on blind luck to lead you to whatever subjects you encounter.

Once you have a subject, the hard work begins. In a given situation you might have asked yourself: "How can I make an interesting composition?" or "How can I accurately record what I see?" I think your answer to the first question depends upon successfully answering the latter because if the image is improperly exposed or blurred, the composition usually fails, too. Achieving a certain level of competency with your gear also contributes to a great composition since you'll know exactly what piece of equipment will work best and why. This is critical in wildlife photography because many subjects are wary, and shooting opportunities may last for only seconds. Luckily, plenty of books deal with equipment competency. My first book published by

BURROWING OWL.
Fort Myers, FL.
600mm F4 lens.
1/125 sec. at ƒ/4.
Fuji Velvia at ISO 40.

In southwest Florida, burrowing owls nest wherever they find suitable nest sites and adequate food. This owl's nest, which was next to a public library, was cordoned off with surveyor's tape to keep people from getting too close. Despite this barricade, a 300mm lens would have been adequate for making portraits from a shooting position safely outside the protected area. I used a 600mm lens to minimize potential background distractions and to visually compress the owl against the flowers that rimmed its nest.

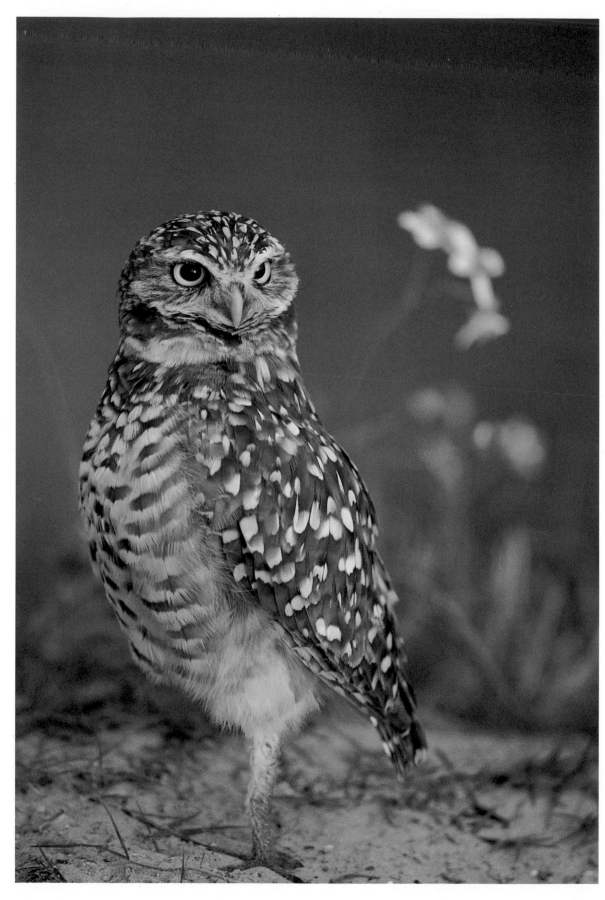

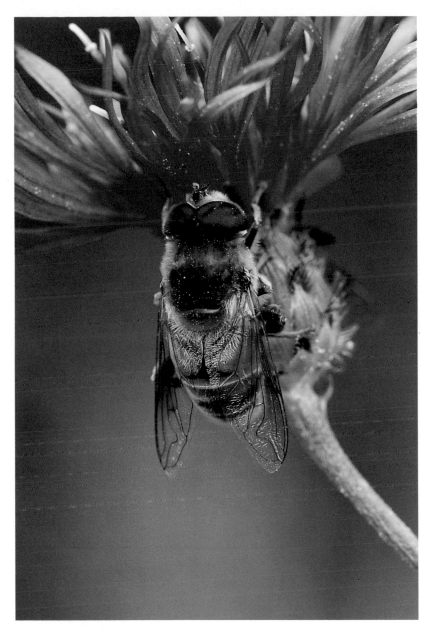

DRONE FLY. Glacier
National Park, MT.
100mm F2.8 macro
lens. 1/8 sec. at ƒ/11.
Fuji Velvia at ISO 40.

After a heavy morning
frost, I was surprised
to find these flies alive.
Because they were
torpid from the cold,
subject movement
wasn't a problem. I
did, however, have to
wait for gaps when
the light wind abated
before shooting.

and where to find a particular subject, you'll be well on your way to tackling similar subjects. And that is what this book is all about.

To provide a common ground for this discussion, I've included a review of the fundamental photographic principles I've applied throughout the text. I hope that this information won't be new to you (I discuss it thoroughly in my first book) but will simply serve as a refresher course while acquainting you with the way I work. I also hope that you'll be able to apply my techniques to your own unique set of circumstances. True, you may never film trumpeter swans on a frigid morning in Yellowstone National Park, but you may have many chances to photograph mallards or Canada geese on cold mornings at a nearby city park. And while you may live hundreds of miles from the nearest American toad, you may be within an easy drive of another species that exhibits similar behavior. In fact, each of my examples includes a suggestion about how you can utilize this specific information in various shooting situations.

And just as in my last guidebook, you'll notice that I made many of this book's photographs in a limited number of locations. The reason for that is simple. These spots—Yellowstone; South Florida and the Everglades; and Hoot Hollow, McClure, Pennsylvania—are the sites of most of my workshops and tours, areas where I do much of my photography. Some of my readers, people who have participated in these trips, will no doubt have similar photographs, and I hope that they'll take some pleasure in seeing mine within this book.

Of course, there isn't any substitute for field work, and I suspect that you'll get little from this book if you don't get out there and try these techniques yourself. That shouldn't be too hard as there are literally thousands of subjects available, ranging from the alpine tundra to your own backyard. Even with a single subject, you can choose from an unlimited number of lighting conditions, angles, and perspectives to make it appear unique. In fact, you could spend an entire summer shooting around your nearest field or wood lot and only scratch the surface of the possibilities available.

I hope that with your subjects at hand and this book as reference, you'll be able to make the most of your photographic opportunities. I also hope you enjoy this text, and that any enthusiasm that I may generate in you to photograph wildlife is tempered with your commitment to do so safely, for yourself and for your subjects. I believe our photographs can make a difference in public awareness, in revealing the unseen, the beautiful, and the unusual. In explaining my methods, I hope that my own concerns for our wildlife have been conveyed, and I hope that you, too, share in my stewardship of our most precious resource, our wildlife.

Amphoto, *The Complete Guide to Wildlife Photography,* deals extensively with mastering your gear in order to make better wildlife images.

But there are still the matters of "seeing an image" and of handling your gear so that you make a great photograph. "Seeing" can be difficult, but I don't believe it requires an artistic gift. You may develop this ability simply by being exposed to other people's work. I think that this method is quite valuable, and I believe that after being moved by an image, it is natural to want to create a similar one. I've done this frequently, not by trying to copy someone else's work, but by trying a similar technique on an entirely different subject. In doing so I've produced my own unique images. However, by knowing how an image was made or how

FUNDAMENTALS

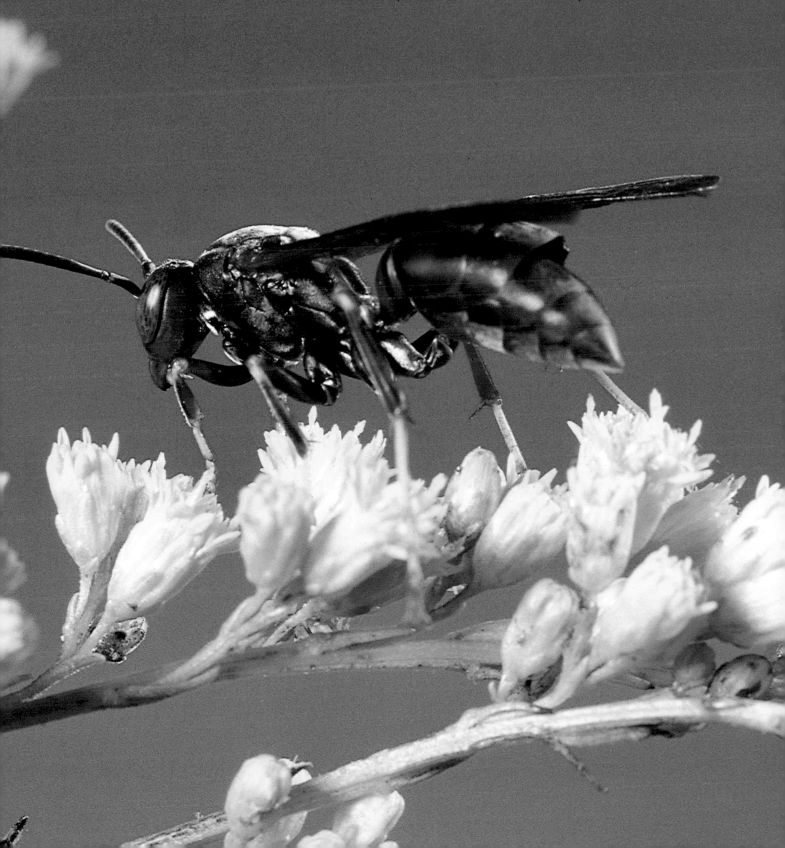

PREPARING TO SHOOT

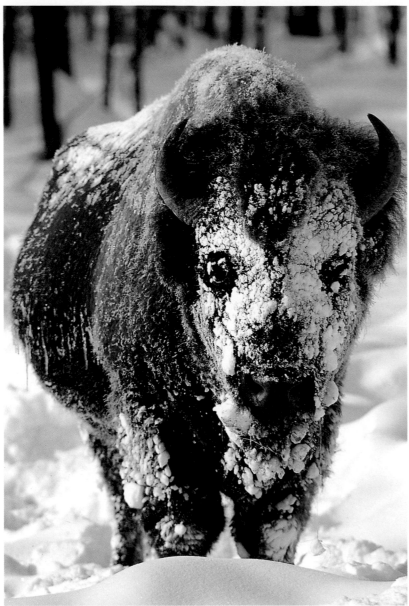

BISON. Yellowstone National Park, WY. 300mm F2.8 lens. 1/250 sec. at ƒ/5.6. Kodachrome 64.

Photographing bison in snow poses a challenge. I've obtained my best results by trusting a spot-meter reading taken off the subject's tawny-colored hump. Humps range from middle tone to slightly darker than middle tone, but they usually serve as a good compromise between the bison's black head and the white snow.

The heart of this book describes the various techniques I use to make wildlife photographs. As you'll see, these techniques vary from the simple to the complex and apply to subject matter that ranges from common backyard insects, birds, and mammals to species found in some of the most beautiful and exotic wildlife locations in North America. Designed as mini-workshops, these should be helpful for everyone who wants to improve their pictures. Although the information I present regarding finding and photographing each subject will improve your photography, this alone may not be enough to make a difference.

For real photographic success, you must also become proficient with your equipment. This doesn't merely mean knowing how to use your gear, but how to do so quickly and surely when you are under pressure and every second counts. It doesn't matter how much or how little gear that involves. You can shoot a body of great work with just a single lens, provided you know everything that the lens is capable of doing.

While your having a variety of lenses should increase your chances at making better images than you would be able to with just one or a few lenses, the reverse often holds true. Too much gear can create confusion or indecision, especially if you haven't taken the time to master each piece individually. There is a lot to be said for acquiring gear piecemeal and discovering what that lens, flash unit, or bellows can do. The best way to learn this information is to read the instruction manual that comes with the piece of equipment. During my workshops and tours, I'm continually amazed that some participants' familiarity with their gear ends with the knowledge necessary to mount a lens, filter, or flash on their camera. Basic functions, such as using a depth-of-field preview button or screwing in a mechanical release, are mysteries to some people even though this information is readily available in the instruction manuals. Truly, equipment competency starts there.

In this book, you'll go beyond the fundamental how-to's as you use your equipment and apply techniques to specific wildlife subjects. This may seem simple enough, but you mustn't overlook your personal responsibility in developing equipment competency. This is absolutely essential because opportunities to film wildlife often last mere seconds, and it is too late to learn proper camera handling or to ponder exposures when a buck mule deer emerges unexpectedly from a thicket. When you see a great shot, you must be ready.

DEVELOPING A METHOD

Suppose you're photographing a mule deer. You hear leaves crackling in the thicket beside you, look up, and see a buck, camouflaged and barely perceptible, standing at the edge of the clearing. Unless you've come upon a very tolerant animal in a national park, it is quite unlikely that your subject will maintain the perfect pose while you're digging into your gadget bag for the right lens, light meter, and tripod adapter. Still, I've frequently seen photographers who are completely unprepared when the subjects they sought out or expected to encounter suddenly appear before them. They weren't ready, and they missed the shot.

You can often measure the time you spend actually making wildlife photographs in seconds, yet you may have to devote hours or days to waiting for these decisive instants to take place. It is common sense, then, to be prepared for them. However, if you aren't fully prepared or you're caught completely off guard, you can at least learn from your mistakes.

All photographers miss shots, but many people dwell on the lost images themselves without carefully examining the reasons why they missed these shots. You should ask yourself the following questions after an unexpected oppportunity arises and you don't take advantage of it. For example, why exactly did I miss

the shot of that bald eagle soaring just overhead? Why wasn't I ready when the male anole displayed its dewlap? Why didn't I have my exposure ready when the ram bighorns crashed together? Could I have been prepared, anticipated the moment, and captured the image? What did I do wrong, or, more accurately, what didn't I do that cost me the shot? Do I always wait until my subject arrives before selecting a lens or setting a base exposure? Do I make last-minute adjustments to the composition that costs me the fleeting shot? Do I simply get too excited to focus correctly or hold my camera steady in order to make a sharp image?

If you answer these questions honestly, you may discover a pattern. For example, you may find a consistent lack of preparation that continually costs you some of your best shots. This preparation goes beyond basic competency with your gear and extends to applying that information to fast-breaking situations.

Fortunately, there is a solution to this dilemma, and that is to develop a methodology, or a sequence you consistently follow during a shoot. I think successful wildlife photographers make a number of decisions as they prepare to shoot, which in turn become subconscious steps that are as important as the subject at hand. While you prepare for the arrival of or begin to approach a potential subject, several factors or steps to follow should come to mind, perhaps sequentially, but definitely in a manner that becomes routine as you make wildlife photographs.

In this section of the book, I dissect the steps I take when making a photograph. For the most part, the demands or tolerances of my subject dictate the method because the conditions and the behaviors of each subject differs. I consider the camera-to-subject distance, and how close I can approach because of the subject's size or wariness. With that in mind, I then make a quick assessment of the basic exposure, the probable composition, and the required lens. After choosing the lens, angle of view, and basic framing, I finally direct my concentration to the camera-handling requirements necessary for a razor-sharp image.

As you read on, keep in mind that by conveying this information, I don't expect you to adopt my methodology. Instead, by explaining my techniques, I hope that you'll analyze your own methods and, perhaps, discover some important steps that you aren't currently considering. I'm not implying my methods are the best, but they do work very well for me.

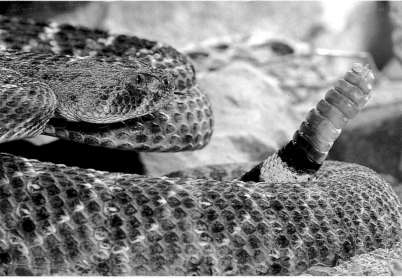

WESTERN DIAMONDBACK RATTLESNAKE. Hoot Hollow, McClure, PA. 200mm F4 macro lens. 1/250 sec. at *f*/16. Three manual flash units. Fuji Velvia at ISO 40.

Rattlesnakes are dangerous, and this one, poised to strike, required a sufficient working distance to ensure my safety. By using a 200mm macro lens, I remained outside the snake's strike zone.

WORKING WITH WILDLIFE

Wildlife photography shouldn't be intrusive. I've made my best images, as well as had my favorite experiences, when I was either accepted or ignored by the animals I was photographing. For this to take place, I've needed patience, luck, and the cooperation of my subjects. Frequently, for the latter, this simply meant giving the animals room.

ARGENTINE HORNED FROG. Hoot Hollow, McClure, PA. 200mm F4 macro lens. 1/250 sec. at ƒ/16. Two manual flash units. Fujichrome 50.

For this shot, I framed tightly to minimize the habitat. In that way, the generic setting remained biologically accurate.

Nearly all subjects have a fight-or-flight zone, from the anole lizard basking at arm's length to the grizzly bear with cubs 200 yards away. If you enter this protected, off-limits area, the animals feel threatened. In response, they may run or attack out of fear or anger. The response, of course, depends on the species. I would have little to fear from the anole because its response would be to run; however, I would be quite concerned about the grizzly, which could run away or attack, or could run in order to attack for that matter! If you are aware of this zone and are sensitive to the sometimes subtle changes in behavior an animal may show, you can stay out of trouble. Generally, this simply means backing off or stopping as soon as you see these signs.

Having this sensitivity to wildlife is very important today because national parks are crowded with photographers. Park animals are remarkably habituated, but even they have their limits. I've found that the safest way to work with a mammal is to allow it to approach me first. Instead of trying to sneak up on the animal or stalk it, I'll slowly meander toward it or toward its line of travel in the hopes that it will continue in my direction. During my approach, I usually stand upright and pause frequently, sometimes even sitting down for several minutes so that my intentions aren't obvious to the mammal. By being conspicuous, I avoid surprising the animal while still enabling it to determine its fight-or-flight zone.

I work with habituated birds the same way, slowly advancing with my tripod extended to the required working height. For those that are less tame, either I use a blind or I just sit quietly and wait for the birds to come to me. I've had little success stalking truly wild birds.

If I have the time and I'm shooting in a location where it is legal to do so, I'll condition mammals or birds with baits. (Baiting is illegal in most parks and refuges because it can create nuisance animals that can become dangerous.) Most of this work takes place around my home where I am able to maintain feeders, develop special routes, or otherwise condition subjects.

Working with wildlife poses another challenge, too. Because some animals are shy, nocturnal, rare, or simply elusive, they are nearly impossible to photograph in the field. Fortunately, some of these may be found and photographed in zoos or private collections. Others, typically small, less dramatic creatures, such as

salamanders and burrowing snakes, are rarely displayed or kept as pets. To photograph these, I might have to catch the animals first. Obviously, this places a certain amount of stress on them (how would you like to be picked up by a giant?), and a purist may pass on photographing anything that requires subjects to be picked up, moved, or placed in a studio environment.

I, however, think that documenting these less-well-known animals is too valuable to subscribe to that philosophy. Perhaps this is because I became interested in wildlife when I was a ten-year-old boy and began catching snakes. I am still intrigued by lesser-known animals, and I actively seek them out. However, if I catch a salamander, a bug, or a deer mouse, I'll do so in the least stressful way possible. In addition, I'll maintain it in a healthful, captive environment until I release it either where I originally caught it or in a safer area.

As you continue through this book, you'll note that I often photograph venomous reptiles both in the field and in the studio. In every case I've always done so safely. Although I hope many of my images will motivate you, I also hope that, like the disclaimer on television warns, you "don't try this at home!" Doing so with venomous snakes could get you killed.

Actually, my chief concerns lie with the safety and well-being of your subjects as much as they do with yours. Each year, increasing pressure is placed upon wild animals and wild lands. I don't want this book to contribute to that pressure. It should be obvious that anything you do with animals or in your photography shouldn't be harmful, stressful, or injurious to your subjects. A shot should never take precedence over a subject's welfare. I photograph wildlife because I love animals, and I assume you do, too. I've stressed this in the examples I've included in this book. It is up to you to follow through and to interact with the natural world in as benign a manner as you possibly can. You owe this to your subjects.

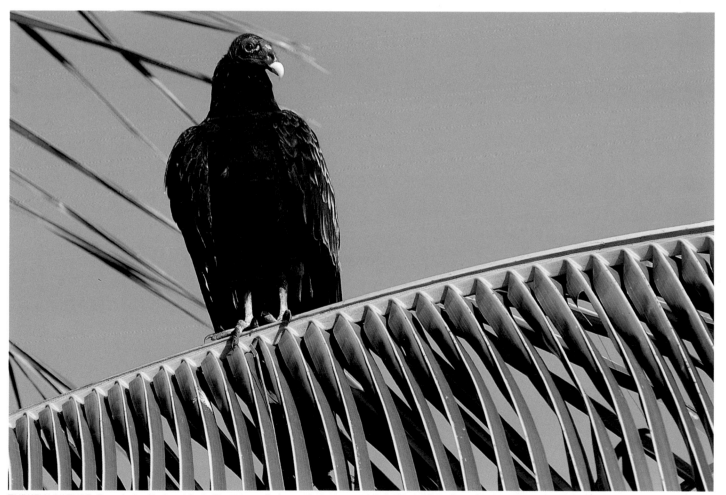

TURKEY VULTURE. Everglades National Park, FL. 500mm F4 lens. 1/250 sec. at ƒ/5.6–8. Nikon SB-24 Speedlight on TTL at –1. Kodachrome 64.

EQUIPMENT AND FILM

I'm often asked about the gear I use, but before I address that question, let me preface this discussion by saying that equipment doesn't make the photographer. I've seen truly outstanding work made by talented people with a minimum of lenses; of course, I've seen the opposite, too. Cameras, lenses, and flashes are simply tools that can provide worthwhile results when used properly.

I've been photographing for more than 25 years, which is a long time to collect "toys" and to try new techniques on a wide variety of subjects that have required special tools. When Canon changed to autofocus and made my old, manual-focus gear obsolete, I switched to Nikon equipment. Nikon has a wider range of accessories, which is necessary for the diverse types of shooting I do. Also, Nikon's flagship camera, the F4, offers mirror lockup, which is a very important feature for macro photography.

I use brand-name lenses because I believe that they are sturdier and better able to endure the abuse I'll subject them to during the course of a year. Off-brand lenses also have superb optics, and if treated with respect, they'll do well. I have lenses with focal lengths between 18mm and 600mm, including several zooms and macros. There is some duplication among the lenses my wife, Mary, and I own, but she shoots, too, and we share gear. I strongly urge shooting couples to

own the same manufacturer's camera bodies. Should you go on a photo tour or safari and one of your cameras breaks, one spare body between the two of you might suffice if you're working with the same system. Couples using different manufacturers' equipment would ideally require a backup camera for each system.

All of my lenses are equipped with lens hoods, which serve two functions. Hoods shade the front element of a lens from stray light rays that can cause unnatural, hexagonal shapes to float ghostlike in your finished images, as well as flare. A lens hood's effectiveness depends on the angle of the sun. If the sun is at your back, in classic "sunny $f/16$" lighting conditions, you won't need a hood to prevent lens flare. If you're shooting into the sun in order to make a silhouette, a hood won't make any difference if the sun appears in the image.

In addition, lens hoods can protect the fragile front lens element from accidental scratches. Hoods can also come in handy should you drop a lens and be lucky enough to have it land face down on the hood. A metal hood may bend or warp on impact, and may even damage the filter threads of the lens, but you'll still be able to use the lens if its front element is unaffected. Some photographers use skylight filters to protect their lenses, but this is impractical for expensive telephoto lenses with huge front elements. With a lens hood in place, you'll always have at least some protection when you're shooting in the field.

To increase the magnification power of your lenses for closeup and macro work, you need extension tubes and/or teleconverters. Don't confuse them. Extension tubes are devoid of optics and merely extend the minimum focusing distance of the lens in use. You can focus closer, but as you approach infinity, focus is lost. Depending upon the tube size and the lens, the new focusing range may be measured in only inches. Tele-extenders work by multiplying the image size through the use of lenses while maintaining the same focusing range. This produces a larger image by increasing the lens' focal length.

Both extension tubes and teleconverters reduce the amount of light reaching the film. With TTL flash or with a camera in the automatic mode in ambient light, this happens automatically. With manual flash or in ambient light using manual mode, however, you must determine exposure. This is actually simple to do with a teleconverter. You always lose one stop of light with a 1.4X teleconverter and two stops with a 2X teleconverter. On the other hand, the amount of light lost with extension tubes depends on the length of the tube and of the lens in use, so tremendous latitude is possible.

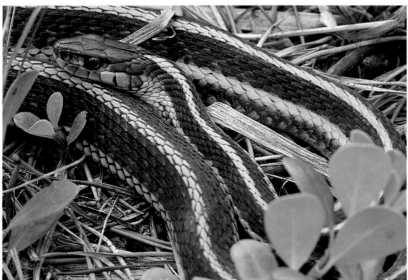

WESTERN RED-SIDED GARTER SNAKE. Glacier National Park, MT. 100mm F2.8 macro lens. 1/8 sec. at $f/22$. Fuji Velvia at ISO 40.

Although I was hoping to photograph mule deer and mountain goats with my telephoto lenses, I brought my macro lens along anyway for the unexpected. This garter snake gave me an opportunity to use it. Shooting at a very slow shutter speed and with a cable release, I locked up my mirror and waited until the snake was motionless before I fired.

To accurately determine exposure, make readings through the lens. Record these exposure differences if you use a given setup frequently, especially with manual flash. In this way, you lessen the need to bracket exposures.

I also use a number of electronic flashes for the variety of subjects I shoot, from my Nikon SB-24 Speedlights for easy through-the-lens (TTL) shooting to Dynalites for my studio work. For high-speed flash photography, I have a number of options at my disposal. For closeup photography using TTL flash, my SB-24s do quite nicely; although the guide number (GN) is very low, they offer a flash duration as fast as 1/50,000 sec. My Sunpak 611 and 522s have a slightly higher GN and flash durations up to 1/125,000 sec. When I need a high GN, as I may for outdoor work involving owls or flying squirrels, I use Olson high-speed units. These have flash durations up to about 1/30,000 sec.

I prefer Gitzo tripods because of their sturdiness, durability, and flexibility in working height. Don't compromise when it comes to your tripod; it is one of the keys to successful shooting. Mary and I work with two types. I rely on the Gitzo 505R when I'm shooting with my heavy 500mm and 600mm F4 lenses, and the Gitzo 320 when I'm using smaller lenses. Mary likes the Gitzo Pro Reporter 210. This lightweight tripod can drop nearly to ground level, permit the changing of tripod heads, and have legs that extend horizontally independent of each other.

Being able to change tripod heads easily and quickly is an important feature for wildlife photography. Nevertheless, the standard inexpensive tripod you'll most frequently see in camera stores comes complete as a unit, with the tripod head attached to the legs. A better-made tripod accepts different heads, providing options for special needs and for personal preferences.

Like most professionals, I use a ballhead tripod with a quick-release system. The industry standard very well may be the Arca-Swiss monoball; this head and those of several competitors use the same type of quick-release plates. These screw directly into the camera body or lens, and by dedicating a plate to each one, you can change gear very fast. Quick-release plates are available from ballhead manufacturers, as well as from independent suppliers for less money and with a better fit. I use quick-release plates from The Really Right Stuff for most of my cameras and lenses, and Arca-style bridge mounts for my longer lenses from Forster's Photo Accessories (see page 143). Bridge mounts provide a firmer support for telephoto lenses because the lens is anchored at the tripod foot and at the end of the lens barrel. On a sturdy tripod, even a 700mm lens will be rock steady with this system.

Naturally, film selection is another critical part of wildlife photography. Not too long ago I was exclusively a Kodachrome shooter, using Kodachrome 64 when I had plenty of light and Kodachrome 200, which I rated at ISO 250 for more color saturation, when I shot in less ideal light. Today, my color palette is more diverse, and I shoot several different films depending on the subject and the lighting conditions.

As a general rule, slow-speed films are finer grained and provide sharper enlargements than fast films, but they require bright light when used with fast shutter speeds and small f-stops. In addition to the brightness of the ambient light, I consider the color and contrast of both the subject and of the entire composition when deciding on a film. While film choice and preference are subjective, I consider Kodachrome 64 to be the best film for wildlife photography because of its color accuracy. However, the new and improved Fujichrome 100, which is approximately one stop faster than Kodachrome 64, is accurate as well. And because of the increased shooting flexibility it affords me, I've made it my overall film of choice.

Kodak's Lumiere 100 is the first of a new generation of moderately fast films with extremely fine grain; I think, however, that these films have a brown-yellow bias. They are also very contrasty, and the difference in exposure between lights and darks is exaggerated. As such, I use Lumiere film only when the conditions and subject warrant it. For example, if my subject is a wolf or cougar in the woods during the fall or early spring, the film's brown bias will enrich the image. In dramatic sidelighting, Lumiere's increased contrast exaggerates the effect to my advantage. Of the two Lumiere films, LPP and LPX, I find LPP 100 the more accurate, although I usually avoid using either if the light is golden and its yellow bias would be exaggerated.

When I want the colors in my images to pop, I use Fuji Velvia 50. This is a great film for subjects with vivid colors, such as reptiles, amphibians, and insects, as well as for scenes where you can exploit greens. Velvia renders a blue sky blue without a polarizing filter, or polarizer; in fact, using a polarizer with this film can turn a blue sky nearly black. I rate Velvia at ISO 40 to slightly reduce color saturation.

When lighting conditions are problematic, I use Kodachrome 200. Although this film is a little grainy, it still produces sharp images and true colors. I like the way it renders greens, especially on overcast or rainy days when the light is low and shadows are absent or minimal—ideal conditions for mammal portraiture.

Just as with lenses, it is important that you master the films you use. Don't take my word for a film's contrast or color. Do your own experimenting. Ultimately, the film or films you select will depend on the subjects you shoot, the lens speed you use, and the colors you want to render.

SHOOTING IN THE FIELD

What gear I carry in the field depends on where I am. Believe it or not, around home I spend a lot of time afield without my camera. Admittedly, I sometimes miss a shot, but I find the trade-off worth it. While wandering my woods or fields, I can truly "see" without the burden of carrying equipment or the pressure of having to produce images. I consider this my data-collecting time. Once I find a subject, I'll

BISON. Yellowstone National Park, WY. 500mm F4 lens. 1/250 sec. at ƒ/5.6. Kodachrome 64.

In general, I take a meter reading off the shoulder hump of a bison or I'll follow the "sunny ƒ/11" rule if the conditions are right for correct exposures. The hump of a bison is darker than middle tone but works well as a compromise when I want to record realistic detail in the black face of this large animal.

return with the correct gear to photograph whatever it was that I'd discovered.

When I shoot, I sometimes carry several lenses into the field with me. What I mount on my tripod and what I pack depends upon what I hope to photograph. If I am in bird or wildlife country where a shooting opportunity may suddenly arise, I'll usually mount my longest telephoto lens on my tripod so that I'll be ready. If I then encounter an interesting flower or scenic, I'll usually have enough time to change lenses for the shot.

Unfortunately, this doesn't work in reverse. If a great bird flies into view when I'm prepared to shoot a macro subject, I'll rarely have time to switch lenses before the bird disappears. If I'm photographing insects or similar subjects around my home, I'll mount a macro lens and pack my telephoto lens. In truth, when I'm doing macro photography, I often leave all my other lenses behind. Because I find this work to be quite demanding, I have more energy and enthusiasm when I carry only the gear I absolutely need.

I don't use filters regularly, and I'll carry them only if I anticipate a definite need. For most wildlife work, in which action or portraiture is the focus, filters aren't required. But they can enhance an image when the scene plays an important role in the picture, and for those occasions I ordinarily select one of three types of filters. I probably reach for my polarizer most often because I use it to emphasize clouds in blue skies, as well as to reduce or eliminate reflections on leaves, reptile or amphibian skins, and water surfaces. It does this while decreasing the amount of light that enters the lens by one or two stops depending on its rotation. A polarizer can be essential when you shoot through glass, especially if it is impossible either to bring the lens close to the glass surface or to darken the area in front of the glass to avoid reflections. If you decide to buy a polarizer, keep in mind that there are two types, linear and circular. Check your camera manual to see if your camera's metering and focusing systems require the circular design.

When I have enough time and the scene demands it, I use a graduated neutral-density (ND) filter to reduce the contrast between very bright and very dark areas in the frame, such as sky and land. Metering the darker of the two areas before adding the filter to obtain the correct exposure and then adjusting the filter's gradation to make the image appear natural take time. Since time is often a precious commodity for many wildlife shoots, I don't use ND filters very often.

My least frequently used "favorite" filter for wildlife photography is Tiffen's enhancing filter. It jazzes up

reds and oranges without appreciably changing other colors. I consider using it when I'm shooting in red-rock or sand country or photographing animals in their habitats during fall-color season.

I recommend using a filter only when necessary. I've often observed people photographing wildlife with their polarizer in place because "they always use one," not because the conditions warrant it. Most filters reduce the amount of light reaching the film, and light in wildlife photography is usually at a premium. I try not using a filter unless the scene demands the manipulation a filter provides; I prefer having a faster shutter speed or greater depth of field.

However, I almost always wear an incident-light meter on my belt. I use Minolta's Flash Meter III, which measures both ambient light and artificial light from a flash. But because today's in-camera meters are quite accurate, I rarely use my off-camera meter to measure ambient conditions. Instead, I spot meter a scene through my lens. Sometimes, though, light conditions are challenging, so by measuring the ambient light I can estimate the exposure before I confirm it with my camera's meter.

I do, however, use the meter for flash pictures, especially when I'm shooting in the studio or in the field with more than one flash. My Minolta meter enables me to determine lighting ratios and the aperture in order to create the exact lighting effect I envision. If I have the chance, I may also use the meter to confirm a TTL flash setting. I simply hold the incident-light meter's bulb just outside the area that the lens covers. This is an important point because holding the meter inside the picture area would change the exposure because the camera's flash sensor meters the light reflecting into the lens. You want to be sure that light is coming from the subject, not off the white bulb of your meter!

Typically, I carry all my gear in a backpack and/or in a photo vest. My pack is a roomy, comfortable, internal-frame backpack. Although a pack designed specifically for photography is fine, I'm not too enthusiastic about dedicating compartments for specific pieces of gear because my equipment changes according to my shooting needs. Since my backpack lacks built-in foam dividers, I protect my equipment by wrapping everything in pouches I make from the foam used for backpackers' bedrolls. These generic pouches fit several different pieces of equipment. Strapping tape liberally wrapped around the foam both secures the pouches and keeps them from tearing.

I wear a photo vest only when I expect to be changing gear frequently, such as when I'm shooting macro subjects or scenics. I use an L. L. Rue photo vest with roomy pockets that can accommodate four camera bodies, several lenses, cords, and cable releases, which is more equipment than I'll ever carry on any given day. Generally, I carry just one extra body in the vest and use the other pockets for short lenses or filters.

I'm not a fan of gadget or shoulder bags, either. If you carry a lot of gear and travel some distance from your car, as I usually do, you'll find that shoulder bags are very uncomfortable. Regardless of the width of the shoulder strap, the weight of the bag inevitably cuts painfully into your shoulder. These bags are great for keeping gear organized and are fine for photographers who work out of cars, but they are impractical for serious field use.

As I walk, I mount my 500mm lens on my tripod, wrap the lens strap between the folded tripod legs and around the knob of the ballhead, and then sling the tripod over my shoulder. This way, if the lens accidentally falls off, it will only dangle from the tripod, not crash to the ground. Make this process of securing your lenses a habit that you faithfully adhere to; it may save them!

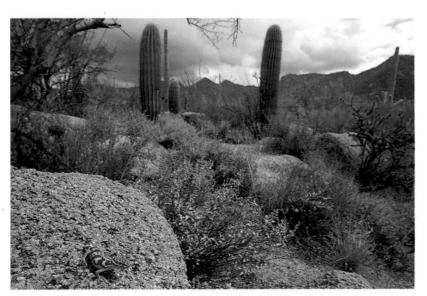

BANDED GECKO. Saguaro National Monument, AZ. 18mm F2.8 lens. 1/30 sec. at ƒ/11. Fuji Velvia at ISO 40.

My working distance was less than 8 inches, yet the image size is tiny because I used an ultrawide-angle lens for this shot. Although a focal length of 18mm should provide great depth of field, whether or not it does depends on both the working distance and the hyperfocal distance. Because I was shooting within the hyperfocal distance here, the background is soft.

CHOOSING LENSES

Practicality is the key to determining which lens to use for a particular shooting situation. Ordinarily, several factors dictate which lens I use for a wildlife shot because each lens has a particular function it performs best, as well as some limitations. When making this choice, I usually consider both the subject and the background and what I can do with them. For example, with a shorter lens, even though I may want to include an interesting background, I may not be able to obtain an adequate image size without causing the subject undue stress. With a longer lens and greater magnification, I may not have sufficient depth of field to keep the background sharp. Exactly how close I can get to my subject, how large an image I need, and how important the background is all play a role in determining which lens I use.

When I select a lens, my first consideration ordinarily is usable depth of field. This depends on two factors. Depth of field increases as the size of the aperture decreases. For example, you might decide to switch from a relatively wide open f-stop of $f/4$, which produces an out-of-focus background, to a much smaller f-stop, $f/16$, which provides a sharper background. Depth of field also increases as the image size gets smaller. This happens two ways. You can either increase the working distance or change to a lens with a smaller focal length. To maximize depth of field, use a short lens, back away from your subject, and set a small aperture. To minimize depth of field, use a long lens, move in close, and select a large aperture. Obviously, some combination will result in the desired effect. The problem is finding it!

I do most of my wildlife work with only a few lenses since getting close to the subject poses the biggest problem. For the most part, I use my 300mm F2.8 lens, 500mm F4 lens, and 105mm and 200mm macro lenses for their respective magnifications. Longer lenses provide both greater magnification and greater working distances, the space that exists between you and your subject. For example, you get the exact same image size of a rutting elk with a 600mm telephoto lens at a working distance of 150 feet as you do with a 300mm telephoto lens at a working distance of 75 feet. The discernible differences between these two shooting situations involve your safety, which is far greater at 150 feet than it is at 75 feet, and your angle of view, which is minimal with the 600mm lens. A restricted angle of view can, however, reduce the number of distractions in the final image, thereby enhancing it. Conversely, a broad angle of view that includes the background of the subject's habitat may strengthen an otherwise mundane animal closeup.

A telephoto lens' increased magnification works well for distant subjects but is less practical in macro photography (see page 42). For very small subjects, such as frogs and dragonflies, the minimum focusing distance of a telephoto lens is too far away in order to obtain a large image size. Using a macro lens designed specifically for close-focusing work is much more practical in these situations. Try the following exercise. Focus on a film box first with a 500mm lens at its minimum focusing distance of 15 feet, and then with a 105mm macro lens at its minimum focusing distance of 15 inches. You'll practically fill the frame with the macro lens; you won't even come close to doing so with the telephoto lens.

The working-distance and angle-of-view principles that apply to telephoto lenses are also used in macro photography. For a half-life-size image on film, or 1:2 magnification, the working distance from the front of a 50mm macro lens is about $4^{1}/_{2}$ inches; from the front of a 100mm macro lens, about $8^{3}/_{4}$ inches; and from the front of a 200mm macro lens, around $19^{1}/_{2}$ inches. Keep in mind that although the image size is

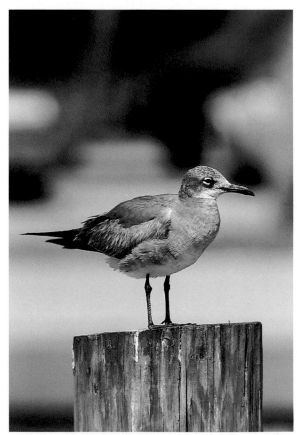

LAUGHING GULL. Everglades National Park, FL. 300mm F2.8 lens. 1/250 sec. at $f/8$. Kodachrome 64.

the same with all three lenses, the working distance increases as the lens length increases. The angles of view progressively decrease, too, from 48 degrees with the 50mm lens to only 12 degrees with the 200mm lens. If the background is important, use a short macro lens.

When you consider what lenses to bring when you shoot in the field, remember this truism about equipment for nature photography: You'll always need the gear you left behind. This is Murphy's Law at work, and you probably won't always be able to get around it. Although certain camera bags and backpacks can hold everything but the kitchen sink, carrying all that gear around becomes more work than fun, and you may find yourself too tired to shoot. Keep in mind that it is impractical to attempt to cover every contingency in the field. Simply choose your lenses based on the subjects you are likely to find outdoors, and bring along only the pieces of equipment that are appropriate for them. If, however, you're shooting from your car, pack it all.

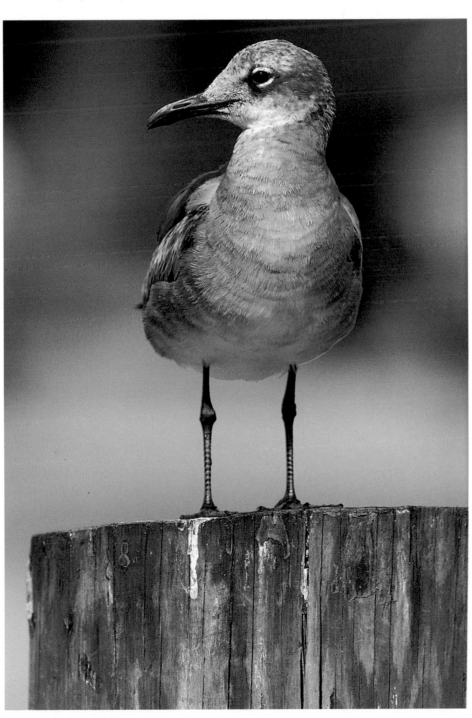

LAUGHING GULL. Everglades National Park, FL. 500mm F4 lens. 1/250 sec. at ƒ/8. Kodachrome 64.

I made my first shot of this bird with my 300mm lens (far left). Then I switched to my 500mm lens in order to eliminate the distracting elements in this scene (left). Of course, the image size increased, too, because I maintained the same working distance. Had I backed up, I would have reduced the image size while preserving, to some extent, the restricted angle of view of the longer-focal-length lens.

DETERMINING EXPOSURE

Many people have problems with exposure and opt for the easiest way out. But this solution, simply setting your camera on an automatic or a programmed mode, may not give you the result you want. To understand exposure, you must remember that your meter reads everything as a middle tone. Gray cards are, perhaps, the best example of this, but colors have middle tones, too. In fact, many of my exposures are based on direct readings of an animal, blue skies, tree bark, or rocks—parts of the scene that may not be gray.

Although many animals are middle tone, some are black or very dark, and others are white or very light. An exposure meter won't know, and a direct meter reading may overexpose a dark animal or underexpose a light animal because it reads both as gray. To prevent this, you must determine your subject's tonality.

Camera manufacturers recognize this, even when they advocate using the sophisticated automatic-exposure modes their cameras offer. This is why the cameras have exposure-compensation dials with plus (+) and minus (–) marks. If your subject requires more exposure, as white does, you can add light by using the plus dial. Conversely, to underexpose for black, you can reduce the amount of light with the minus dial. Unfortunately, if you forget to reset the exposure-compensation dial to zero (0) after taking the shot, you'll run the risk of incorrectly exposing other subjects of different tonalities.

I don't use the exposure-compensation dial with non-middle-tone subjects. Instead, after taking a direct reading off the subject or off a middle tone value that is in the same light, I correct the exposure by changing either the aperture or the shutter speed. This requires me both to meter the precise area I want to expose for and to recognize its tonality.

If I determine that my subject is middle tone, I'll just base my exposure directly off it. If that isn't possible and if another middle tone isn't available, I may take an incident-light reading with my hand meter. However, I ordinarily don't use an incident meter when I shoot in snow or sand because I've found that the light bouncing off these surfaces adds more illumination than the meter indicates.

When shooting white or lighter-than-middle-tone subjects, I use a different approach. I meter them if I can, but after taking the reading, I overexpose by either half a stop or a full stop. Generally, I overexpose by half a stop when I photograph light-colored subjects or white subjects that are backlit or in deep shade. I open up a full stop for white subjects in sunlight or in cloudy-bright conditions.

Sometimes, however, I can't take a direct exposure reading off a white subject. In these shooting situations, I take a reading from a middle-tone area in the same light. Then I close down, usually by half a stop or a full stop, in order to correct for the subject's greater reflectivity. Remember, if I didn't stop down, I would overexpose the subject.

LYNX. Wild Eyes, MT. 300mm F4 lens. 1/125 sec. at f/4. Kodachrome 64.

You can meter such middle-tone subjects as this lynx directly. The grayish rocks present in this scene, as well as an incident-light reading, would also have yielded a correct exposure.

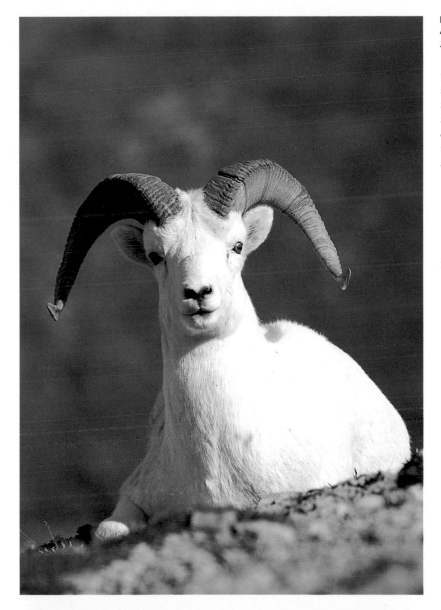

DALL SHEEP. Denali National Park, AK. 500mm F4 lens. 1/1000 sec. at ƒ/8. Fujichrome 100.

When I directly metered these white Dall sheep, they were underexposed and as a result, rendered gray (below). But by metering for white and then overexposing by one ƒ-stop, I was able to achieve the proper tonality (left).

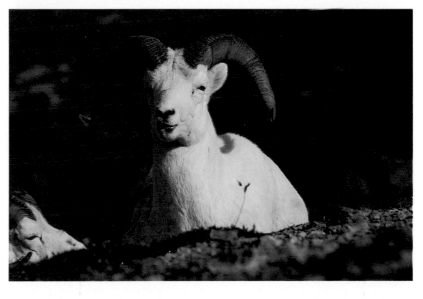

DALL SHEEP. Denali National Park, AK. 500mm F4 lens. 1/1000 sec. at ƒ/11. Fujichrome 100.

THE SUNNY *f*/16 RULE

Film	Exposure Setting	
	Average-Light Middle Tones	**Wildlife-Equivalent Middle Tones**
Fuji Velvia	1/30 sec., *f*/16–22	1/250 sec., *f*/5.6–8
Kodachrome 64	1/60 sec., *f*/16	1/500 sec., *f*/5.6
Fujichrome 100	1/125 sec., *f*/16	1/500 sec., *f*/8
Kodachrome 200	1/250 sec., *f*/16	1/1000 sec., *f*/8
	Average-Light Dark Tones	**Wildlife-Equivalent Dark Tones**
Fuji Velvia	1/30 sec., *f*/11	1/250 sec., *f*/4–5.6
Kodachrome 64	1/60 sec., *f*/11–16	1/500 sec., *f*/4
Fujichrome 100	1/125 sec., *f*/11	1/500 sec., *f*/5.6
Kodachrome 200	1/250 sec., *f*/11	1/1000 sec., *f*/5.6
	Average-Light Light Tones	**Wildlife-Equivalent Light Tones**
Fuji Velvia	1/30 sec., *f*/22–32	1/250 sec., *f*/8–11
Kodachrome 64	1/60 sec., *f*/22	1/500 sec., *f*/8
Fujichrome 100	1/125 sec., *f*/22	1/1000 sec., *f*/8
Kodachrome 200	1/250 sec., *f*/22	1/1000 sec., *f*/11

I do the reverse when I'm photographing either black or very dark subjects, although I usually don't meter directly off black. Instead, I meter a middle-tone area in the same light and open up by either a full stop if the animal is truly frame-filling, or a third-stop to a half-stop if the subject doesn't fill the entire frame. Opening up brings out some detail in the dark areas. If I were to leave the meter reading alone and not open up, I would be basing the exposure solely on a middle tone; however, this would render very little discernible detail in my dark or black subject.

But when the sun is behind me, I can accurately estimate exposure by using the "sunny" rules (see chart). You are probably familiar with the "sunny *f*/16" rule, which states that the base exposure for a middle-tone subject in bright, over-the-shoulder sunlight is *f*/16 at the shutter speed that closely approximates the reciprocal of the film-speed rating. Suppose you're shooting ISO 100 film in this type of illumination. The base exposure, then, is 1/125 sec. at *f*/16.

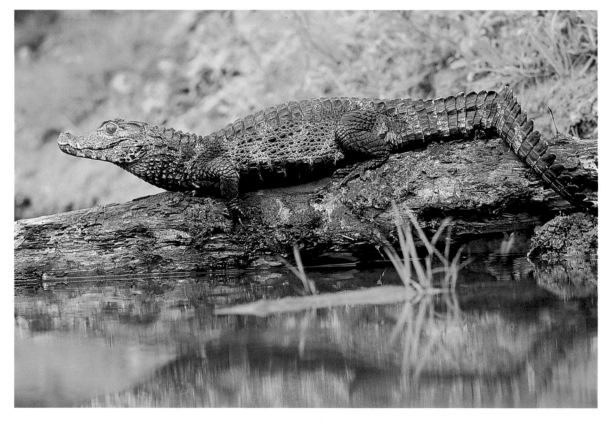

DWARF CAIMEN. Hoot Hollow, McClure, PA. 300mm F4 lens. 1/125 sec. at *f*/4. Fuji Velvia at ISO 40.

The "sunny f/16" rule applies only to the proper conditions, such as bright, over-the-shoulder sunlight. When working in shade or overcast light, I meter a middle-tone area and go with the reading (right), or I compensate according to my subject's requirements (far right).

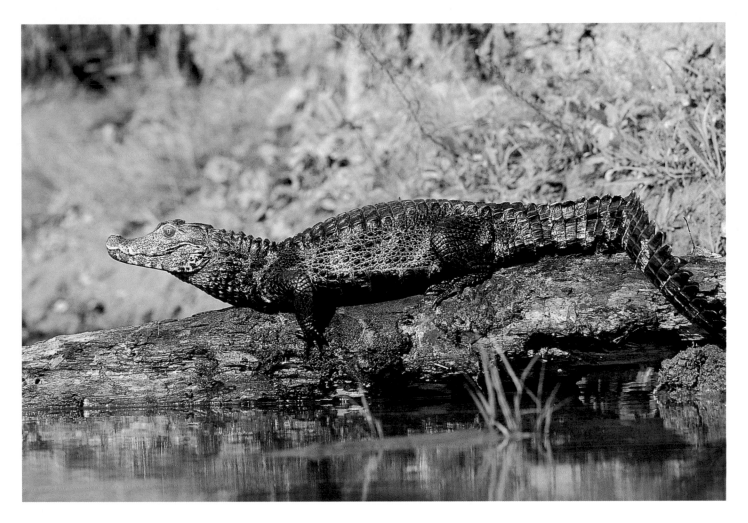

DWARF CAIMEN. Hoot
Hollow, McClure, PA.
300mm F4 lens. 1/250
sec. at ƒ/5.6. Fuji Velvia
at ISO 40.

A variation of this concept is the "sunny ƒ/22" rule for white subjects. Here, the shutter speed remains the reciprocal of the film speed, but the aperture is set at ƒ/22. Conversely, the "sunny ƒ/11" rule works for black subjects where the aperture is set at ƒ/11. Of course, my wildlife exposures usually require a faster shutter speed than an ƒ/11, ƒ/16, or ƒ/22 aperture allows. Accordingly, then, I use an exposure equivalent with a larger aperture, such as ƒ/5.6, and a correspondingly faster shutter speed.

Even if you don't like the "sunny" rules, knowing them simplifies the process of checking exposure. If you memorize equivalent exposures for the "sunny" rules, you'll have an instant reference point. For example, with ISO 64 film, the "sunny ƒ/16" exposure at 1/60 sec. is the same as ƒ/5.6 at 1/500 sec. If I meter a deer, a goose, or some other middle-tone animal

and my meter indicates the need for a smaller aperture or a faster shutter speed, a warning bell goes off. I ask myself two questions: Is there more (or less) light than I thought, or am I reading the correct area? By noting the difference between my meter reading and my estimated exposure, I can decide which I should trust.

As you read this, I am sure you're wondering when you would have enough time to do all of this. Leaving the camera on automatic seems like a much easier—if not better—solution. In truth, you probably won't have the time to go through a lengthy decision-making ritual each time that you shoot a wildlife photograph. But you shouldn't need to. If you practice taking meter readings in non-critical shooting situations, your thought processes, checks, and double-checks will become automatic, too. They have to be because wildlife won't wait while you think about exposure.

THE BENEFITS OF USING FLASH

Although I don't really like working with flash, I use it frequently—but not randomly. Flash photography requires a leap of faith, so to speak, in trusting that a TTL-determined exposure or a calculated exposure is correct. Unlike ambient light, in which you can estimate exposures if you have the experience, flash doesn't enable you to "read" it by eye. You must use a flash meter, a GN formula, or a distance scale, or you must place blind trust in the automatic-flash-metering capabilities of your system. This uncertainty and the difficulty some photographers experience in previsualizing the lighting make flash photography intimidating. But it doesn't have to be, and it shouldn't be. Flash is invaluable, and the results I obtain are definitely worth any trouble it poses.

I use flash for a number of reasons, including the obvious. Flash simply provides enough light to permit an exposure. Perhaps its most exciting application is high-speed photography; flash freezes motion better than any shutter speed can when it is the sole light source. When flash is combined with natural light, however, there are two limiting factors: the brightness of the ambient light and the shutter speed in use. Most modern cameras sync at a maximum shutter speed of 1/125 sec. or 1/250 sec., while most flash units emit light much faster, at bursts that last between 1/800 sec. and 1/50,000 sec. In bright light, your film will record both a flash image and an ambient-light image if the subject moves too fast for the shutter speed.

Consider, for example, a bluebird flying to a nest box where the ambient light reads 1/250 sec. at $f/11$. Suppose that the flash exposure is also $f/11$, the sync speed is 1/250 sec., and the flash duration is 1/12,000 sec. Despite the flash's short light burst, its ability to stop action depends on the shutter speed. Is 1/250 sec. sufficient to stop the flying bird? Probably not. A shutter speed of at least 1/1,000 sec. is required to freeze a small bird's flight. The film will record a sharp flash image of the bird (produced by the flash) and a blurred "ghost" image (produced by the ambient-light exposure at 1/250 sec.). To obtain crisp action shots, either the flash must be the solitary light source or the flash exposure must be so much brighter than the ambient-light exposure that the latter doesn't register on the film.

Of course, you don't have to use flash at the maximum synchronization speed; you can also use it at any shutter speed below that setting, all the way down to "B," or "Bulb," if you wish. This is important,

especially if you want to use flash as a fill light. As fill, flash reduces contrast and softens shadows in harsh daylight. Here, flash has an advantage over reflectors or mirrors, which I also use at various times. With a hotshoe flash or a flash mounted on a special bracket, I am free to wander about to seek the best angle or to follow a moving subject. With reflectors or mirrors, I am more closely tied to one spot.

For the most part, flash looks like sunlight and produces a natural color. If the flash is crudely used, though, the resulting illumination can appear unnatural and may cast objectionable shadows. I usually aim the flash to simulate either direct or diffused sunlight. To achieve a direct-sunlight effect, I simply hold the flash high and at an angle so that the flash strikes the subject the way sunlight would. To create a diffused effect, I bounce the flash off a reflector or aim it through a plastic diffusion screen. I may also use a very slow shutter speed to balance the flash exposure with the ambient light.

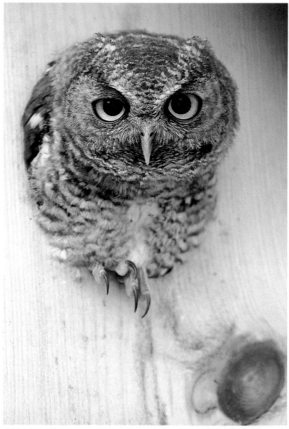

SCREECH OWL. Hoot Hollow, McClure, PA. 300mm F4 lens. 1/8 sec. at $f/5.6$. Fuji Velvia at ISO 40.

SCREECH OWL. Hoot Hollow, McClure, PA. 300mm F4 lens. 1/250 sec. at ƒ/11. Nikon SB-24 Speedlight on TTL at -⅓. Fuji Velvia at ISO 40.

Flash enables you to record detail, not only by permitting a smaller aperture for greater depth of field, but also through flash's directional, laserlike light. As you can see here, natural light that filtered through a canopy of green leaves produced an unattractive color shift (left). When I used my Nikon SB-24 Speedlight, the resulting image proved to be far more appealing (right).

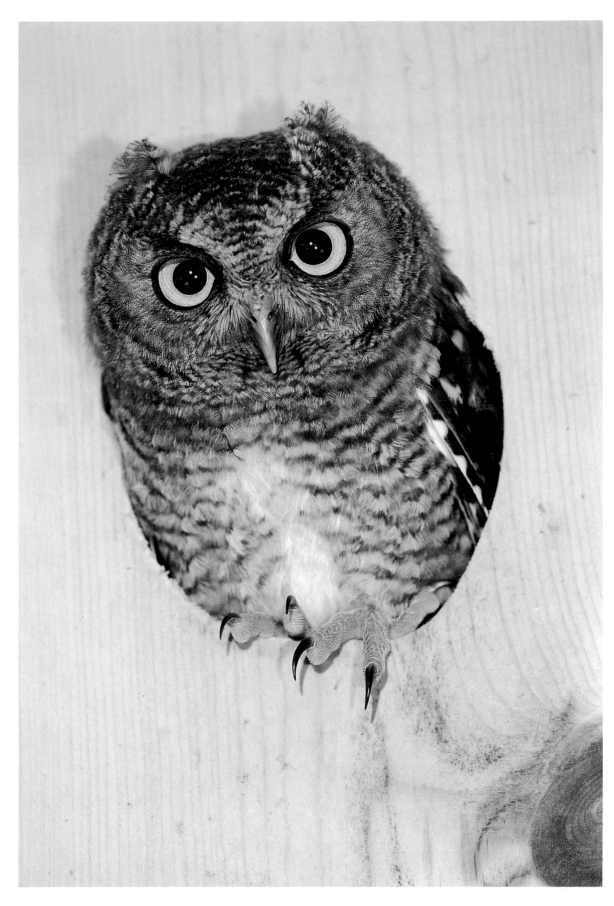

I advocate mastering both the TTL and manual modes for your flash units. TTL flash automatically reads the light reflecting off a subject just as an in-camera meter reads ambient light. This is convenient and accurate for most subjects. By determining the aperture, the flash produces the correct exposure for that particular f-stop. Because TTL metering may err with very light or very dark subjects, I rely on the exposure-compensation dial on my SB-24. I add +1/2 or +1 for a white subject, and I subtract anywhere from –1/2 to –2 for a dark subject. Both types of subjects require that I recognize their tonality and compensate accordingly.

Of course, when I use the TTL flash as fill, I base my exposure on the ambient light. Then I adjust the minus setting on the flash's exposure-compensation dial to add a visual snap without overpowering the ambient light. In any case, exactly how much compensation I use depends on numerous factors—enough to fill

another book, actually—but sometimes I just make a subjective guess.

When working in the manual mode, I can determine exposure several ways. First, I can measure the flash-to-subject distance and then base the lens-aperture setting on that measurement. Naturally, the flash unit's scale must be accurate for this method to work. For other shooting situations, I can use the GN formula (GN ÷ distance = f-stop). Actually, I rarely use either method. Instead, I determine exposure by holding an incident flash meter near my subject and take a reading. If getting close to the subject is impossible, such as when I want to photograph an unapproachable animal, I take a reading off a nearby area. Of course, its camera-to-subject distance and lighting must be the same as those of my subject.

If you use flash arbitrarily, you'll probably be unhappy with the results. If you master this wonderful tool, you can create some great shots.

TEMPLE VIPER. Hoot Hollow, McClure, PA. 200mm F4 macro lens. 1/250 sec. at f/16. Fuji Velvia at ISO 40.

Flash provides a brightness and clarity lacking in many natural-light shots, and it is almost essential for photographing exotic species in the studio.

THE DALEBEAM: ANOTHER FLASH DEVICE

You can fire a camera and/or a flash unit remotely a number of ways. These methods include trap-focus, radio-controlled releases, trip wires, extra-long air-cable or electronic releases, and photo-electric trippers. I've used all of these at one time or another, but my absolute favorite—and the one I've enjoyed the greatest success with—is a photo-electric tripper called a Dalebeam.

The Dalebeam is a small rectangular box that fires a flash or trips a camera when an infrared light beam is broken. (A separate function enables gear to fire when activated by sound, but I haven't tried this with wildlife.) A camera connects to the Dalebeam via an electronic remote cord that you attach with two banana plugs. Manual cameras, such as the Canon F-1 and the Nikon F3, work only with a motor drive because the camera bodies don't have provisions for an electronic release. Alternatively, you can attach a flash to the Dalebeam by plugging the flash cord into the Dalebeam's PC socket. You can't directly connect the Dalebeam to a hotshoe flash.

In the light mode, the Dalebeam sends and receives an invisible infrared light beam, requiring you to aim it at a reflector placed across the target's path. Although the Dalebeam reacts instantaneously when an object breaks this beam, a camera doesn't. Because of a camera's mechanics (i.e., the mirror flipping up, the shutter opening), there is a delay before the camera fires. This lag time may range from as much as 1/10 sec. to about 1/30 sec. This is significant because a bird flying 15 miles per hour (mph) travels about 2.2 feet in 1/10 sec., and about 7 inches in 1/30 sec. Consequently, you must make allowances if you wire a camera to the Dalebeam because if a camera is focused at the beam's position, the subject is likely to be out-of-focus by the time the camera fires.

You might be wondering about your own camera's lag time. Protech, Dalebeam's distributor, may be able to give you exact figures for your camera model (see page 143). If not, you can estimate that the delay is between 1/10 sec. and 1/30 sec. In most cases, the lag time will be reduced if you depress the shutter-release button to make the liquid-crystal display (LCD) light up in the viewfinder. You do this by taping the shutter-release button down just far enough so that the LCD shows. On occasion, I've taped an AA battery over the button to create the necessary pressure. If you don't activate the electronics, the camera's response time is slowed considerably.

Fortunately, you don't have to worry about lag time when you wire a flash to the Dalebeam. When the beam breaks, the flash fires. Here, though, you must set the shutter on "B." Obviously, this works only when you shoot studio subjects in darkened rooms and when you shoot at night. With this setup, the Dalebeam trips the camera or flash whenever the beam breaks, regardless of where this occurs in the light path.

CAROLINA WREN. Hoot Hollow, McClure, PA. 300mm F4 lens. 1/250 sec. at ƒ/16. Four high-speed flash units and Dalebeam. Fujichrome 50.

Here, I wired my camera directly to the Dalebeam and took into account the resulting lag time. However, I minimized this delay to about 1/30 sec. by depressing the shutter button enough so that the LCD lit up in the viewfinder. For this shot, I positioned the Dalebeam between a feeding tray filled with mealworms and a house wren's nest.

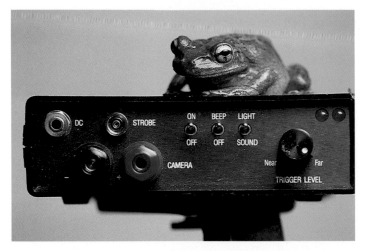

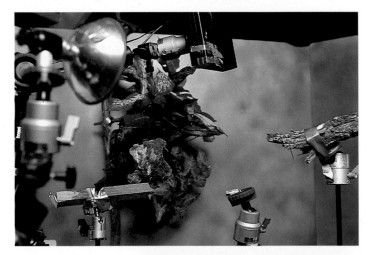

Unless your lens covers this entire distance, your subject might not be in view when it breaks the beam. For example, if the Dalebeam and the reflector are separated by 5 feet, a bird could break the beam only inches away from either end. And if you're focused on the middle 4-foot space, you'll miss the bird!

You can minimize this problem two ways. Frequently, I make some type of frame through which my subject must pass, with the Dalebeam and the reflector on opposite sides of the frame just out of view. Branches, logs, and/or leaves help direct the subject toward the middle of the frame, thereby increasing my chances of catching it successfully. Sometimes, however, this isn't possible and I have to wire two Dalebeams in sequence. With this setup, my camera or flash won't fire unless the beams are broken simultaneously. By my placing the Dalebeams at 90-degree angles to the subject, an invisible "X" is formed when the beams cross. My subject must then cross at or close to the middle of the "X" in order to break both beams and fire the system. If I've wired the flash to the Dalebeam, I'll focus on the "X"; if I've wired the camera to the Dalebeams, I'll focus on some point beyond the "X." Either way, I am fairly certain that my subject will be within the frame.

Admittedly, using the Dalebeam isn't for everyone, but it can make a big difference in the images you make. Coupled with high-speed flash, the Dalebeam opens up a whole new world of fast-moving subjects to you. You'll be impressed by the results you can achieve with this combination.

CUBAN TREEFROG. In studio, Fort Myers, FL. 100mm F2.8 macro lens. Bulb at ƒ/16. Four high-speed flash units and Dalebeam. Fujichrome 50.

To photograph this Cuban treefrog, I decided to use a Dalebeam, whose control panel is shown here (top). I then positioned the Dalebeam so that it would intersect the jump of the treefrog (bottom). Next, I arranged my high-speed flashes around that point. The background served only as a wall to keep the treefrog from disappearing in my cluttered studio. I had to keep the camera on Bulb so that the flash fired at the instant the treefrog's jump broke the Dalebeam's infrared beam (right).

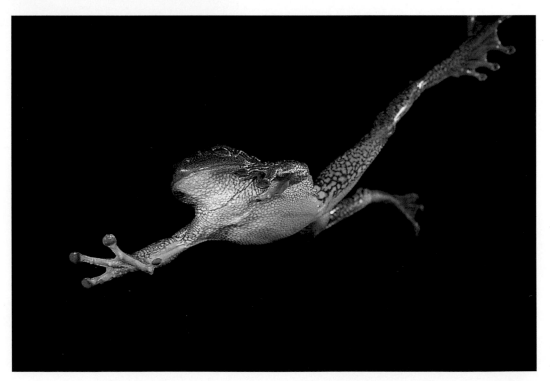

EFFECTIVE COMPOSITION

Although nature photography and wildlife photography are often discussed in the same breath, they are quite different in one critical way. When you photograph nature, you should try handholding your camera as you look at a scene. This enables you to quickly assess a composition from many different angles before shooting with a tripod-mounted camera. But this approach doesn't work well for wildlife photography. The lenses you need are sometimes so heavy that you can't comfortably handhold them when you shoot.

Here you see the rectangular 35mm image format divided into thirds. The points of intersection mark the points of power.

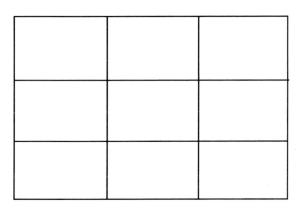

SCREECH OWL. Hoot Hollow, McClure, PA. 80–200mm F2.8 zoom lens. 1/125 sec. at *f*/8. Two manual flashes. Kodachrome 64.

Out-of-focus foregrounds either can be distracting or can add a sense of depth and a natural quality to an image. For this selective-focus closeup, I decided to frame my subject with leaves that lacked sharp detail.

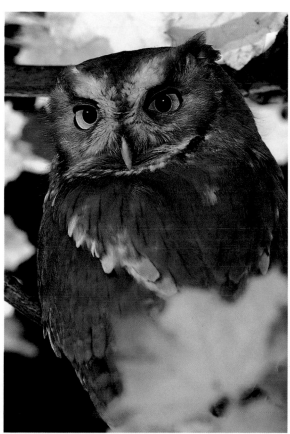

In addition, your subject may leave while you're still deciding on how to compose the image.

When I photograph wildlife, I find some subjects that look great, and I have no trouble deciding on how to compose. Others are less compelling, and they cause me the most agony. They are just there, and I'm really challenged to avoid making a boring record shot. When shooting these subjects, I run through a list of possibilities, one of which I hope will work.

I ordinarily consider subject placement first. Chances are I unconsciously center the animal when I start. Next, I ask myself if doing this makes the picture look balanced or static. Some centered images work. But if the subject doesn't look good centered, I ask myself where I should place it. As a rough guide, I consider the points of power in the "rule of thirds" grid as it relates to the subject's pose. Is it looking toward me, or to its left or right? For the most part, it is best not to have your subject looking out of the frame. For example, a red fox facing left may not work as well when positioned at a left power point as it will when placed at one on the right. This isn't always the case, of course, but it usually holds true.

The lines of the subject and of its habitat are important and generate more questions. Are there strong graphic elements running through the picture? How does the subject best fit into the frame? Is the subject taller than it is long, and does it nearly fill the frame in one of these dimensions? I think most photographers shoot more horizontals than verticals because cameras are designed to be used most easily in the horizontal orientation. Consequently, I make a special effort to switch to the vertical format whenever I possibly can.

The subject's implied direction helps me determine the composition, too, and I may give it space to move into the frame. Whenever I can, I shoot at my subject's level because this implies subject intimacy and presents a view foreign to many. For most mammals and birds, I use my tripod at minimum extension; this gives me more support than is possible when I extend my tripod to its full height.

When I compose a wildlife shot, I also watch for distractions, both in front of and behind the subject. I can usually eliminate or reduce these simply by changing my camera position. In time and with practice, you'll automatically assess the proper perspective and position your camera correctly. Too often, photographers shoot from their most comfortable position (standing upright) or from the position they last set their tripod legs for. If this is a habit of yours, break it.

Sometimes I purposely incorporate distracting elements in the foreground of an image by using selective focus. In order to obtain the best result, I put some distance between the subject and the distractions, and I keep the foreground elements fairly close to the camera. I've found that long lenses and wide-open apertures minimize depth of field and enhance this effect.

When I work with short lenses, I often consider the hyperfocal distance. This is the point of focus where everything is sharp from half the focused distance to infinity. Hyperfocal distance changes with different lenses and apertures. Knowing this is most useful when I shoot with 28mm and shorter lenses. Hyperfocal distance has no practical value when you use lenses that are longer than 50mm. Nevertheless, the general principle still holds, and you can apply it to maximize the depth of field and apparent sharpness in a picture.

Regardless of lens length, when I need a detailed background, I close down as far as I can without sacrificing image sharpness because of camera shake or subject movement. These are a result of the slower shutter speeds required. Technically, the background in the shot may not be razor sharp, but it may contain discernible details. I call this area the "zone of apparent sharpness." Depth-of-field scales don't show this zone; to see the effect, I must use the depth-of-field preview button. This stops down the lens to the image-making aperture, which darkens the viewfinder as it sharpens the image.

When shooting closeups, I also consider the plane of focus, which lies parallel to the film plane. If the subject is perpendicular to this plane, depth of field suffers, and the lines of the subject will extend beyond this limited area. Those areas outside the depth of field become progressively less sharp and potentially distracting. However, if you keep the subject parallel to the film plane, all, or most, of the subject will lie within the depth of field.

I am also very aware of the contrast, or the exposure differences between light and dark areas, within a scene. If my subject is in shade but is surrounded by sunlit areas, some portion of the image will be improperly exposed. If I base my exposure on the subject, the sunlit area will be overexposed. Conversely, if I base my exposure on the areas in the sunlight, the underexposed subject may seem to disappear. I can handle this contrast problem a number of ways, depending upon the circumstances. If I can, I'll switch to a longer lens to minimize or eliminate the bright areas. Sometimes I fill in the dark areas by using mirrors, reflectors, or flash. On partly cloudy days, I may just wait for a cloud to obscure the sun, thereby reducing the contrast in the scene. If none of these options is possible, I may pass on the picture!

I like to shoot silhouettes, and I am acutely aware that black on black produces a shapeless blob. The thought "I can't shoot a silhouette against a silhouette" continually runs through my mind as I compose such images. You must visually separate silhouetted shapes so that they don't coalesce. And remember, you may not see this merger through your viewfinder since you are able to discern subtle differences in tonality much better than film can. Furthermore, you perceive subjects three-dimensionally, while film is limited to a two-dimensional rendition of a scene. Keeping your images clean and simple eliminates this problem.

This last point is essential. Simple images, such as frame-filling portraits, usually work. Complex ones may not succeed if they confuse the viewer's eye and require subtle, subjective decisions. Don't expect your audience to do your work for you.

RED FOX. Wild Eyes, MT. 300mm F4 lens. 1/250 sec. at *f*/5.6. Fuji Velvia at ISO 40.

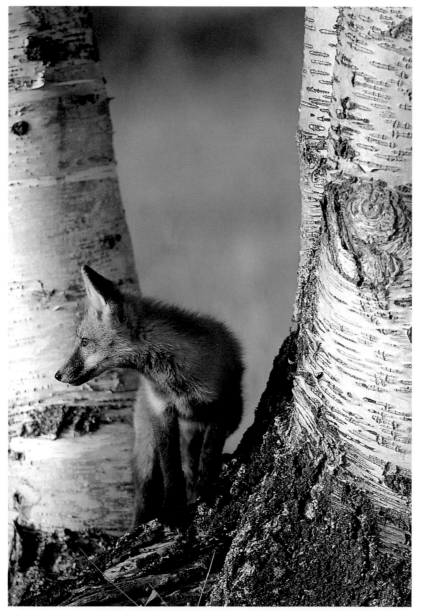

RED FOX. Wild Eyes,
MT. 300mm F4 lens.
1/250 sec. at ƒ/5.6. Fuji
Velvia at ISO 40.

Positioned toward the
left side of the frame
the fox appears to
be looking out; the
result is an awkward
composition (left).
Fortunately, the fox
moved in the dynamic
"v" of the tree bark,
and its gaze balanced
the composition (right).

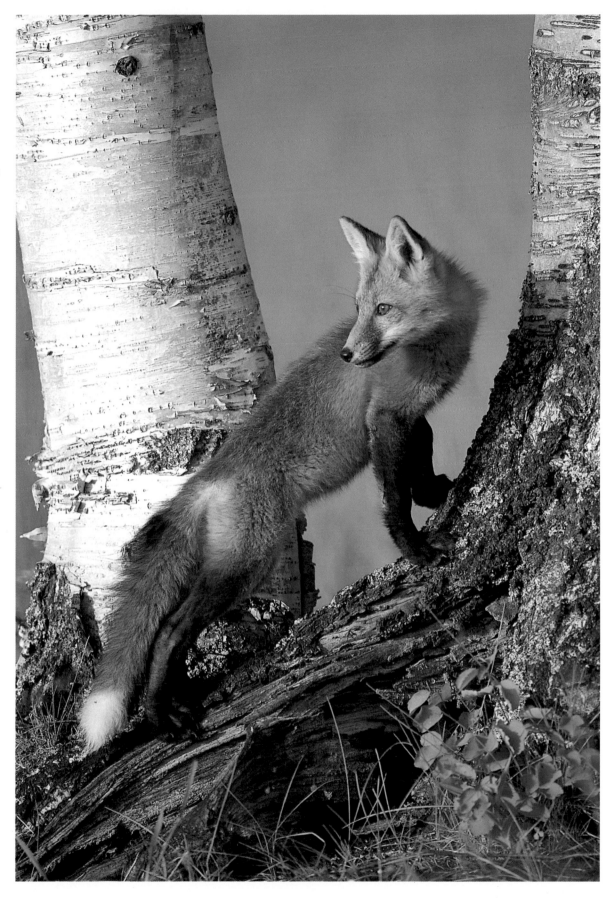

ACHIEVING IMAGE SHARPNESS

When you photograph wildlife, do you consider the effect shutter speed, lens length, wind, or a motor-drive burst may have on image sharpness? Do you think about how the height of your tripod may influence composition and image clarity? If my workshop experiences are a reliable guide, the answer to these questions is no. I've seen photographers repeat dozens of common errors so often that they've almost become the rule. If you know exactly what kind of gear you need, understand exposure, and can compose well, your biggest obstacle to consistently making crisply focused images is learning how to master the operation of your equipment.

As a first step, consider the cable release. I recommend using a cable or electronic release only when tripping the shutter by hand might produce vibrations. This is quite likely to happen when you use slow shutter speeds, long lenses, rickety tripods, or any combination of the three, or if you violently stab the shutter-release button every time you take a picture.

I use a cable release under various shooting conditions. It is quite helpful when I work with long lenses and shutter speeds slower than 1/125 sec. Tripping the shutter by hand in such situations causes camera shake. Similarly, I rely on a cable release when I use reflectors, mirrors, or flash, as well as when I am near the subject and must fire the camera from my subject's position. Finally, I use a cable release with almost any lens when I require a shutter speed of less than 1/30 sec.

If I forget to bring a cable release, I may use my camera's self-timer instead. This provides time for vibrations caused by manually depressing the shutter-release button to dissipate before the camera fires. However, the self-timer doesn't prevent vibrations produced by mirror slap. Despite camera manufacturers' claims to the contrary, the flipping mirror causes camera shake. This problem is most noticeable between shutter speeds of 1/15 sec. and 1/4 sec., although a long lens may record tremors at faster shutter speeds, too.

Ideally, when using slow shutter speeds, I use my Nikon F4 with its mirror locked up in order to reduce or eliminate vibration. This method has its limitations though; it calls for a stationary subject because I can't refocus once the mirror is locked into place. Nevertheless, I've made sharp exposures with a 500mm lens and a shutter speed of 1/4 sec. this way.

Some models activate the mirror lockup only if the camera is tripped with its self-timer. Here, the mirror locks up a few seconds before the shutter opens. This works effectively when the subject doesn't move during

When working in gusty winds, I not only use my maximum stability stance, but I also remove the lens hood and shoot at the lowest tripod height possible in order to reduce the wind's effect. These practices enable me to produce sharp images in adverse shooting conditions. Photograph by Mary Ann McDonald.

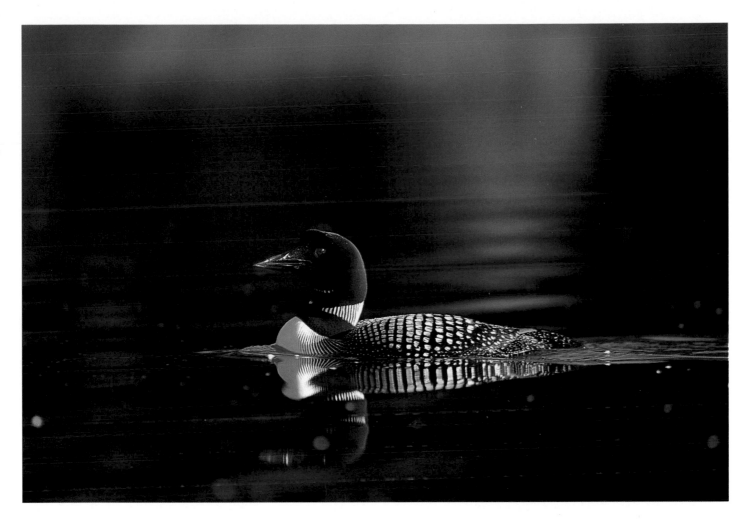

COMMON LOON. Lake No. 9, MT. 500mm F4 lens. 1/250 sec. at ƒ/4. Fuji Velvia at ISO 40.

My friend Cody piloted Bill, another friend, and me across a lake for loon closeups. Mounting our 500mm lenses onto tripods and setting them across the hull of the canoe proved awkward, but it was necessary for sharpness. Whenever a loon surfaced, Cody stopped paddling, and we would drift forward, trying to focus on this fast-swimming bird at the same time. The low morning light and black, contrasty reflections made determining exposure an absolute nightmare.

that length of time. Unfortunately, most older camera models don't do even this, and mirror lockup is a very rare feature in today's cameras.

Shutter speeds are also critical for image sharpness. As I determine exposure, I ask myself a question. Do I need depth of field, or do I need speed? If I want extensive depth of field, I'll select a slow shutter speed and a small aperture. I'll choose a faster shutter speed if the scene contains action, or if I purposely want a shallow depth of field. The faster the shutter speed, the sharper the image at the point of focus, although areas around that point may be soft. For example, the first time I made closeups of a purple sandpiper with my 300mm lens set at ƒ/2.8, the bird's eye was razor sharp, but its bill and body were in soft focus. (Of course, all the slides from this shoot went into my circular file.)

A motor drive can influence image sharpness, too. At slow shutter speeds, I fire one frame at a time rather than a burst of frames in quick succession, so that vibrations have a chance to dissipate between exposures. Motor drives have another surprising function regarding image sharpness when you're handholding a camera at slow shutter speeds. Many people have a tendency to

punch in their shutter button, causing a slight vibration. At a slow shutter speed, this produces a blurred image. By firing a short motor-drive burst, you can eliminate that flinch after the first frame is fired.

By the way, motor drives and motor winders are practically invaluable for wildlife photography because they advance film much faster than you can doing it by hand. Additionally, a motorized film advance enables you to keep your eye at the viewfinder between frames, which isn't possible with a manual thumb-advance lever. Using a motor drive gives you an edge when you photograph wildlife. You can watch for the decisive moment when your subject's pose or expression is perfect and have a better chance of recording it.

At up to 6 frames per second (fps), motor drives advance film faster than motor winders do, which work around 3 fps. Don't get complacent; a motor drive isn't a guarantee that you'll catch your subject at peak action. Consider the following example. Suppose you're shooting at 6 fps and using a shutter speed of 1/1000 sec. When you press the shutter, you'll record the scene for only 6/1000 of a second; a great deal can happen during the 994/1000 of a second remaining.

You also shouldn't get carried away with your motor drive in order to ensure capturing a scene. I don't use my motor drive in a scatter-gun approach unless the action is happening so quickly that my only option is to hold down the motor drive, focus, and hope. Instead, I use the drive as a "fast thumb" to advance the film more rapidly than I can manually. In these situations, I can snap off frames as the action dictates.

When I shoot on windy days, I minimize the lens area that is exposed in order to render my images sharp despite the challenging environmental conditions. I keep as low to the ground as I can, shooting from what I call my "maximum-stability stance." As a rule, I always use my tripod at the minimal required extension because this makes it as sturdy as possible. To minimize the wind's effect even further, I remove the lens hood. Then if the wind is still a factor, either I'll try to reduce or eliminate vibration by adding weight to my camera-and-lens system, or I'll support the camera body with a second tripod or a Bogen Magic Arm. The Magic Arm acts like a brace. One end clamps onto a tripod leg, and the other end screws into the camera body's tripod socket. The Arm is quite versatile; you can set it in an almost infinite variety of positions that when locked in place make it rock solid. Of course, sometimes nothing helps, so I just don't shoot.

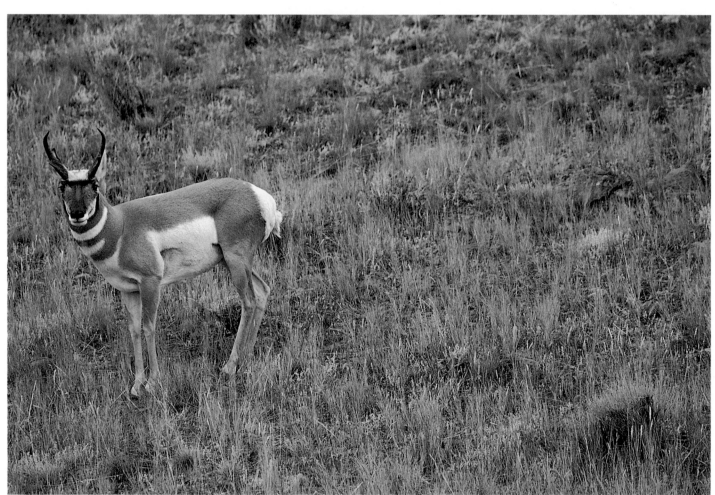

PRONGHORN. Yellowstone National Park, WY. 500mm F4 lens. 1/4 sec. at ƒ/16. Kodachrome 64.

When resting, some animals can be absolutely motionless. To get this pronghorn in sharp focus, I locked up my mirror, used a sturdy tripod, and tripped the shutter with a cable release. This simple image clearly illustrates that sharpness may depend upon your technique, not on the subject's movement.

I ordinarily use a tripod for my wildlife photography. In fact, I made all but four of the pictures in this book with my camera mounted on a tripod. But using a tripod does have its disadvantage. Although a tripod certainly increases your chances of obtaining sharp images and of being ready when a long wait for a subject is involved, it can also be restrictive and slow you down as you move about or change positions. But if you buy a good tripod, it won't limit your shooting flexibility.

Sometimes shooting conditions make it difficult to use a tripod. For example, I've had to pan birds and mammals while handholding telephoto lenses. And I've used the ground as a brace for photographing low

creatures, bracing my elbows snugly on the earth. For action sequences shot with 200mm or shorter lenses, I've relied on a shoulder-mount, monopod system called the Stabilizer Quick Shot; this has proved to be a surprisingly stable support. I use the Quick Shot with an 80–200mm zoom lens when I've kept my 300mm or 500mm lens on the tripod. You can use this stabilizer with longer lenses, but I don't trust my own steadiness above 200mm.

Obviously, you must confront a number of factors when it comes to image sharpness. Make the careful consideration of these a habit. Then when you aim your camera at a great subject, you'll be ready to create a quality image.

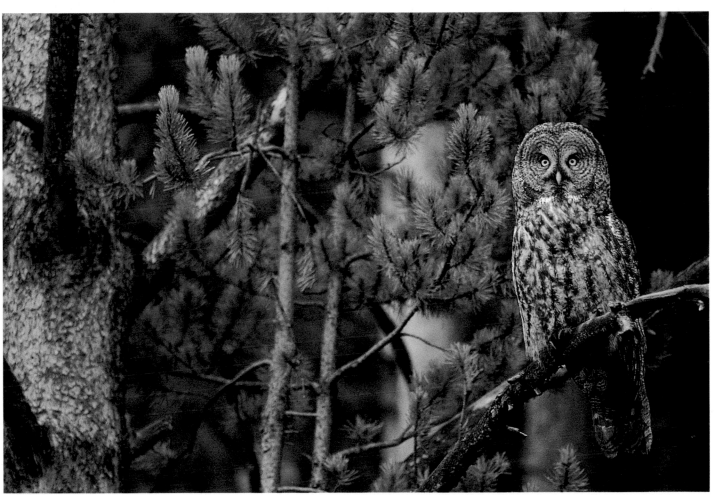

GREAT GRAY OWL. Yellowstone National Park, WY. 600mm F4 lens. 1/125 sec. at *f*/4. Kodachrome 200 at ISO 250.

The great gray owl, the largest owl in North America, is also one of the tamest. In some western-mountain national parks, you can find great grays hunting for voles along the edge of high meadows. When this owl roosted, it remained perched within easy camera range of dozens of photographers throughout the day.

MASTERING MACRO PHOTOGRAPHY

Macro photography is a fascinating specialty that provides you with easy access to an almost unlimited choice of subjects. Although I've included images from around the United States in this book, I do most of my macro photography near my home in Pennsylvania. To find subjects, I study flower heads and plant stalks, and I keep alert for the sudden movements of flying or jumping insects. With the exception of large dragonflies and butterflies, most insects and spiders aren't very conspicuous. In fact, I'm always amazed at how scarce insects can be when I'm looking for something to shoot!

Since breezes often arise within an hour after sunrise, closeup photography becomes pretty difficult throughout much of the day. The time of day determines the lighting I use for macro subjects. For natural-light images, I work either in the early morning before the wind picks up or on muggy, humid days when the air is reasonably still. Shooting at midday is fine when I'm using regular flash for honeybee closeups, as well as when I'm using fill-flash for portraits of butterflies on flowers.

Macro photography requires magnification, which creates challenges. Remember, depth of field decreases as magnification increases, and motion is more detectable at higher magnifications. This is another reason I often use flash. It freezes motion and provides the small apertures required for extensive depth of field. But using flash as a light source can produce problematic dark backgrounds. Light falls off rapidly in closeup shooting, so I lose two stops of light each time I double the distance to the flash.

For example, suppose I'm photographing a black damselfly that is 10 inches from my flash against a background that is 10 inches farther back, or 20 inches from the flash. Because I'm working with just one flash, this will result in a two-stop exposure difference between the damselfly and the background. If the insect requires an aperture of $f/16$, the aperture for the background will be $f/8$, which will make it appear almost black in a slide. Properly exposed, a black damselfly will practically disappear against this dark background. To increase the contrast so that the insect stands out, I can either bring the damselfly and the background closer (if this is possible) or aim another flash at the background.

I often decide to use two flash units. Much of my in-field flash photography involves two flashes mounted on a Lepp II Macro Flash Bracket. I mount my main light, an SB-24, close to the lens, and position my fill light, an SB-22, a bit higher to strike both the subject and the area beyond it. With TTL metering, the main light pretty much determines the exposure; the other flash simply illuminates the background.

I can also control the lighting ratio by balancing the flash and ambient-light exposures via the aperture or the shutter speed. Which one I use depends on either the depth of field I need or the movement I must freeze. If my subject is motionless, I'll use a small aperture, such as $f/16$, and a slow shutter speed. If the subject is moving, I'll probably need a shutter speed of at least 1/125 sec. in order to stop the motion. But this is too fast for most ambient-light exposures where depth of field is desired, so I just open up to a wider aperture and sacrifice some depth of field.

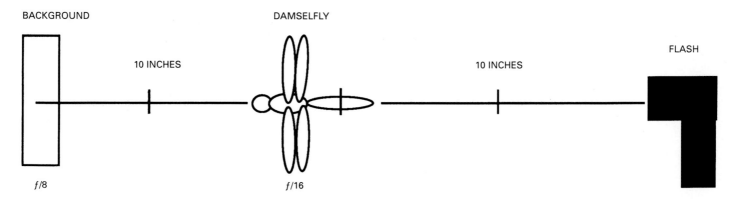

BACKGROUND DAMSELFLY FLASH

10 INCHES 10 INCHES

$f/8$ $f/16$

For this macro setup, the flash-to-background distance of 20 inches is twice that of the flash-to-subject distance of 10 inches. Because two stops of light are lost each time the distance to the flash doubles, the $f/16$ aperture required for the subject means that the background will be exposed at $f/8$. To prevent the background from appearing too dark, you would have to aim another flash at it or, if possible, bring the subject and the background closer together.

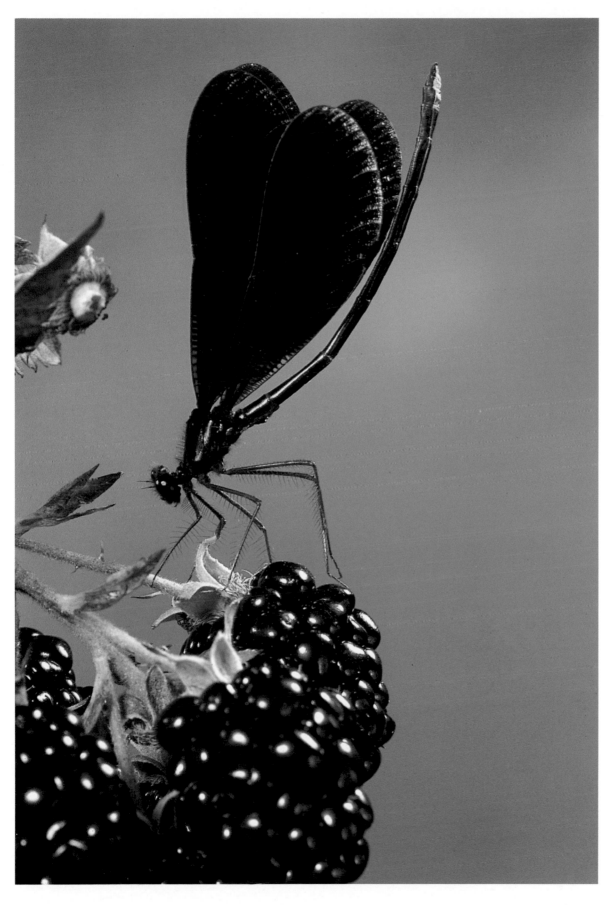

BLACK DAMSELFLY.
In studio, Hoot Hollow,
McClure, PA. 200mm
F4 macro lens. 1/250
sec. at *f*/16. Three
manual flash units.
Fuji Velvia at ISO 40.

*I had to direct one
of my three flashes
toward an artificial
background in order
to obtain an exposure
similar to that needed
for the damselfly.
Otherwise, the dark
insect would have
merged with the
black background.*

My favorite lens for macro photography is a 105mm F2.8 macro lens that focuses down to 1:1, or life-size. If you're confused about reproduction ratios, such as 1:1, 1:2, 1:3, and 3:1, just think of them as fractions. Replace the colon with a slash mark so that they read 1/1, 1/2, 1/3, and 3/1. At 1/3, then, the image on the film is one-third life-size; similarly, at 3/1, it is three times life-size.

Macro lenses come in many focal lengths, which typically range from 50mm to 200mm. The differences boil down to working distances. Getting within 20 inches of your subject with a 200mm lens for 1:2 magnification is usually easier than getting within 5 inches for the same image size with a 50mm lens.

Choosing a longer lens for macro work offers another advantage as well: I have a less extreme lighting ratio to be concerned about when I use flash. Consider the damselfly shooting situation again, in which the background was 10 inches behind the insect. If I use a 50mm lens at a working distance of 5 inches here, the background will be three times farther back (a total of 15 inches). If I use one on-camera flash, this setup will result in three stops less light. But if I use a 200mm lens at a working distance of 20 inches, there will be only a one-stop difference between the insect and the background. Here, the background will have to be 20 inches behind the damselfly (double the working distance) in order to lose two stops of light. Keep in mind, though, that at any given f-stop, more flash energy is required for a subject 20 inches away than it is for one 5 inches away, so the flash recycling time is slower. You have to decide whether you need the recycling speed or the less extreme lighting ratio when using flash.

WOLF SPIDER. Hoot Hollow, McClure, PA. 100mm F2.8 macro lens with PN11 tube. 1/30 sec. at f/16. Nikon SB-24 Speedlight on TTL. Fuji Velvia at ISO 40.

Although my flash was on TTL, my camera was on manual. I used a shutter speed slow enough for the background, which was in natural light, to provide enough illumination to offset this eggcase-carrying spider.

WOLF SPIDER. Hoot Hollow, McClure, PA. 60mm F2.8 macro lens with PN11 extension tube. 1/250 sec. at ƒ/16. Two TTL flashes (Nikon SB-24 and SB-22 Speedlights) at −²/₃, mounted on Lepp II Macro Flash Bracket. Fuji Velvia at ISO 40.

Although I used TTL flash, the spider was darker than middle tone, so I compensated accordingly. The flash bracket helped to maintain my flash placement no matter where I moved to follow the spider.

Short macro lenses, however, provide an easy way to achieve extreme magnification, such as two times life-size. With extension tubes, you need a smaller lens/tube combination since magnification is determined by the following formula: length of extension ÷ length of prime lens = magnification. My 60mm macro lens focuses to 1:1. If I then add a PN11 extension tube, which provides about 50mm of extension, I'll have nearly 2X or 2:1 life-size. Conversely, I would need 200mm of extension added to my 200mm lens to reach 2X life-size!

Remember, you don't need a macro lens to make closeups. A 50mm extension tube added to an 80–200mm zoom lens provides ratios close to, or exceeding, 1:2. Accessory closeup lenses, such as Nikon's double-element lenses, produce similar results. Unfortunately, zoom lenses that offer "macro" focusing at the short end of the zoom range—for example, at 28mm on a 28–80mm zoom lens—are impractical. The working distance is much too close, and many "macro" zooms don't focus close enough for 1:2 ratios.

With the wide array of alternatives available, you may not be sure about what gear to use. When I want to shoot extreme closeups approaching 2X, I use a 60mm

macro lens with extension tubes. For other subjects, I use either my 105mm macro lens or my 200mm macro lens, depending on the working distance required. I use flash when I need it, which is most of the time with macro work. Fortunately, with so many subjects available, you'll have the chance to try a number of methods to determine which one is best for you.

MINIMUM FOCUSING DISTANCES WITH EXTENSION TUBES AND CONVERTERS	
Lenses	minimum focus (lens-to-subject)
500mm	14'6"
500mm + PN11 + 1.4X	8.3"
500mm + 1.4X + PN11	11'
300mm	7'
300mm + 1.4X + PN11	5'2"*
300mm + PN11 + 1.4X	3'10"**

* at minimum focus, the image size is 3.5" across.
** at minimum focus, the image size is 2.9" across.

MACRO SUBJECTS IN THEIR ENVIRONMENT

GOLDEN ARGIOPE SPIDER. Hoot Hollow, McClure, PA. 80–200mm F2.8 zoom lens. 1/30 sec. at f/5.6. Kodachrome 64.

Early morning is the best time to photograph spiders, before wind-induced vibrations begin. Long-focal-length lenses, like the 80–200mm zoom lens I used for this shot of a spider, provide an extensive working distance that keeps a tripod's legs away from the web or the vegetation that supports it.

Making environmental shots of macro subjects poses a challenge: getting close enough to them in order to obtain a sufficiently large image size without losing the essence of their habitat. While potential subjects appear to be everywhere when I don't have a camera with me, finding worthy bugs when I'm prepared to shoot is a different story. Patience, sharp eyes, and a reliable exposure system are all musts.

Macro portraiture demands care. Lighting can be tricky. I've used natural light, reflectors, and electronic flash for catching macro subjects at rest. And since depth of field is so limited, you need to focus your attention on keeping your camera parallel to the subject. For example, when shooting a golden argiope spider in its web, I knew that the light breeze was just enough to make using a slow shutter speed too risky, so a fairly shallow depth of field would result. Limiting the depth enabled me to keep the background vegetation soft, thereby rendering it less busy. The rest of the picture-taking process was easy. First, I simply determined the point at which the spider, web, and plant were roughly parallel. Then I set up my tripod, adjusted my position, and fine-tuned the angle and distance by focusing with the lens wide open. In this way, without any depth of field, I was able to see when everything looked reasonably sharp. Next, I closed down the aperture one stop to ensure image sharpness.

As this picture shows, you won't need a macro lens if you don't need a large image size. And remember, the important ways depth of field affects the final image. Here, too much depth would have resulted in a very distracting background, and the fine silk threads in the bottom of the frame may have been lost.

While photographing a waterfall along the Firehole River, I encountered a hatch of recently metamorphosed stoneflies. These inch-long insects spend their immature naiad stage in fast-moving streams. Before adulthood, the naiads leave the water, clamber onto rocks or vegetation, and change into winged adults. I missed the actual metamorphosis, during which the naiads' exoskeletons split and the adults climb out, but their thick, dried skins were everywhere.

Having missed this image, I wanted to at least include both an adult and a naiad exoskeleton within the frame. Several minutes passed before I found two subjects that were in the same plane of focus and in a fairly open area. Upright and paired on opposite sides of the plant, they looked best composed vertically. The horizontal format contained too much dead space on either side. While the following statement might seem obvious, it never hurts to be reminded that if your subject is vertical, your composition generally should be, too. Remember this when you shoot.

When I tried to capture these stoneflies with a 200mm lens, my angle of view was so limited that only the nearest leaves behind them were visible. I then switched to a 100mm lens. This produced a clear separation between those leaves and the more distant field, which didn't work either, so I returned to my 200mm lens.

Macro subjects usually require somewhat extensive depth of field, but on occasion achieving maximum sharpness creates a problem: the background becomes too busy. The only way to find out if this has happened is to use the depth-of-field preview button. Although your lens may have a depth scale, it shows only what is in sharp focus, not what appears to be sharp or what is merely discernible. In fact, the depth-of-field scale on a macro lens is so narrow that the only practical function it performs is to indicate just how shallow that depth actually is. For this reason, I often use a 200mm macro lens even though my cameras have, and I use, a depth-of-field preview button.

In setting up this shot, I first lined up the insect and the exoskeleton as close to parallel to my film plane as possible, at the image size I liked. Next, I determined both depth of field and the zone of apparent sharpness. I did this by holding down the depth-of-field preview button, turning the aperture ring from $f/4$ to $f/32$, and noting the f-stop at which the subject looked sharpest and the background didn't appear too busy.

To double-check the ideal compromise, I rotated the ring again, this time from $f/32$ to $f/4$. Both times, the image looked best between $f/9.5$ and $f/11$. The smaller aperture balanced the exposure at 1/15 sec.

You could make the same comparison I made with my 100mm and 200mm macro lenses by using an 80–200mm zoom lens with an extension tube. The working distance will change as you zoom in or out, as will the angle of view and the amount of background included within the image. But there is no substitute for the depth-of-field preview button in determining ideal image sharpness. If your camera doesn't have this feature, you are definitely at a disadvantage. You'll then have the best chance of "blowing out" a busy background by using either a longer macro lens or a zoom lens at its longest focal length with extension. This will at least permit you to minimize distracting backgrounds, regardless of the f-stop you choose.

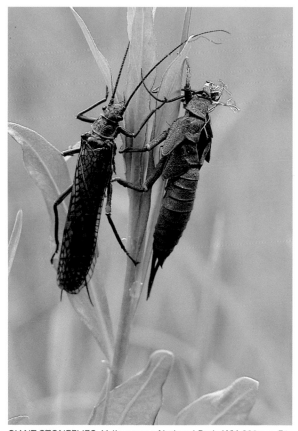

GIANT STONEFLIES. Yellowstone National Park, WY. 200mm F4 macro lens. 1/15 sec. at $f/11$. Fujichrome 50.

If you want to photograph the wildlife found near intertidal zones, you must plan to go at low tide when the rocks and pools are exposed. Keep in mind, however, that these are dangerous areas because the rocks are covered with algae, and every step is treacherous. In fact, I've had my worst falls while shooting in tide pools.

You should be aware of two other dangers associated with tide pools. In some areas, "sneaker" waves may form. These are huge, completely atypical waves that roll in unexpectedly, swamping anything in their path. On the Galapagos Islands I saw an elderly couple almost swept to their deaths at a blowhole, appropriately named "Darwin's toilet," when a sneaker wave crashed onto the rocks. You don't get any advance warning, so be sure to keep on the lookout for any large waves rolling in.

The second problem isn't life-threatening, but it is still a serious concern. I've seen people place their equipment on a nearby rock rather than on the biggest (highest) one in the area, wander off, and later find that the returning tide flooded their gear. To keep your equipment safe and dry, leave any extra pieces that you

aren't using at the moment on a large rock or above the high-tide mark on the beach. I don't want to frighten you and prevent you from shooting at tide pools, but I want to make it clear that you must be careful when you work in these potentially dangerous locations.

In North America, the northeastern and northwestern coasts offer the best tidal-zone subjects. Although the sandy shorelines common to much of the United States are tidal, they are less productive than intertidal zones because they support life that hides or burrows at low tide. In contrast, the stony tide pools of the northern coasts support a diversity of subjects that are exposed at low tide. My favorite spots include Point Lobos in California and Rialto Beach in Olympic National Park, Washington.

To emphasize the texture in the sea star and the kelp in this shot, I backed up until I was able to position both of them relatively parallel to my camera. Because the blackish kelp holds little interest other than as a frame, I strengthened the composition by placing the sea star in a point of power on the "rules of thirds" grid.

Using a 100mm macro lenses had two advantages. It gave me a short working distance and the 1:2 reproduction I wanted. A 200mm macro lens, on the other hand, would have been impractical. The working distance needed to obtain the same image size would have forced me to raise my tripod so high that I wouldn't be able to comfortably look through the camera's viewfinder.

SEA STAR. Point Lobos State Park, CA. 100mm F4 macro lens. 1/8 sec. at f/16. Kodachrome 64.

Exposing for dark-green kelp and wet, highly reflective sea stars fool a camera's spot meter because there is no true middle tone present. Here, I used an incident meter and opened up one-third stop to compensate for the many dark tonalities in the scene. When you work with an in-camera meter, I suggest exposing off a gray card or a similar known middle tone at the subject's position, and then either trust that reading or do what I did and open up.

I don't think a programmed exposure using a matrix- or evaluative-meter reading of the scene would have worked in this shooting situation. These metering modes read the entire scene, and while they emphasize exposure values in particular sections, these might not correspond to the areas you want to properly expose. Here, the dark tonalities would have fooled the meter into overexposing the image. I also wouldn't recommend dialing in exposure compensation for a programmed reading. How much compensation would you need? I can't say exactly because I couldn't be sure what exposure value the camera would place on the various dark tones.

On a cool May morning, I found this unusual fly perched beneath a large leaf in the hollow near my house. During the spring, the forest canopy is undeveloped, so enough light passes through the trees to make shooting in natural light possible. But by summer, the canopy shades the forest floor to such an extent that shooting without flash is very difficult.

After positioning a collapsible reflector to add some fill light, I stuck several branches and weed stalks into the soil to brace the plant against the slight breeze.

MYDAS FLY. Hoot Hollow, McClure, PA. 200mm F4 macro lens. 1/15 sec. at f/8. Fujichrome 50.

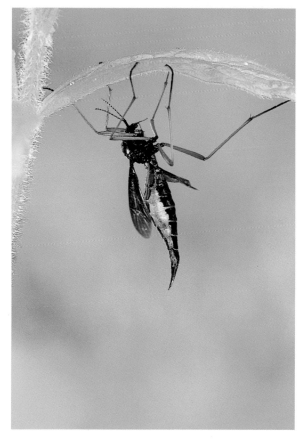

At the slow exposures this low level of illumination requires, film records a greenish or bluish color shift as the light passes through innumerable leaves. Regardless of the season, however, mornings are usually best for doing macro photography in natural light, before thermals stir the wind.

When I came upon this Mydas fly, I photographed it both horizontally and vertically. But as you can see, the fly's position lent itself more readily to the vertical format. I had to back off slightly to accommodate the fly's long abdomen for the horizontal image; this led to a smaller and less effective image size.

The fly was quite lethargic, so I had no difficulty slowly moving in to a good position with any lens I chose. First, I tried composing with my 60mm and 100mm macro lenses. Although the resulting image sizes were fine, the lenses' larger angles of view included too much of the background, which consisted of black and light-green shades. In addition, the image didn't look right when divided by both colors, and the fly virtually disappeared when framed against the black part of the background. I then decided to try my 200mm macro lens. This framed the fly against the green leaves, showing it to its best advantage.

Even in the relatively still morning air, an almost imperceptible breeze occasionally rocked the plant. At a shutter speed of 1/15 sec., this movement would register on film. To minimize this problem, I braced the top and bottom of the stem by sticking two thin reeds into the soil. I used my Nikon F4's mirror lockup and a cable release to reduce in-camera vibrations and then waited for the leaves to appear motionless.

Next, I propped a large aluminum reflector on the shaded side to bounce light onto the fly and the underside of the leaf. This dramatically increased the scene's contrast and brightness. To determine exposure, I metered one of the leaves and opened up about one-third stop to compensate for the fly's dark body. My incident meter confirmed the accuracy of this setting when I held it in approximately the same light. I couldn't risk scaring away the fly by holding the meter any closer.

It took me about an hour to brace the plant and my reflector, double-check my exposure, determine the right angle of view and the right lens, and wait for the light breeze to subside. The time passed quickly, but this illustrates that you can't hurry macro photography.

FLASH: THE MACRO PROBLEM SOLVER

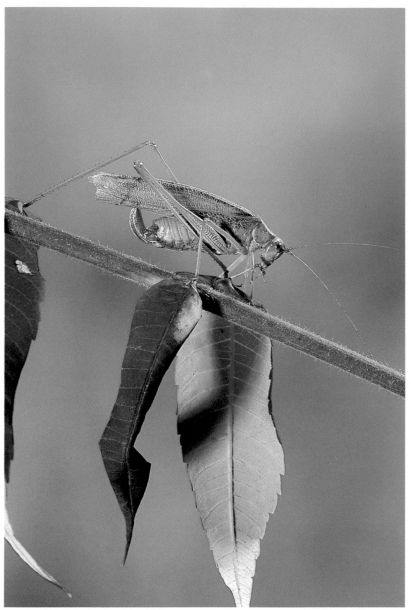

BUSH KATYDID. In studio, Hoot Hollow, McClure, PA. 200mm F4 macro lens. 1/250 sec. at *f*/16. Three manual flash units. Fujichrome 50.

In an almost effortless way, using flash eliminates many of the difficult challenges macro photography poses. For example, stopping motion, obtaining extensive depth of field, and maintaining a color temperature that resembles daylight are all simple to do with flash. Motion is especially evident in macro photography because the extreme magnification involved exaggerates even the smallest movement. Fortunately, the very short flash duration of most electronic flashes freezes most motion. In fact, in TTL closeup mode, this flash duration can be incredibly brief, up to 1/50,000 sec. This will stop the motion of any living creature.

When you shoot in natural light, a fast shutter speed requires a wide-open aperture. But when you shoot with flash, the aperture and the duration of the flash are independent of each other. Aperture is determined both by the flash's GN and by the flash-to-subject distance. If you hold a flash at a specific distance, the exposure will be correct.

Flash comes to the rescue in another way, too. Many macro subjects are active at night or inhabit dark or shaded areas. Even if a subject remains still long enough for you to make a sharp image, in low light you'll still face the problem of a film shifting color because of filtration through a forest canopy or because of reciprocity failure. Here, flash produces a natural-looking light similar to that of midday. Arguably, you may not like that look for every macro shot you make. Keep in mind, however, that you can correct for this. Flash placement, bounce, or filters can soften or tint a flash's light so that, with care, it can appear quite natural.

As the name of these colorful invertebrates implies, tree snails are arboreal residents. They were once common in the hardwood hammocks of south Florida, but fires and zealous collecting have reduced their numbers and varieties. Fortunately, a healthy population continues to exist in Florida's Everglades.

Obviously, you can't practice still-life-photography techniques with wildlife subjects too often. But tree snails move around only during rainfalls, so you have all the time you need to set up. The snails spend

TREE SNAIL. Everglades National Park, FL. 105mm F2.8 macro lens. 1/30 sec. at f/16. One manual flash. Kodachrome 64.

their days attached to a branch or tree, secreting a cover that locks in their moisture. If the seal breaks, the snail could die. As such, you should photograph a snail where you come across it; don't move it to a more photogenic spot.

By searching diligently, you can find tree snails in the hardwood forests, or hammocks, that surround Long Pine Key campground and the Gumbo Limbo Trail. I've seen snails at all heights, from mere inches off the ground to high up in the forest canopy. I found this snail right off the trail at a height of about 6 feet. As I composed, I decided that I wanted my flash to illuminate both the snail and the tree. I thought that the curved ridges of the tree's thick bark framed the snail well, so I placed the subject in the center.

Flash is necessary inside the deep shade of a hardwood hammock. Natural-light exposures call for slow shutter speeds, and reciprocity failure may become a factor. This failure occurs when a film's window of sensitivity is exceeded, resulting in a change in its natural color rendition. You may also obtain unnatural colors in your images because the light passing through the leaves is essentially filtered, producing a bluish or greenish cast in the images. Flash, with its daylight color balance, eliminates both reciprocity failure and color shifts via leaf filtration, thereby resulting in natural-looking pictures. I usually photograph tree snails in midafternoon when breezes rock the trees. Flash freezes this motion, whereas the slow shutter speeds required to achieve any depth of field when you shoot in deep shade wouldn't.

For this shot, I held a single flash over the snail and diffused the light with an 8 × 10-inch plastic diffusion panel. The fluorescent light panels that I use for this are available in most hardware stores. I simply cut them into small sizes that I can pack easily, which makes them convenient for field work. Below the snail, just out of camera view, I positioned a white reflector to bounce light back toward the snail. Since I ran out of hands, I asked some friends to hold everything in place while I tripped the shutter.

I determined the exposure with a flash meter while the diffuser and reflector were in place. I opted for manual flash rather than TTL flash because I was worried that the bark might be overexposed in TTL mode without flash compensation. In the manual mode, I knew that I could trust the middle-tone reading. You can easily apply this technique to other motionless subjects as well.

Unlike most moths, sphinx moths often feed during the day. Because they hover around flowers and dart about, they're often called hummingbird moths. The moths' resemblance to hummingbirds can be uncanny; in fact, some sphinx moths have patterned compound eyes that resemble those of birds. In addition, the wing colors visible in this image are rarely discernible with the naked eye because, like a hummingbird's wings, those of a sphinx moth beat too quickly.

Several species of sphinx moths visit the butterfly bushes and bee balm in the fields near my house by midsummer. Most of the moths are skittish at first, but all become fairly tame and approachable when I move slowly and let them work their way toward me as they visit the flowers.

If you spot a sphinx moth, stake out a flower patch and wait. Keep in mind that when you watch sphinx moths with the naked eye, they appear to hover motionless around flowers, but this is deceiving. When you look at the moths through your camera's viewfinder, their movement is vexingly apparent. The moths dart in and out of focus, usually spending, at best, a second or two at any flower. Obviously, then, obtaining a crisp image of a sphinx moth poses a challenge. To be honest, image sharpness is my primary concern when I photograph sphinx moths; I try to balance flower heads and dominant shapes to create a more pleasing composition only if I have the time. For this image,

I was fortunate enough to be able to balance the centered moth with the repetitive shape of two bee balms at either corner.

The first time I photographed sphinx moths in the TTL mode, I worried that the background might bias the metering toward an overexposure. In most cases, this didn't happen, thereby eliminating a lot of problems shooting in manual mode would have caused. On manual, I would have had to continually recalculate the exposure as the flash-to-subject distance changed, or I would have had to stick with a preset distance and one f-stop. Naturally, both conditions would have been very impractical with these moths!

While photographing this sphinx moth, I tried using both my 100mm and 200mm macro lenses. As I shot, I discovered that the working distance was too short with the 100mm lens and the moth was scared off. With the 200mm lens' working distance, I didn't frighten the moth. I was also able to take advantage of more uniform lighting between the subject and background.

For this shot, I decided to use my Lepp flash bracket, as its two adjustable arms and small ballheads provide exact flash placement. Aiming the flashes properly is critical. To do this, I mount the flash bracket on a tripod, focus on an object that is at the same distance as my anticipated subject, and fine-tune the placement of the flash units by looking at the scene from the subject's position. I find that it is easy to miss my subject if I aim the flashes while standing behind the camera.

When you shoot closeups in the TTL mode, the flash duration is quite fast (as high as 1/50,000 sec.), so using a tripod for sharpness isn't absolutely necessary. Nevertheless, I use one because I think that it is easier to follow a subject, anticipate its movement, and wait patiently when I'm not carrying around a weighty camera/flash system. I am sure that I've lost a few shots when I had to pick up my camera and tripod in order to change positions, but I believe that the trade-off has been worth it.

You can apply this technique to bees, butterflies, other types of moths, and other insects that regularly visit flowers. Simply position two flash units, like those I mounted on the Lepp bracket, to strike both the subject and the background. The light falloff that ordinarily occurs with flash is effective with other moths since most of them are active at night.

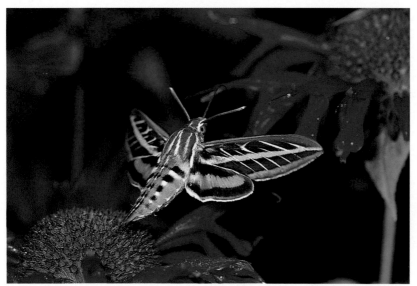

SPHINX MOTH. Hoot Hollow, McClure, PA. 200mm F4 macro lens. 1/250 sec. at f/22. Nikon SB-24 and SB-22 Speedlights on TTL, mounted on Lepp II Macro Flash Bracket. Fuji Velvia at ISO 40.

Fiddler crabs are common salt-marsh residents. Males use their large pincer for displaying and for defending against predators. They dig burrows and retreat to them whenever they feel threatened. I discovered this crab beneath a slab of driftwood that had washed onto the beach. Apparently the fiddler crab had sought shelter here because there were no burrows nearby.

I wanted a full-frame image, so I simply moved in close enough to achieve this effect. The background sloped upward behind the crab, framing it in middle tones. I decided on two manual flash units for the lighting. I connected one flash to my camera's PC socket, and I attached the other flash to a slave unit. While Mary held the slave flash behind the crab, I held the other flash and based the exposure upon a flash-meter reading.

Determining lighting ratios in either the manual or the TTL mode is easy when the flash units have the same GN. If you base your exposure on one flash and hold the other one farther back, the second flash will act only as a fill light in either mode. If, however, you hold the second flash closer and shoot in manual mode, it will either highlight or rimlight an area. But in TTL mode, this flash may end up acting as the key or main light since both flashes will automatically shut off when the correct amount of light has been emitted, regardless of which one supplied it.

Next, you have to compose the image. As I've learned, fiddler crabs are fast and active, and you may not have the time to refocus when your subject moves. After obtaining the all-important magnification ratio, you'll sometimes find that it is easier to simply move back and forth until the crab pops into focus. This way you are more likely to frame your subject correctly than you would if you continually tried to refocus.

Some photographers elect to work in the autofocus mode in such shooting situations. If you want to try this, remember that obtaining the right magnification ratio may be a problem since this varies as the lens-to-subject distance changes and the lens refocuses. Additionally, on autofocus, you may have difficulty focusing if the sensor is positioned on a smooth area and the lens starts searching. I've seen many frustrated people waste precious time this way when switching to manual mode would have solved the problem.

Finally, before you attempt to start shooting, you should know the working distances for your macro lenses or closeup equipment, as well as determine the required magnification ratio. This will probably call for you to focus on the subject once, but after you've determined the right working distance, you can leave it alone. Then to achieve image sharpness you'll simply change the lens-to-subject distance by moving closer or backing away, not by refocusing the lens.

FIDDLER CRAB. Cape May Beach, NJ. 105mm F2.8 macro lens. 1/60 sec. at ƒ/16. Two manual flashes. Kodachrome 64.

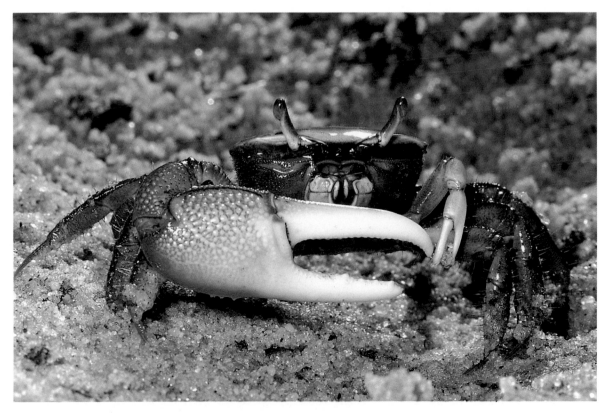

I found this paper wasp preparing its nursery on an unusually raw, cold day in mid-May. Too chilled to fly, the wasp simply hung onto its ceiling-mounted nest. The insect was torpid and moved ever so slowly as I shot closeups. Interestingly, however, the wasp quickly heated up after I made a few exposures with my flash held nearby. Whenever the wasp fanned its wings in preparation for takeoff, I backed off and let the cool air chill it again so that I could shoot safely.

Hornets and wasps can be aggressive and extremely dangerous if provoked, especially around a nest. The risk intensifies for anyone allergic to their stings. Cool days slow insects down, but even on the coldest day a nest of hornets, wasps, or bees can attack if threatened. Tread gently!

Since the subject and the background were both middle tones and were adjacent to each other, I trusted the TTL flash. As usual, I reduced my TTL exposures by one-third stop for a "toned-down" flash look. I stopped down to $f/22$ for maximum depth of field and held the flash off-camera to control the shadows. For the vertical image, a friend held a mirror out of camera view in order to bounce the flash's light toward the shaded side of the wasp. This softened the shadows created by the flash, thereby producing a less contrasty image. I didn't do this with the horizontal image, and the difference in the shadows is apparent.

Holding a flash off-camera close to the wasp provided several other advantages as well. I was able to use a small f-stop and not drain my flash batteries. I also enjoyed a shorter flash duration at this flash-to-subject distance, which increased image sharpness. Finally, with off-camera flash I was able to cast the shadows wherever I wanted them.

Equipment manufacturers often recommend using a zoom flash head at its wide-angle setting for off-camera macro work. This technique provides all the advantages listed above, as well as two others. First, at the wide-angle setting, the illumination from the flash is dispersed; this increases your chances of hitting the subject you're aiming at! As silly as this may seem, missing your intended subject isn't too difficult when you're looking through your viewfinder and handholding a flash. To prevent this problem, I suggest composing, focusing, and then looking at where the flash is pointed when you fire.

Second, with the wide-angle setting, the likelihood that the flash will shut off properly for the correct exposure is greater. Exposure is governed by the flash duration, which has limits. If you hold the flash too close to your subject or use too large an f-stop, you'll overexpose the shot. With the wide-angle setting, you'll scatter the light and reduce the chance of overexposure.

Here, the vertical image of the wasp is more interesting than the horizontal picture because the diagonal line of a ceiling tile across the horizontal frame is distracting. In addition, by sitting on top of the nest, the wasp presented a fairly static pose. If I could make this shot again, I would reduce the image size a fraction, swing a bit to the left, and include the wasp's rear foot within the frame.

PAPER WASP. Pine Barrens, NJ. 200mm F4 macro lens. 1/125 sec. at $f/22$. Nikon SB-24 Speedlight on TTL at $-1/3$. Kodachrome 64.

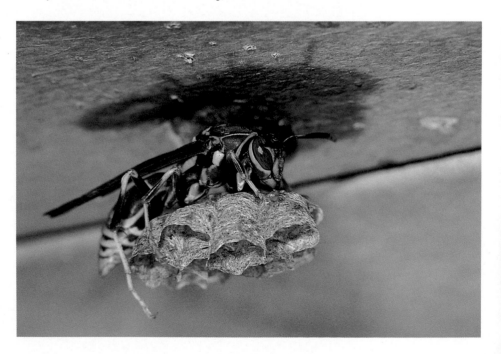

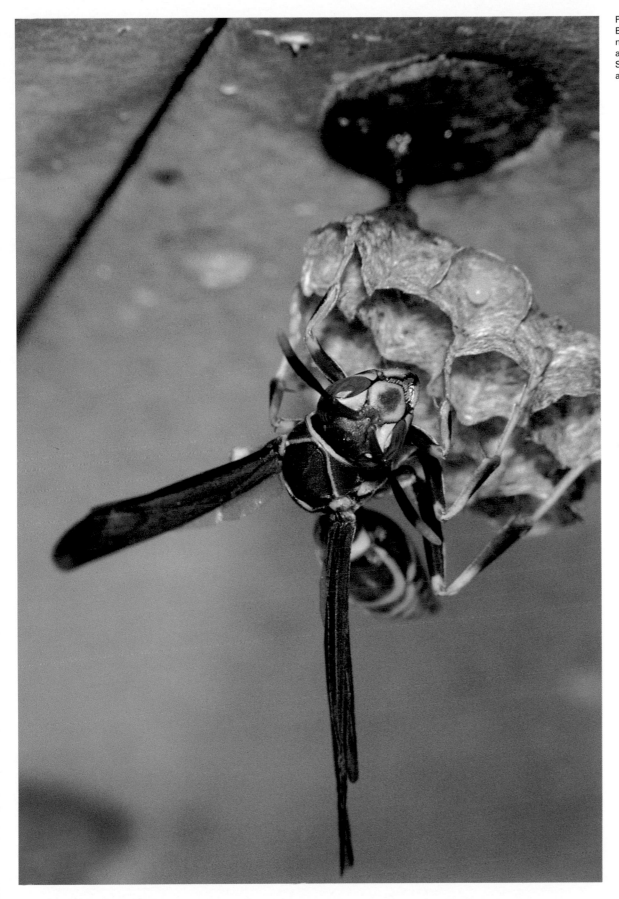

PAPER WASP. Pine Barrens, NJ. 200mm F4 macro lens. 1/125 sec. at *f*/22. Nikon SB-24 Speedlight on TTL at −¹⁄₃. Kodachrome 64.

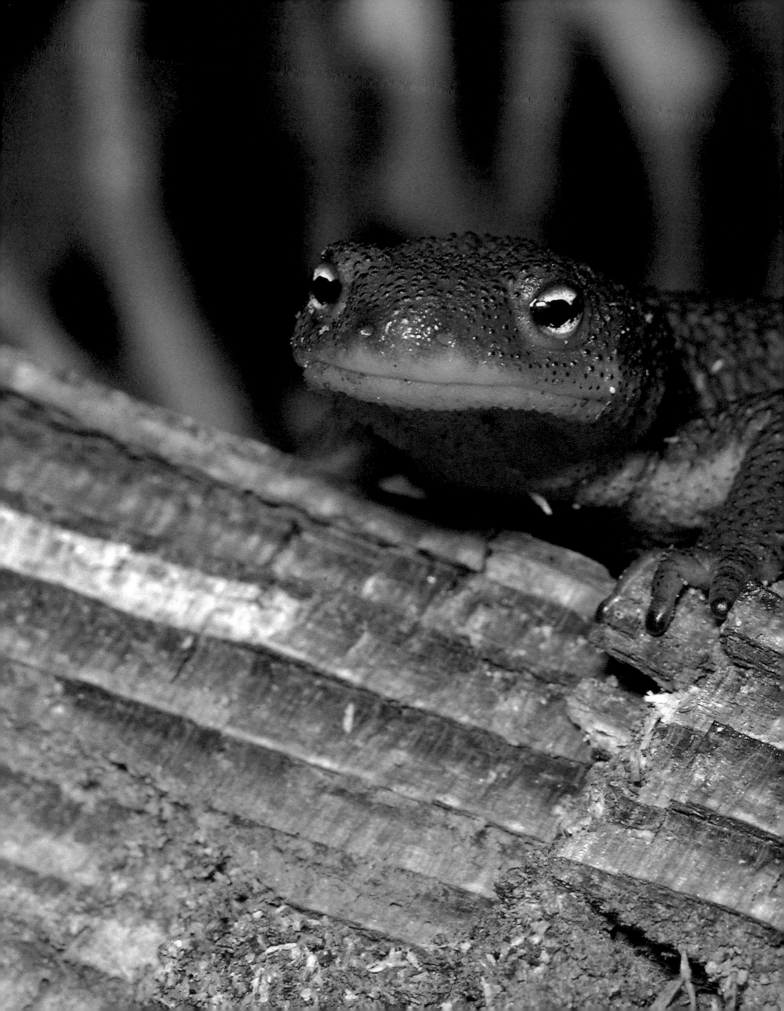

AMPHIBIANS

THE AMPHIBIAN CHALLENGE

Amphibians encompass the photogenic and common frogs, tree frogs, and toads, as well as the less frequently seen newts, salamanders, and aquatic hellbenders and mud puppies. Representative species live throughout North America; one, the wood frog, even ranges above the Arctic Circle, which is quite a feat for a cold-blooded animal. Another, the red-backed salamander, may be the most common terrestrial vertebrate in eastern woodlands.

Amphibians aren't easy subjects to capture on film. Unlike birds and mammals that can be photographed in daylight, many amphibians are active only at night; furthermore, many frequent marshes, swamps, and other difficult-to-negotiate habitats. Quite a few amphibians are recluses, living under rocks or logs, and only individuals who are specifically looking for them ordinarily see them. To seriously photograph amphibians, you must know your subject, where it lives, what time of the day or night it is active, and what cover it seeks. If you don't, you'll be limited to photographing the odd frog or toad you happen upon by chance.

The habits and habitat of my subject dictate my photographic method. I photograph frogs and toads in the field in spring as they breed or sing. But I often photograph salamanders, newts, and some nonbreeding anurans in the studio, where it is reasonably easy for me to restrict their movements while maintaining the proper lighting. I also make my action shots of jumping frogs and all of my underwater subjects in the studio.

When their breeding season is over, salamanders, aquatic species, and many frogs and toads are quite difficult to find or to approach without creating some type of disturbance. For example, in my 30 years of field work I've seen only a handful of red-backed salamanders on leaf litter—and this is the most common salamander species. Even more frustrating, I wasn't able to photograph any for various reasons!

Unfortunately, it is impossible to photograph amphibians without some degree of manipulation. Merely finding them requires lifting up rocks, and most species immediately flee when exposed. Should photographers ignore these subjects because they usually don't encounter amphibians? As a naturalist, I can't, and as a photographer, I consider depicting these little-understood creatures to be a pleasing challenge. That said, I hope no one rushes out and begins collecting amphibians for photography without first preparing for their needs. I urge you to consult one of the numerous field guides on amphibians; this will not only help you make identifications but will also provide you with valuable tips on how to care for your captive subjects.

Keep in mind that amphibian photography requires patience. Even on a table-top setup, subjects can be uncooperative. Frogs hopping off the set and salamanders darting beneath the moss can try anyone's patience, and I caution you to remain calm and to persist. Even though amphibians seek cool environments, I don't recommend refrigerating any cold-blooded animals in order to control them. By purposefully chilling them, you may harm them, and never, ever, place cold-blooded animals in a freezer! This will kill them.

For most amphibians, I use either a 100mm or 200mm macro lens. Occasionally, I photograph frogs in the field with a longer telephoto lens and extension tubes, but I don't recommend this as basic equipment because it is heavy to carry. I rely extensively on flash for several reasons. First, many amphibians are active at night, so flash acts as my main light source. I need its bright illumination because I often use small apertures with slow-speed films. Flash also helps bring out the colors of dark amphibians. And because direct sunlight can be harmful to the moist skin of amphibians, flash is less stressful to them. Finally, flash is essential when I use a Dalebeam for the high-speed photography of leaping frogs.

GREEN TREEFROG. In studio, Fort Myers, FL. 200mm F4 macro lens. 1/250 sec. at *f*/16. Three manual flash units. Kodachrome 64.

I photographed this treefrog in the shade of a carport on a hot, humid Florida afternoon. Flash provided the necessary illumination without causing my subject any stress.

WHEN AND WHERE TO SHOOT

Of all the amphibians, the true frogs and the toads are the easiest to shoot *in situ,* that is, where they lie. Because most of them are cryptically colored and rely on their camouflage to conceal them from the eyes of predators, these amphibians remain motionless unless frightened. If you can spot one before it feels threatened, you are likely to have a fairly still, cooperative subject. Unfortunately, most frogs and toads aren't likely to be sitting in perfect light. Many hide or wait for prey beside a grass tussock or brush pile, where shooting in the natural light alone can be very difficult. I've probably passed up more shooting opportunities for precisely this reason; the foreground or background was just too bright and distracting to make a pleasing image.

Flash can help in such situations, filling in shadows and decreasing the overall contrast in a scene. Under these conditions, I usually base my exposure on the ambient light and let the flash fill in the shadows. Deciding whether to use the flash in a synchro-daylight mode, which renders both the flash and ambient-light levels equal, or merely as a fill is a personal choice. I usually prefer flash-fill.

Flash is especially valuable for photographing frogs and toads when they are most active, namely at night. One hotshoe-mounted flash unit will be sufficient if your working distance is far enough so that parallax doesn't occur; this should be the case with a 200mm macro lens. For closeup work, you may need an off-camera flash system since a hotshoe-mounted flash unit may fire over and miss your subject.

As you photograph more and more amphibians, you'll find that patience is a requirement when you work with wild frogs. Although I've seen thousands of frogs, I can't make a generalization about the best way to move in. Going slowly certainly helps, but whether you should wait and give the frog some time to get accustomed to your presence, or whether you should immediately move in to your shooting position depends on your subject. Such unpredictability can be frustrating, but it can also be one of the reasons why photographing amphibians is so much fun.

GIANT TREEFROG. Indonesia. 105mm F2.8 macro lens. 1/125 sec. at *f*/22. Two manual flash units. Fujichrome 50.

Although the palm frond and the strong radiating lines enhance this image, they could have resulted in limited depth of field. By using flash here, I was able to obtain the amount of light needed to produce the required depth of field.

The courtship activity of frogs, toads, and tree frogs is a can't-miss photographic opportunity, provided of course that you are present when mating takes place. Frogs and toads breed at different times of the year based upon temperature, moisture, or both. Many species are eruptive, which means that they appear in large numbers at breeding ponds that were completely deserted just hours earlier. The whole process may be over in only one or several nights, and peak activity rarely lasts more than two weeks. Watch the weather, and be ready to shoot with short notice. Throughout much of North America, the first warm nights of spring trigger the breeding cycle, although different species require different temperatures to start.

Since most courtship activity occurs at night, you need a focusing light and at least one flash unit. I often use a headlamp to spot subjects, but this can create problems when I try to shoot. The lamp wires and the flash cords can get tangled and make moving around awkward. Also, a hotshoe flash can block the headlamp when I look through the viewfinder, so I sometimes find it easier to mount the headlamp on a separate support.

When I shoot with flash at night, I always sweep the edges of the viewfinder and watch out for foreground obstructions. It is easy to miss a weed or some other similar object when your attention is focused on the amphibian in your headlamp's beam. These obstructions will appear as distracting, overexposed blurs if illuminated by your flash.

My wife, Mary, and I enjoyed watching a courtship spectacle one warm mid-April night near our home in Pennsylvania. Our ponds were filled with singing American toads and spring peepers. The sight of three toads clambering onto the nearest shoreline compelled me to run and get my gear. During the next three hours, I shot several rolls of frame-filling singing amphibians.

In order to shoot dramatic portraits, I photographed most of the toads straight on. This also increased the

sense of intimacy. This angle works well with American toads since their vocal sacs are fairly small. (In contrast, the vocal sacs of western Great Plains toads are enormous and look best in profile.) I always try to shoot the collapsed vocal sacs, too, to illustrate this remarkable change in the toads' appearance. You can do this either before or after the toads stop singing; the effect will be the same.

For this shot, my 105mm lens provided a fairly limited angle of view and a close working distance that minimized the chance of obstructions in the frame. Lying prone in the mud I found my headlamp so cumbersome that I finally took it off, propped it on the ground, and aimed it at the toad. To support the flash units, I used a Lepp II Macro Flash Bracket, which has two articulating arms for precise flash positioning. Because of the close working distance and the resulting fast flash duration, image sharpness wasn't an issue. Although I didn't use a tripod, I supported the flash-bracket system with a pistol grip that rested on the shoreline a few inches from the toad. This makeshift mount afforded me a lower camera angle than my tripod would have.

I tried my flash units on the camera and off, and in both TTL mode and manual mode. I must confess that when working in the TTL mode, I wondered if the flash would reflect off the water or the toad's vocal sac, shut off prematurely, and underexpose the toad. Fortunately, this didn't happen. And in the manual mode, the flash emits a given quantity of light for a specific distance, regardless of the subject's reflectivity. To determine those exposures, I made a meter reading by holding the meter over the toad's back. Remarkably, the toad ignored my hand, which was only inches away from it.

Placing the flash on a small ground-level tripod produced a constant flash-to-subject distance. This, in turn, enabled me to change my perspective or the camera-to-subject distance without affecting the flash exposure. But I still had to compensate for light loss due to extension because a 105 macro lens lengthens as it focuses toward 1:1. In the TTL mode, this wasn't a concern since the camera and flash automatically adjust for this loss.

Frogs and toads live almost everywhere, so you must exercise some caution when shooting. If you use an auxiliary battery pack with your flash unit when you work around open water, be sure to keep it dry to eliminate the possibility of an electrical shock. And if you expect to shoot while standing in cold water for any length of time, you might want to consider wearing hip or chest waders, or even a wetsuit. Water draws out body heat, and you can get very cold, very quickly.

AMERICAN TOAD. Hoot Hollow, McClure, PA. 105mm F2.8 macro lens. 1/250 sec. at f/16. Nikon SB-24 and SB-22 Speedlights on TTL mounted on Lepp II Macro Flash Bracket. Kodachrome 64.

Although most amphibians leave their ponds after breeding season, frogs can usually be found around permanent water sources. In fact, when the weather is warm, you can find frogs anywhere there is water. Unfortunately, most are wary and won't permit you to get close, at least initially. But you should watch frogs closely. Although they jump into the water for safety, many make an immediate U-turn and return to shore. On land, the frogs may allow you to shoot closeups if you move slowly.

On occasion, I've had some species of frogs exhibit no fear at all after making that initial leap to safety. For example, I spotted this green frog along a mountain stream when it jumped from cover. After swimming a short distance, the frog climbed on top of a rock and ignored me as I eventually moved within 20 inches of it. I think green frogs are particularly tolerant because

GREEN FROG.
Pocono Mountains, PA.
200mm F4 macro lens.
1/15 sec. at ƒ/5.6.
Kodachrome 64.

MINK FROG. In studio, Hoot Hollow, McClure, PA. 105mm F2.8 macro lens. 1/250 sec. at ƒ/22. Three manual flash units. Kodachrome 64.

I've been able to hand-feed worms to wild frogs sitting only a few inches from my lens. Unfortunately in this situation, the stream limited my options. I decided to frame the frog in an upper-right point of power so that the smooth water leads your eye to the subject. A slow shutter speed gave the moving water a featureless surface.

Although the green frog appeared tame, it wasn't. Many photographers, preoccupied with their equipment, often forget their subject's wariness. They then move too quickly and frighten it, thereby scaring it away. To avoid this problem, approach slowly and don't make any sudden movements that may appear threatening.

You'll also learn that some frogs aren't as tolerant as green frogs are, and that others live in such thick cover that they are almost impossible to shoot *in situ*. This is what happened with this mink frog, which I had to photograph in the studio. After a few days in captivity, the frog was "tame" and accepted crickets and grasshoppers from my fingers. I was able to shoot at the mink frog's level by using a high table for my setup. The working distance wasn't a problem, so it was easy to fill the frame with this uncommon northern frog.

I photographed the green frog in natural light. Although the ambient light was dim, it was attractive, and depth of field was very shallow. Switching to a smaller aperture and a longer shutter speed would have increased the chances of blurring since the frog was occasionally buffeted by tiny changes in the current.

I had Kodachrome loaded, which may not have been the best choice because this film can appear cold or bluish in low light. The picture of the green frog retained its green shades, but I suspect that it would be more attractive if I'd used a film with a green bias instead. Shooting with flash prevented a color shift in the photograph of the mink frog. Additionally, the flash enabled me to use a small aperture that produced greater depth of field. This difference is obvious when you compare the two images. Even though the shot of the mink frog has a larger image size, it is sharper overall than the shot of the green frog. Flash also provided the real-looking greens in the mink-frog picture that are missing from the green-frog shot.

The mink frog's set was easy to make; I simply added some duckweed, wolffia, and water-shield plants to a small water pan. Nevertheless—and quite frankly— it is much easier to photograph your subjects in the field than it is to hunt for studio subjects and create authentic-looking habitats. When you shoot afield, the backgrounds are natural, and you don't have to worry about specimen maintenance. As a result, I strongly recommend photographing your subjects in the wild.

RECREATING HABITATS IN THE STUDIO

Most amphibians are recluses, seeking shelter and avoiding the type of bright light photography requires. And bright sunlight can harm many amphibians by drying out their sensitive, moist skin membranes. For this reason, shooting with flash is a great option for this wildlife group.

As I've mentioned earlier, working with leaping frogs or tree frogs or cover-seeking salamanders can be quite frustrating. In the field, one good leap may put a frog out of sight, and one lucky turn may lead a salamander into a labyrinth. Bringing amphibians into the studio eliminates or at least minimizes many of the problems a field photographer faces. For some species that are nearly impossible to shoot in the field, studio work is the only alternative. For other amphibians, it is not only easier and conducive to more pleasing results, but also safer for your subject because you are less likely to harm its skin when you use flash.

The key to any studio setup is realism, and the key to a successful setup is bare-bones realism. When I begin to design a set, I study my subject's habitat and look for the key elements that best characterize it. Including all the hiding places a salamander, for example, would seek in the wild is counterproductive. If you do this, you'll spend more time digging for your subject than you'll spend shooting. A setup that suggests the subject's entire habitat works best. You could effectively recreate the salamander's habitat simply by using some moss, a few decayed leaves from the forest floor, and a small piece of rotted log. It is unnecessary to add the twigs, bright leaves, and light-colored rocks that may be present in the landscape. Furthermore, they may add distracting hotspots. Without them, you can convey a natural look while maintaining a pleasant, contrast-free tonality in the set.

A table-top setup eliminates much of the backbreaking stress inherent in photographing tiny, ground-level creatures. Simply incorporate a few props that suggest your subject's habitat, and add one or two flash units to provide the proper illumination.

Jefferson salamanders live in burrows and are rarely seen. Fortunately, in the spring they gather at forest ponds and pools to lay conspicuous clumps of eggs. As a result, you can find them relatively easily at night during this season. Still, however, photographing a salamander and its egg mass underwater in the field is almost impossible. Tannins from decomposing leaves stain the water, making it the color of tea, and mud is readily stirred up, further obscuring any view. When disturbed, salamanders dart to the pool bottom for cover and burrow into the mud or leaf litter. Your only recourse is a studio setup.

The key to a successful setup is simplicity: add just enough material to give the correct impression without making the scene appear too busy or cluttered. For this shot of a Jefferson salamander, I recreated its underwater environment by putting leaves, a few sticks, and an egg-mass-covered branch into a 10-gallon tank. I used a glass partition to divide the aquarium into two sections. I placed the salamander and egg mass in the smaller half next to the front glass, and added leaves and more branches to the other half. The salamander was then able to swim in the smaller area without disturbing the background or stirring up the bottom. I put an olive-colored posterboard behind the tank to suggest an expanse of water, as well as to reduce the chance of catching reflections. This is critical because a black background can produce a mirror effect and ruin images.

Next, I placed two flash units on either side of the tank and a third flash on top. I positioned the side flashes at a 45-degree angle to the front glass so that any light reflecting off the glass would bounce off at that angle and miss my lens. I aimed the top flash straight down since reflections bouncing directly up wouldn't affect the image. After placing my flash meter inside three zip-lock bags, each of which I'd sealed individually after squeezing out the excess air, I taped the outermost bag to ensure water-tightness. Then I held my flash meter underwater at my subject's position and test-fired the flash in order to determine exposure. I readjusted the flash units until I obtained the desired aperture, $f/16$.

Aquatic subjects like the Jefferson salamander are quite difficult to shoot in the field, usually because the water isn't clear. If you decide to photograph this amphibian in a tank setup, use water from its pond or let tap water set for a few days to remove the chlorination. Filter out any sediment, detritus, and other material that makes the tank water cloudy by pouring it through a cloth. And remember, return your subject to its pond when you're finished.

JEFFERSON SALAMANDER. In studio, Hoot Hollow, McClure, PA. 105mm F2.8 macro lens. 1/250 sec. at $f/16$. Three manual flash units. Kodachrome 64.

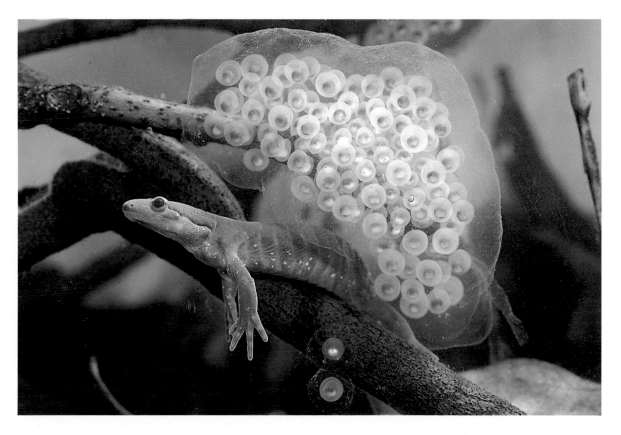

Although I've been catching bullfrogs since I was eight years old, I've never been lucky enough to live anywhere near an ideal wetland. The ponds, lakes, and creeks I've wandered around have contained plenty of bullfrogs, but tall grasses, quicksand-like muck, and/or shy frogs have conspired to foil all my attempts to photograph a bullfrog at water level. I've found it easy to shoot down on my subjects from minimum tripod height, but that next step in perspective, to frog level, continued to elude me.

My frustration peaked while I was teaching a week-long photography course at a nature center. Bullfrogs were abundant, and dozens bellowed their guttural songs each evening. With the aid of my headlamp, I watched the bullfrogs sing, wrestle, or chase smaller frogs across the duckweed-covered pond. Unfortunately, the shoreline was quite muddy, and entering the pond resulted in my sinking knee deep in boot-swallowing mud. To solve this problem, I decided to try a setup. If my students and I couldn't get to a bullfrog, I would bring one to us. We collected one that evening and the following morning photographed it in a pond we'd made in a baby pool. Depending upon my subject, I've used pie tins, pans, litter trays, and baby pools to simulate pond environments. When I recreate a habitat, I look for the features that are typical of that area.

I don't try to include everything, only the essentials that characterize the area best. For this bullfrog, I decided to include muddy pond water, duckweed, and a couple of grass tussocks.

To obtain a frame-filling portrait of the bullfrog at subject level, I raised my tripod high enough for my 200mm lens to just barely clear the pool's lip. But since the pool wasn't mounted perfectly flat, I wasn't able to fill it to the rim; as a result, I still wasn't quite at the frog's level. Shooting in natural light, I increased the setting indicated by the sunny $f/16$ rule by one-half stop because of the frog's dark tones and the partial sidelighting in the scene. I never let the shutter speed fall below 1/60 sec. because a seemingly motionless frog's vocal sac and sides move as it breathes, and these may blur at slower shutter speeds.

Later, I reworked this setup, using a sharply edged cat-litter tray as my pond. By shooting lengthwise down the rectangular tray and filling it to its very brim, I obtained an image of a green frog that more closely approximates subject level. For this shot, I used a manual flash. Flash stopped the movement of the frog, which was bobbing in the pond slightly, and $f/22$ provided good depth of field. In both examples, however, depth of field is still quite shallow because of the large image size.

GREEN FROG. Hoot Hollow, McClure, PA. 200mm F4 macro lens. 1/250 sec. at $f/22$. Nikon SB-24 Speedlight on manual. Kodachrome 64.

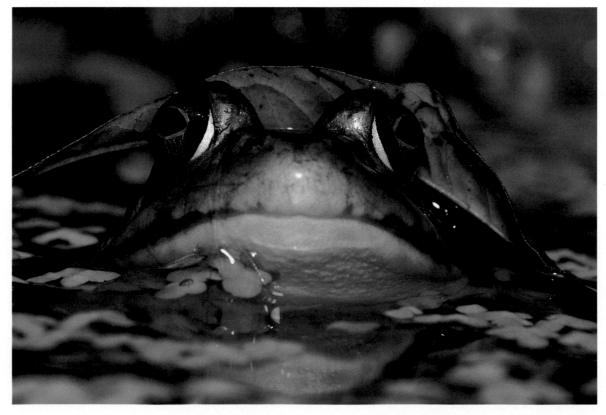

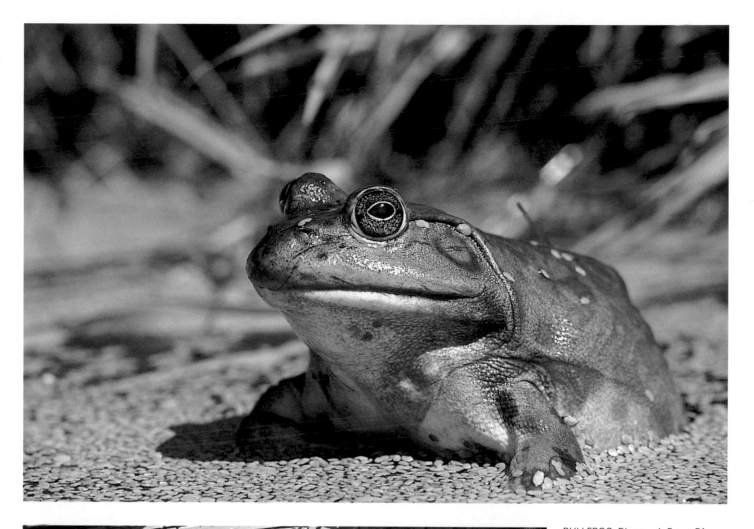

BULLFROG. Dingman's Ferry, PA. 200mm F4 macro lens. 1/125 sec. at ƒ/8–11. Kodachrome 64.

To create an authentic-looking habitat for a bullfrog, I used duckweed, pond water, and tussocks.

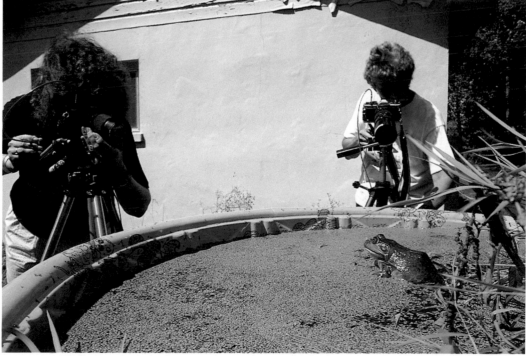

Salamanders are recluses, so encountering one away from shelter is a rare occurrence. Accordingly, I've found it easier to shoot these most difficult subjects in my studio, where I can work comfortably and at my own pace. Once again, I need to be patient. Long-taileds are, perhaps, the prettiest salamanders living around my home in Pennsylvania. I ordinarily find them underneath slabs of sandstone along a nearby stream, but on very wet nights I've been surprised to see some climbing in the shrubbery.

Depth of field is always a problem with closeups, and it is even more difficult when you shoot long, thin subjects. Salamanders are like snakes: when completely stretched out, they look awkward. To avoid this composition dilemma, I waited until the salamander curled over a moss bed. It was critical for my subject to remain fairly parallel to the film plane for overall sharpness. Still, I lost some detail in the salamander's tail.

I used two Dynalite studio flash units equipped with modeling lights for this setup. Modeling lights eliminate the need to previsualize the lighting effect. Of course, they aren't necessary if you can do this, or if you either make independent checks of each flash with a meter or use the GN to determine the lighting ratio. I diffused the flash heads through a frosted fluorescent light panel that I'd suspended above the set. I'd added wood strips to the flexible panel, one to each end to bend them down, and a third strip to the middle in order to hang the panel from the ceiling. A softbox, in which the flash is placed inside a frame and is encased in a plastic or cloth cover, works in a similar fashion, but a light panel in a home-studio set is much more economical. I positioned the light panel so that it would provide relatively even illumination across the entire set.

Table-top setups don't have to be large. Here, I used a 30 × 30-inch sheet of plywood as my base, and simply put a log and some moss on top of it. I placed the board on a trash can that I was able to slide about or spin; this enabled me to keep the salamander within the borders of the film plane as it roamed the set. This setup required only a minimum of props as well. You can easily achieve a similar effect at home with items you have on hand. Whatever base you use, make sure that it is tall enough so you won't have to stoop to handle the subject or to operate your equipment. This is tiring, and your photography will suffer because of it.

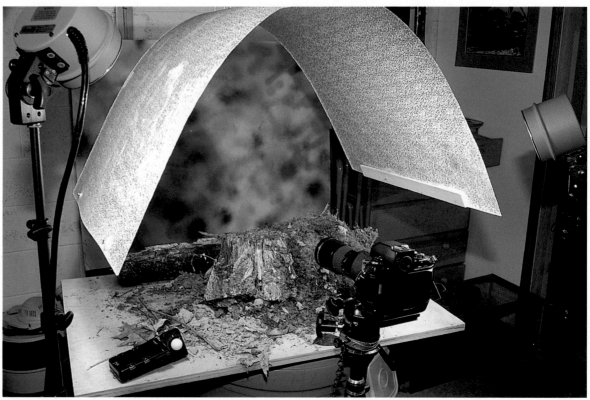

This salamander setup included a painted background and a frosted plastic flash diffuser.

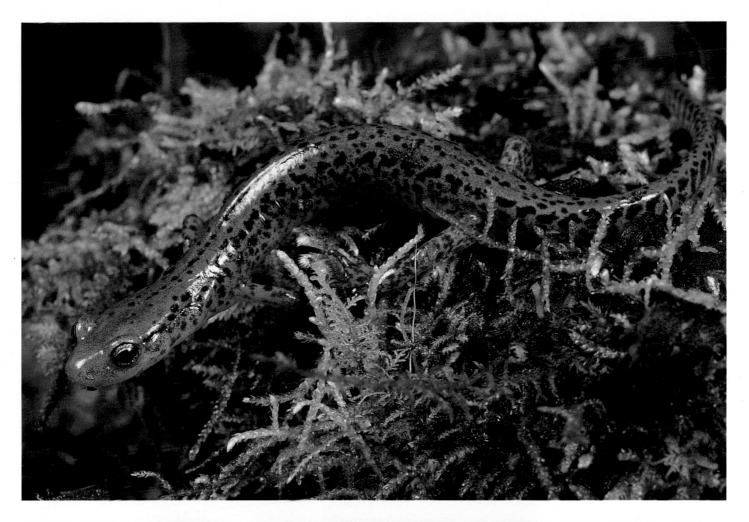

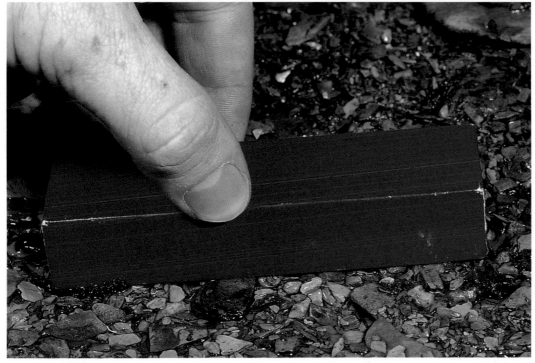

LONG-TAILED SALAMANDER. In studio, Hoot Hollow, McClure, PA. 105mm F2.8 macro lens. 1/250 sec. at f/16. Two manual flash units. Kodachrome 64.

Salamanders and other cover-seeking subjects may calm down and remain still if you provide them with shelter before you begin shooting. Then after you remove the box, the amphibian usually will pause long enough for you to get off some shots.

Tree frogs are, arguably, the most photogenic group of amphibians. With bulbous eyes and flat, rounded toe pads, they are both comical and cute. Tree frogs' toe pads act like suction cups when they climb or leap from branch to branch. In nature, you encounter tree frogs primarily during their breeding season, which warm weather and/or heavy rains usually trigger. This is when the frogs are calling in ponds, marshes, and even flooded roadside ditches. Their calls vary but all tree frogs are ventriloquists, which can make finding a singer difficult. Having one or two people listening to calls in several different locations can help locate these well-camouflaged frogs.

Still, photographing those tree frogs you find isn't easy. Most are in the water or in the thick cover of low shrubs, which discourages attractive portraiture. But making the effort is always worthwhile, of course, because it is usually the only way to capture the balloon-like vocal sac of a singing male. This proves even more difficult when the breeding season ends. As such, doing a studio setup makes a great deal of sense.

Keep in mind, however, that tree frogs require special care in the studio. Since they can disappear in a crowded workspace with just one jump, make your studio escape-proof. Don't use flood lamps in the studio area, even if only for focusing. A tree frog would fry if it jumped onto the lamp. If I need extra light for focusing, I'll use a 6-volt, battery-powered lantern whose plastic lens face is tree-frog-safe. My studio is carpeted, too, which softens the jolt if a frog leaps to the floor. Finally, since tree frogs' moist skin readily picks up dirt or lint off carpeting, I mist my subject clean after handling if it jumps to the floor.

I photographed these three tree frogs in the studio using three sets that were fairly easy to arrange. Beginners' setups often appear unimaginative or redundant. Some photographers new to this concept may always position the lights the same way and continually recycle the same props. When you shoot indoors, it is essential that you don't recreate the same habitat time after time. Use your imagination when selecting props that are appropriate for a specific environment.

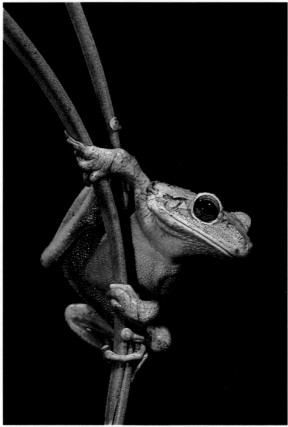

CUBAN TREEFROG. In studio, Hoot Hollow, McClure, PA. 200mm F4 macro lens. 1/250 sec. at ƒ/16. Three manual flash units. Kodachrome 64.

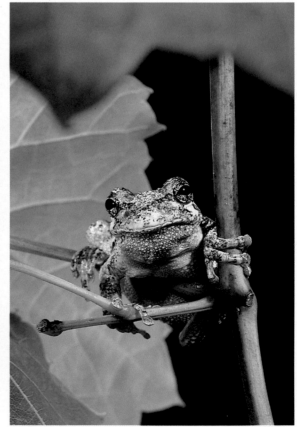

GRAY TREEFROG. In studio, Whitehall, PA. 100mm F4 macro lens. 1/60 sec. at ƒ/16. Three manual flash units. Kodachrome 64.

Studio setups offer several other advantages, too. For example, I can photograph tree frogs at, or below, subject level simply by elevating their perch. I can also make the set as clean and distraction-free as I want. This is far different from shooting in the field, where the number of leaves and branches can seem insurmountable. Furthermore, they can cause hotspots if they are between the subject and the flash. Focusing is easier in the studio than in the field, too. When working inside, I can use room lights rather than the cumbersome headlamps required for field work.

For the shot of the gray tree frog, I decided to include a section of vine taken from my backyard garden. I wanted to suggest the clutter in this amphibian's habitat by shooting through the vegetation and framing the frog with leaves. The pictures of the Cuban tree frog and the reed frog were cleaner images, for which I simply added one small bromeliad. For the reed-frog shot, I called on the same out-of-focus, painted background that I used in the long-tailed-salamander setup (see page 64). Here, the background received about one stop less light than the main subject did. For the shots of both the Cuban and the gray tree frogs, I selected a black-cloth backdrop. To determine exposure for the Cuban and reed tree frogs, I used a flash meter; for the gray tree frog, I used the GN formula (I made this shot while I was in college, before I knew about flash meters).

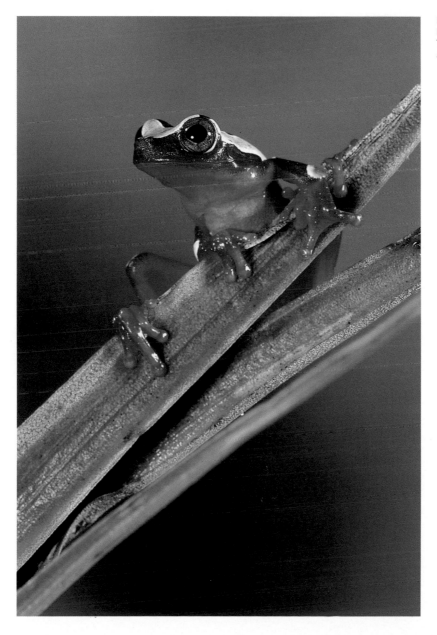

REED FROG. In studio, FL. 200mm F4 macro lens. 1/250 sec. at *f*/16. Three manual flash units. Fuji Velvia at ISO 40.

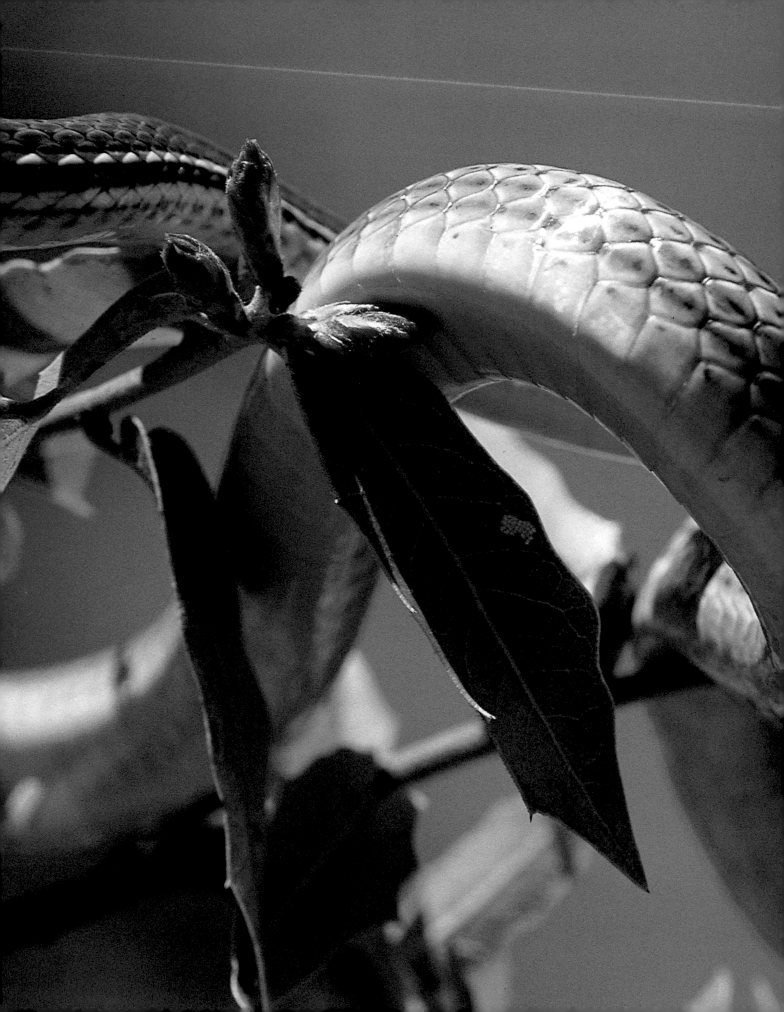

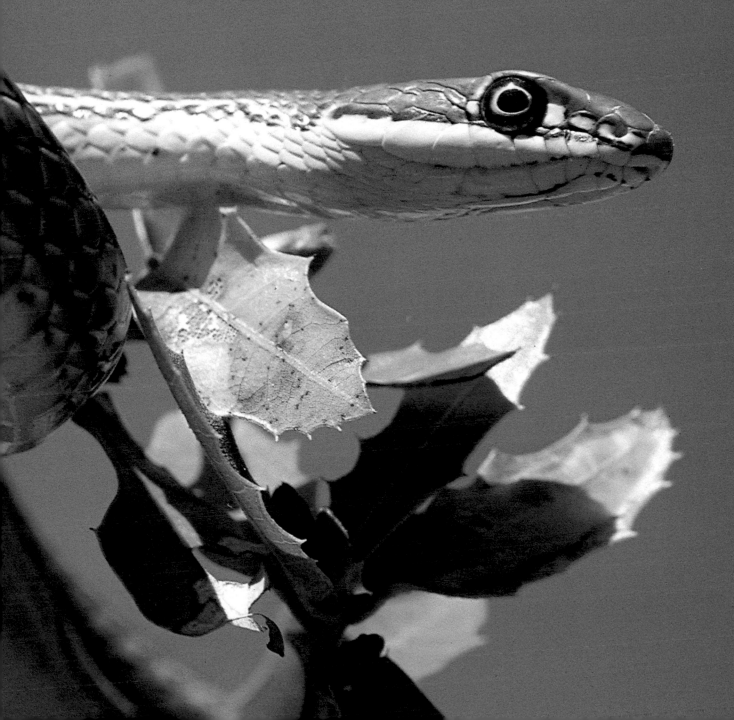

REPTILES

SHOOTING SAFELY AND EFFECTIVELY

I urge anyone interested in photographing dangerous reptiles to do so only with the help of an experienced snake handler. The results could be disastrous otherwise. It is also imperative that anyone who hopes to photograph snakes in the field be able to identify the venomous species. This isn't too difficult in the United States because there are only a few basic poisonous types: rattlesnakes, copperheads, cottonmouths, and coral snakes. Identifying poisonous snakes, however, isn't always easy. For example, a rattlesnake's rattle may be hidden or missing, or a copperhead or cottonmouth snake may be very dark before shedding and lose its distinctive pattern.

Luckily, you can easily photograph many reptiles from a safe distance. Some snakes will lie quietly in the shade and remain there if you approach slowly and stay between 4 and 6 feet away. Lizards, turtles, and alligators like the sun, and under ideal conditions you can photograph them with a telephoto lens.

Unfortunately, ideal conditions aren't the norm. I frequently find branches, grasses, rocks, and other distractions between my subject and lens, thereby preventing me from photographing subjects where they lie. To solve this problem, sometimes all I need to do is move a turtle a few feet into a forest clearing, or pick up a snake and drape it over a rock or log. The reptiles may not stay in these positions—at least not at first—but usually after a few attempts they calm down and sit still. Although reptiles, like amphibians, are cold-blooded, once again I urge you not to chill an uncooperative subject. Reptiles are less tolerant of cold than amphibians, and you can cause even greater harm by chilling them.

Keep in mind, too, that reptiles are intolerant of high temperatures. Some people find it surprising that a lizard sunning on a desert rock at high noon in 100-degree heat can die if it is kept in the sun for even a few minutes. They don't realize that in the wild, reptiles regulate their body temperature by moving into the shade as required.

I probably shoot about 50 percent of my reptile images with flash. Using flash for reptile shots has several benefits. Colors appear natural. Depending on how close I place the flash to the subject and which aperture I select, I can easily control depth of field. This provides me with the flexibility to create either a detailed portrait, complete with scales, or a moody rendering in which only the reptile's sinister-looking eyeballs are sharp. Furthermore, the subjects remain relaxed—as long as I photograph them in the shade.

I find myself using flash more and more often to reduce the shadows or the contrast produced by natural light. This is especially helpful when I'm working with reptiles basking in the sun that are, naturally, surrounded by deep shadows. To supplement the available light with fill, I find it easiest simply to keep the flash on the hotshoe and let the light fall as it may. When you photograph reptiles in the studio, flash is essential. The space between you and your subject is greater in these situations than it is when you photograph insects in the studio. As a result, you can easily simulate natural lighting, whether you want the effect of dappled light, evening cross-light, or direct sunlight. I use studio flash units equipped with modeling lights to readily see the lighting ratio, and I determine exposure with an incident-light meter.

My lens choice varies with the opportunity and the composition, from 24mm wide-angle lenses to 500mm telephoto lenses. I use my 100mm and 200mm macro lenses most often, followed by my 80-200mm lens coupled with an extension tube for close-focusing. If you are a novice reptile photographer, I recommend making a 200mm macro lens your primary lens. It provides sufficient magnification and an adequate working distance to keep you safe and your subjects comfortable as you shoot.

VEILED CHAMELEON. In studio, FL. 200mm F4 macro lens. 1/250 sec. at ƒ/22. Three manual flash units. Fuji Velvia at ISO 40.

Chameleons are among the most colorful and dramatic reptiles you can hope to photograph. One of the best is the hardy veiled chameleon, which can exhibit a feisty behavior that is uncommon in lizards. Despite their aggressiveness, veiled chameleons have become popular pets. Fortunately, captive breeding programs have eliminated the need to import most wild specimens.

PHOTOGRAPHING REPTILES OUTDOORS

FLORIDA COTTONMOUTH
SNAKE. North Fort Myers,
FL. 200mm F4 macro lens.
1/250 sec. at ƒ/16. Three
manual flash units.
Kodachrome 64.

After rescuing this venomous Florida cottonmouth snake as it crossed a highway, I decided to recreate a vignette of the swamp in a studio setup before releasing the snake in a safer location far from a busy road. I needed only a few branches, some Spanish moss, and a black background. Because I rendered the moss out of focus, the background is barely discernible. To help reinforce the impression of a swamp, I decided on a tight composition. I chose my 200mm macro lens to take advantage of both its working distance and narrow angle of view. I determined the lighting ratio and exposure before I coaxed the snake into position on the branch.

Because of the sun-worshipping habits of reptiles, as well as the relatively slow nature of some of these species, obtaining good images of reptiles outdoors isn't too difficult. Turtles and alligators are obvious subjects, basking on rocks or logs near the safety of a pond or slough. In fact, I've made most of my environmental portraits using these animals as subjects. Despite the accessibility of most reptiles, occasionally I have to capture my subject since some reptiles are seen only when they're crossing a road.

Reptiles may be primitive, but they aren't stupid, dull creatures oblivious to the world around them. In fact, the reverse is true, as you'll quickly discover if you attempt to stalk a wild turtle basking on a log. At the first sign of danger, the turtle will slip into the water to safety.

I've made most of my telephoto portraits of crocodilians and turtles in areas where the reptiles were habituated. Wetlands near nature trails are best since various species of basking aquatic turtles ignore passing humans. I've probably done more in-field photography of reptiles in the Everglades, where the likelihood of encountering habituated animals is highest. The national and state parks of the southwestern desert rank second on my list; I've had great luck there approaching tame lizards sunning along the trails. And sometimes while I've waited in a pond-side photo blind or in a muskrat-like float blind, a turtle or snake cooperates by clambering onto a nearby rock. Surprisingly, these reptiles were as alert and wary as the birds I've photographed, and to be successful I've had to move slowly and avoid any sudden jerks or moves that might alarm them.

Believe it or not, I've encountered just as many snakes and lizards attempting to cross a road as I have others crossing a natural path in the same habitat. Obviously, photographing a reptile *in situ* on a highway would be difficult if not impossible, and potentially dangerous. By catching it, I am free to place my subject wherever I choose in order to photograph it. This practice has resulted in some of my most effective portraits.

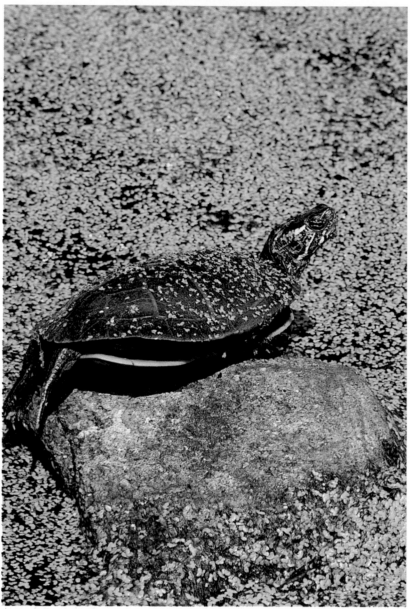

EASTERN PAINTED TURTLE. Hoot Hollow, McClure, PA. 80–200mm F2.8 zoom lens. 1/60 sec. at ƒ/16. Kodachrome 64.

A few painted turtles use the largest pond near my house each summer, but none of the turtles is very tame. Whenever I approach, they slip into the water and disappear. Fortunately, water turtles bask in the sun in warm weather, and they'll usually return to a favorite rock or log if disturbed. I've had some luck photographing turtles while using a blind that I've set up for shooting other subjects, but I'd never been as close as I would like for a pleasing turtle portrait.

One day, a neighbor delivered a painted turtle she'd rescued off a highway. The turtle was as wary as any of mine, but before releasing it into the pond, I thought I would try something new. I set up a mini-pond in a shallow plastic baby pool, adding a large rock and some duckweed from the pond. Even in the pool, the turtle frustrated me. Whenever I drew near, it darted beneath the duckweed. Then as soon as I left, it climbed back onto the rock. Eventually, I had an idea. I decided to attach a 100-foot length of stereo wire onto the end of a Nikon MC-4A, thereby making an extra-long remote cord. I plugged this cord into my motor drive, prefocused on the rock, and ran the wire to the window of my office. I didn't bother to connect my end of the wire to a switch. I then watched the pool from my office window. Whenever the turtle climbed onto the rock, I touched the two ends of the wire together, closing the connection and firing the camera. This setup, which was fun and didn't take much time, provided a nice diversion from my writing when I was stuck indoors on a beautiful day—and paid off with a pleasing turtle shot.

I photographed the turtle on a day when I was able to use the "sunny ƒ/16" rule. If the sky had been cloudy, I would have had to worry about changes in exposure that may have required setting my camera in the aperture-priority mode. I would also have had to consider the turtle's dark shell and its influence on the exposure. I chose an aperture of ƒ/16 for extensive depth of field, thereby ensuring that the turtle would be in focus regardless of its position. I had to fill much of the frame to exclude any portion of the pool. I shot both vertically and horizontally, leaving room at the top of the vertical images for a magazine name.

Everglades National Park's Anhinga Trail is one of the best locations to photograph alligators because these large reptiles search for fish or unwary birds quite close to the nature trail. On occasion, an alligator crawls toward or crosses the trail and provides outstanding photo opportunities. You must be patient, though. Most views are limited to half-submerged or saw-grass-covered animals sunbathing on the opposite shoreline and aren't very satisfying.

My workshop group was watching a great blue heron fishing when I noticed that a small crowd had gathered around an alligator sunning itself only a yard from the path. We quickly joined the others, who were standing in a semicircle about 8 feet wide around the alligator. Since the spectators were on one side of a wooden railing and the alligator and the canal were on the other, the reptile had a clear avenue of escape in case it felt threatened. This is important since habituated animals often fool people into thinking that they are tame. They aren't. Furthermore, if they are large enough, they can inflict great harm. Respect your subject, give it an escape route, and stay out of its fight-or-flight zone.

Three limiting factors governed this shooting situation: the railing, which blocked much of the animal; the crowd, which dictated where I could set up my tripod; and the lines of the subject, which were parallel to the trail's path. Photographing the alligator head-on eliminated these problems. It also kept me out of the way of most of the tourists while offering a more interesting view than a profile. I enhanced this perspective by dropping to ground level.

My working distance was too far to use a short lens because the best spots up close were already taken. After selecting my 500mm lens, I concentrated on the alligator's head. This also helped to exclude any unwanted elements within my restricted angle of view. Shooting at $f/16$, I focused on the front corner of the alligator's eyes to maximize the limited depth of field. Although this was very shallow, the zone of apparent sharpness was sufficient for the area between the alligator's nose and its back scales to be discernible. A wider aperture would have made those features less prominent.

Wet alligators are pretty good examples of the basic "sunny $f/11$" rule. Dry alligators, like this one, require less exposure compensation, and I usually open up by only half a stop off a middle tone reading or off "sunny $f/16$." I double-checked this exposure by taking spot-meter readings off both the alligator's face and the surrounding grass. These showed half-stop variations above and below my exposure, which confirmed that it would fall in the middle of all the tonal values.

At an aperture of $f/16$, the corresponding shutter speed was only 1/30 sec., and I was worried about image degradation due to mirror shake. To minimize this problem, I lay prone, braced my elbows on the ground, and added my hand and head weight to the camera-lens assembly. This absorbed enough of the vibration to keep my images sharp. Luckily, the alligator cooperated further by opening its well-toothed jaws seconds after I began shooting. This final touch made the image.

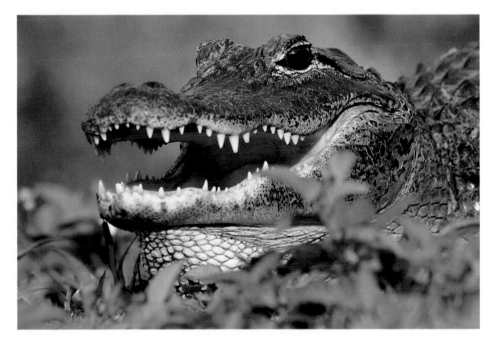

AMERICAN ALLIGATOR. Everglades National Park, FL. 500mm F4 lens. 1/60 sec. at $f/11$–16. Kodachrome 64.

I was speeding through the Australian outback when I spotted a small goanna monitor lizard in the middle of the road. Monitors can grow to be 5 to 6 feet long and can deliver nasty bites. As such, I used discretion and graciously allowed my Australian guide to rescue this 3-foot-long lizard.

Once the guide had the lizard in hand, I had to figure out where to put it in order to shoot an effective portrait of it. Most reptiles look uninteresting if they're just sitting on the bare earth, so we looked for an attractive log or tree limb as a prop but nothing caught our eye. Without an effective prop, the next obvious choice was a tight closeup in which subject details would dominate the final image.

I decided to photograph the lizard in an open clearing adjacent to the highway. I dropped down to goanna level for this portrait so that I could use some of the roadside vegetation as a frame. When I got into a good working position, however, my feet were just barely off the road. Despite the potential risk, I stayed where I was because shooting at subject level afforded greater visual impact than shooting down on the reptile. I chose my 100mm macro lens for its limited angle of view and reasonably close working distance. I had a 200mm lens with me, too, but using it would have forced me to back up more than space allowed.

The subtle orange color of the lizard and grasses adds to this picture. Billowing smoke from a huge brush fire deep in the park filtered the late-afternoon sun and bathed everything in a Martian cast. Although some people may not be enthusiastic about the two ticks behind the lizard's ear, I think that they help to accurately capture a wildlife subject.

Though I would have loved to shoot a full-body portrait of this goanna monitor lizard, the shooting conditions would have forced me to settle for a boring snapshot. Recognize your limitations and options, and adapt, as I did here. You may then be able to salvage a situation by moving in close and concentrating on the important details.

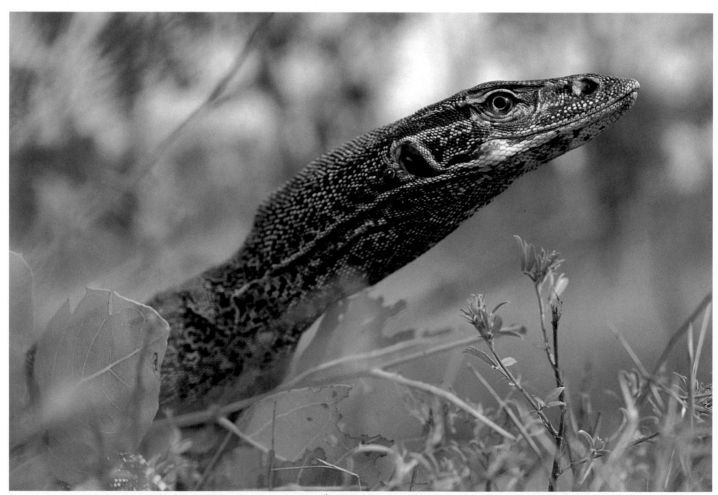

GOANNA MONITOR LIZARD. Kakadu National Park, Northern Territory, Australia. 105mm F2.8 macro lens. 1/125 sec. at ƒ/8. Fujichrome 100.

Although they're sometimes called toads, horned lizards can't be mistaken for any other reptile. Flat and well camouflaged, they are very difficult to spot in their desert habitat. And because horned lizards often bask in the sun on roads, unfortunately most of the ones I've seen have been run over by cars. While rescuing this short-horned lizard from traffic, I almost became a casualty, too. After photographing the lizard a short time later, I returned to the same location but I walked about 100 yards into the desert before releasing it. Naturally, I hoped that the lizard wouldn't wander back onto the road. (I admit that I have a near-suicidal need to rescue animals on busy roads. Many people may not share this view, and some drivers will go out of their way to run over a reptile crossing the road. I am always aware of this possible danger, and I usually don't put myself at risk.)

I would hazard a guess that almost all photographers are intrigued by the details they see in a closeup, and that they're compelled to make a small subject, such as this lizard, look big. The resulting image, however, may not be any more interesting than that of an entire moose jammed into the confines of the same 35mm rectangle. While frame-filling closeups are certainly

worthwhile, don't forget to consider the broader view and include some of the animal's habitat if it will improve your images.

After making the first shot of this lizard, I stepped back and really looked at the scene. I liked the way the lines of weathered wood flowed toward the upper right of the image. By backing away from my subject, I was able to incorporate this element into the portrait.

Next, I considered the lighting in the scene. I photographed this horned lizard in direct sunlight. I wouldn't ordinarily do this with most reptiles, but horned lizards are incredibly heat tolerant. Staying in the sun for 5 or 10 minutes doesn't cause them any stress, and these reptiles open their mouths to pant when they're becoming too warm. This is a clear sign that they've had enough.

As I was shooting, I felt that the sharp afternoon shadows were slightly distracting. I decided to lighten them by bouncing sunlight off a large mirror positioned just out of camera range. This increased the sun's intensity, heating up the lizard even faster than it otherwise would. I worked equally quickly, made my exposures, and placed the lizard back in the shade.

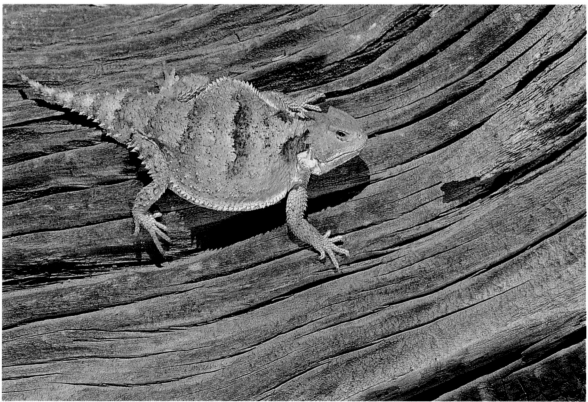

SHORT-HORNED LIZARD. Fort Huachucha, AZ. 105mm F2.8 macro lens. 1/125 sec. at f/11. Kodachrome 64.

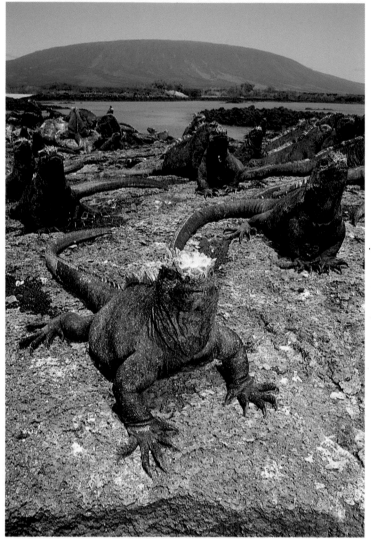

MARINE IGUANAS. Fernandina Island, Galapagos. 24mm F2 lens. 1/30 sec. at *f*/22. Nikon SB-24 Speedlight on TTL at −1. Kodachrome 64.

Located about 900 miles off the coast of Ecuador, South America, the Galapagos Islands are home to a variety of wildlife that is incredibly tame. If you walk around slowly, you can easily get within a few feet of lizards, seals, and seabirds. The marine-iguana population on Fernandina Island is one of the archipelago's largest, and some rocks may be black with hundreds of basking lizards. Obviously, photo opportunities abound.

Choosing a composition was like being a child in a candy store: I found it hard to make a decision with so much available. After my initial excitement abated, my objectivity set in and I began to ask myself questions. How many lizards did I want to include in my picture? How should I deal with depth of field, as well as with partially visible lizards? I came up with a number of answers, depending on what I hoped to convey and the various lenses and working distances I considered using. Two of my strongest compositions relied on two very different lenses, a wide-angle lens and a macro lens. I think this is instructive. I often see people relying on just one lens to capture everything in front of them. By doing this, however, they limit themselves to a very narrow interpretation of the scene. Working with several lenses broadens this scope and produces distinct images.

For the closeup shot, made with my macro lens, I worried about how much of the scene I could eliminate. I wanted to dramatize the juxtaposition of the lizards' sizes. But I didn't want to have the larger lizard's head butting the edge of the frame, or the smaller lizard appearing to be arbitrarily cut in two.

For the wide-angle shot, I decided to include a number of iguanas, the bay, and the volcano in the background. I wasn't able to shoot at lizard level because this position flattened the perspective and merged the more distant lizards as the bay disappeared from view. But shooting slightly down on the scene permitted me to include all the important elements and to frame the central lizard in an open area.

Next, I moved in close to several iguanas that were basking in the late-morning sun. I focused on the nose of the closest lizard and then reset the focus by positioning that distance, which was 2 feet, over the *f*/22 setting on the right side of the lens' depth-of-field scale. This put the infinity mark at the opposite end of the scale over *f*/5.6. As a result, I was wasting potential depth of field in the distance spanned between the *f*/5.6 and *f*/22 settings. I refocused and placed the infinity mark over *f*/16. I did this merely to guarantee image sharpness even though I knew that I would have a bit more depth beyond that setting, toward *f*/22. Now, depth of field extended from infinity to about 1³/₄ feet. Using the

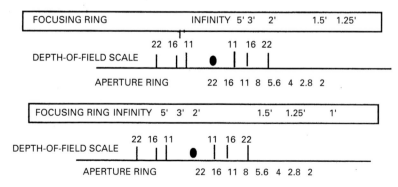

By placing the 2-feet mark on the focusing ring over the f/22 mark on the right side of the depth-of-field scale, I waste the usable depth of field to the left of the focusing mark (top). But when I place the infinity symbol (∞) over the f/22 mark on the left side of the depth-of-field scale, the depth of field increases from about 1³/₄ feet to infinity (bottom).

principles of hyperfocal distance correctly in this way ensured maximum sharpness throughout the image.

It is important to remember, however, that an image won't look sharp through the viewfinder unless you use your depth-of-field preview button. People frequently don't, and after adjusting for hyperfocal distance, they see a blurred subject and refocus to their original settings. But when you use the preview button, the lens stops down to the correct aperture and you see the image the actual way that your film will record it.

I had far less depth of field when I shot the scene with my macro lens. To maximize sharpness for this tight portrait of the iguanas, I positioned myself so that the plane of focus and the subjects' lines were parallel. I didn't attempt to close down to the smallest aperture because this would have sharpened background detail

and been distracting. Here, the depth of field is shallow enough so that these blurs simply frame the lizards.

For both shots, I dialed down the TTL flash to lighten the shadows without completely eliminating them. I needed only a one-stop reduction (–1 on my SB-24 Speedlight) for the wide-angle shot because I included middle tones. I dialed down two stops (–2 on the SB-24) for the closeup because the dark-toned iguanas filled the frame. Here, a straight TTL exposure would have overexposed the iguanas, rendering them an unnatural gray.

Whether you're shooting in an exotic location like the Galapagos Islands or at your neighborhood frog pond, chances are you can compose a scene several ways. Experiment with different lenses and different perspectives, and don't lock yourself into just one look.

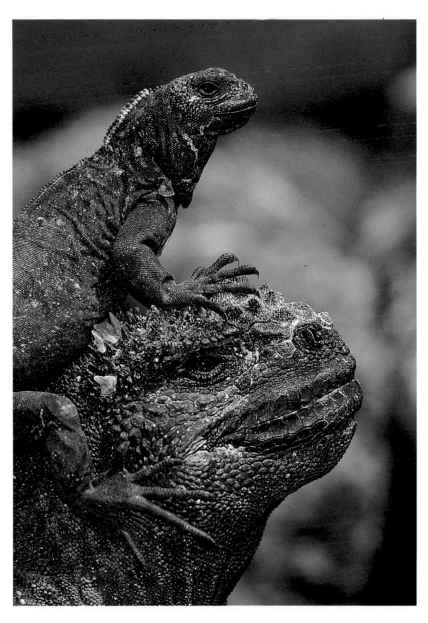

MARINE IGUANAS. Fernandina Island, Galapagos. 200mm F4 lens. 1/125 sec. at f/8. Nikon SB-24 Speedlight on TTL at –2. Kodachrome 64.

PORTRAYING ACTION

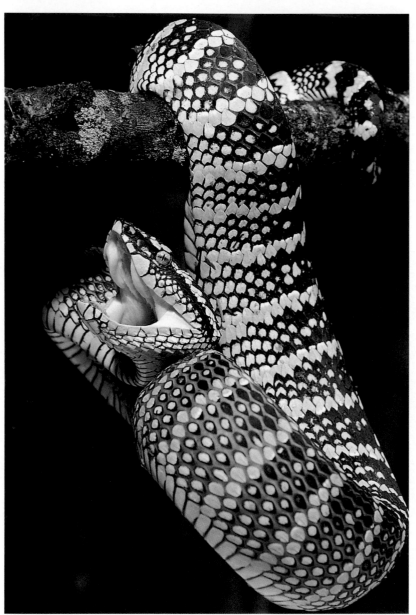

Reptiles aren't every active, and I suspect that most people consider them to be rather inert and uninteresting. Still, dramatic scenes are possible, however fleeting they may be. You just need patience and a bit of luck so that you are present when these moments happen. Reptiles spend a great deal of time doing very little but basking or hiding. You may regard this favorably if you've ever lain on your stomach on the ground and attempted to focus on a slow-moving box turtle wandering across a lawn or a forest floor. You'll find that even a sluggish turtle can cover a lot of ground. This will challenge both your focusing abilities and your endurance as you get up, reposition yourself, refocus, and jump up again in order to follow this "slow" creature. If you've done this, you'll know what I mean; if you haven't, you'll be in for a surprise when you try it.

Reptiles are most active when they feed but unlike birds and mammals, whose pre-eating behavior can be lively and exciting, a hunting reptile generally resembles a resting one. With the exception of vegetarian turtles and lizards, which browse like ground squirrels, prey-seeking reptiles surprise their victims through ambush. Consequently, these reptiles do nothing but lie in wait. Dramatic images are certainly possible when a reptile catches its prey, but you may find, as I have, that your audience isn't appreciative of a bug-eyed mouse or frog being swallowed by a snake.

Fortunately, other, more subtle images effectively depict reptilian action. A bearded lizard fanning its throat in threat, an anole lizard displaying a strawberry-red dewlap in courtship, and a cottonmouth snake gaping fiercely are just three examples. Keep an open mind and broaden your perspectives when exploring this fascinating group of misunderstood creatures.

WAGLER'S TEMPLE VIPER. In studio, Hoot Hollow, McClure, PA. 200mm F4 macro lens. 1/250 sec. at ƒ/22. Three manual flash units. Kodachrome 64.

Because Wagler's temple vipers are poisonous, I had to be concerned about my welfare as well as that of my subject. But I couldn't miss the chance to photograph one of these beautifully colored, graceful, tree-climbing, snakes from Southeast Asia. Wagler's vipers can also be aggressive. Warmed by the studio lights, this one occasionally struck out at me when I passed by. As I went about photographing this viper, both Mary and I worked it with a special snake stick. Afterward, the snake clung to its perch via its tail and held this dramatic pose. My 200mm macro lens provided the proper image size at a safe working distance.

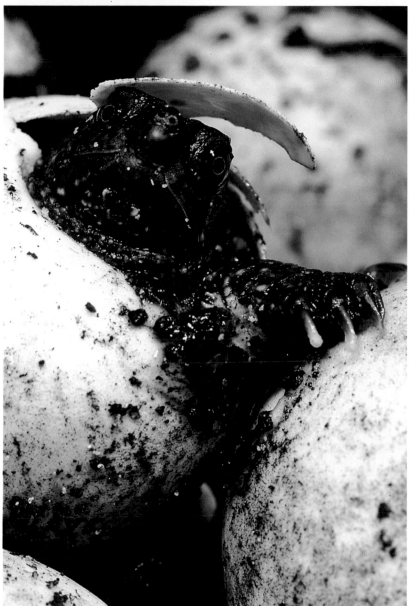

COMMON SNAPPING TURTLE HATCHING. In studio, Hoot Hollow, McClure, PA. 105mm F2.8 macro lens. 1/250 sec. at ƒ/16. Two manual flash units. Kodachrome 64.

Most reptiles lay eggs, although a few snakes and lizards bear live young. You won't have a hard time finding reptile eggs if you enlist the aid of a serious reptile hobbyist. Since many of the most popular species of snakes lay eggs, they are relatively easy to locate; gaining access to the eggs of turtles and lizards, however, is more difficult because they are less commonly available.

To further complicate the issue, the nesting success of many turtles is very poor. I've seen many species dig nests, but most of these were subsequently destroyed by skunks or raccoons. This disturbs me. I know that turtle eggs have been eaten by predators for eons, and in a healthy ecosystem the number of eggs produced compensates that loss. Today, however, adult turtles face dangers that didn't exist a century ago. Automobile tires crush adult turtles, a fact that cannot be compensated for naturally. Of course, fewer adults produce fewer eggs, and ultimately, there will be fewer young to replace old turtles. For this reason, when I find a female turtle at a nest before she has covered up her eggs, I often dig up the nest and incubate the eggs in a predator-free enclosure. When the eggs hatch, I released the young. Although these young turtles are still subject to further predation, at least they're scattered; as such, they are less susceptible to mass destruction by one lucky skunk.

In the wild, it is impossible to photograph a turtle at the moment it breaks out of its shell. Eggs are deposited in a hole 3 to 10 inches beneath the ground, depending upon the species, and are then covered with sand or soil. You can, however, successfully record the hatching sequence in the studio. I kept this nest covered with an inch-thick layer of potting soil until the first of its 30 eggs hatched. Once some turtles emerged, I carefully cleared the soil away from the remaining eggs. The eggs rested inside an elevated mound that provided me with enough height so that I could shoot at their level. I composed tightly, concentrating on the hatching snapper, not on the egg. I wanted to convey the idea of the whole nest by including a portion of many eggs. This worked (although this image is still inaccurate since hatching ordinarily occurs underground).

Contrast is always problematic in hatching shots because most baby turtles are very dark while their eggs are white. Here, I positioned two flashes above and slightly to either side of the egg clutch for fairly shadowless lighting. Since I was dealing with both very dark and very light tones, I based the exposure on a middle tone. I made this photograph while I was still teaching high-school biology, long before I owned a flash meter. To determine the aperture, I used the GN formula for my flash units.

Rattlesnakes are perhaps the best known, and the most feared, group of North American reptiles. Although venomous, most won't strike unless provoked. I've seen exceptions, however, such as the western diamondback that slithered toward me as I lay flat trying to snap a ground-level portrait. Rattlesnakes, all of which are quite dangerous, deserve your utmost respect.

I photographed these two species of venomous snakes in my studio. I wanted to emphasize the rattlesnakes' fangs. For the shot of the timber rattlesnake, I switched to a vertical format to accommodate the snake as it stretched its mouth wide open. Despite the *f*/16 aperture, the close working distance limited depth of field.

Although the image size is smaller and the depth of field was still shallow, probably less than half an inch, I was quite close to the diamondback. Even though the snake's head is looking out of the picture, I think the coils to the left balance the image. Deciding exactly where to cut off a snake is difficult; I just move around until everything looks right.

You can't beat a 200mm macro lens for providing the necessary working distance for snake closeups. I could have achieved similar results with an 80–200mm lens and an extension tube, but I would have lost some light because of the extension. When using flash, you must compensate for this light loss by selecting a wider aperture; this reduces depth of field. With my macro lens, only minimal light loss occurs, and then only at the closest focusing distance, so I can maximize depth of field. Before I posed the snake, I positioned the three flash units and determined the lighting ratio by checking each separately with my flash meter. Afterward, I did a final check by firing all three flashes.

These snakes weren't acting aggressively. Earlier, each had struck at a dead mouse I'd offered at the end of a stick. After striking, most rattlesnakes and other pit vipers gape, flexing their fangs as they do so. Knowing this, I simply waited for the gape. The trick is in the timing. With the timber rattlesnake, for example, this gaping lasted less than two seconds, and during that time only one instant offered the definitive stretch. Catching that is the challenge.

Working with venomous snakes is dangerous. If you have the opportunity to photograph one, let the handler do all the snake work. Never provoke a snake in an attempt to elicit motion. It doesn't work. Only relaxed snakes exhibit natural behavior.

WESTERN DIAMONDBACK RATTLESNAKE. In studio, Hoot Hollow, McClure, PA. 200mm F4 macro lens. 1/250 sec. at *f*/16. Kodachrome 64.

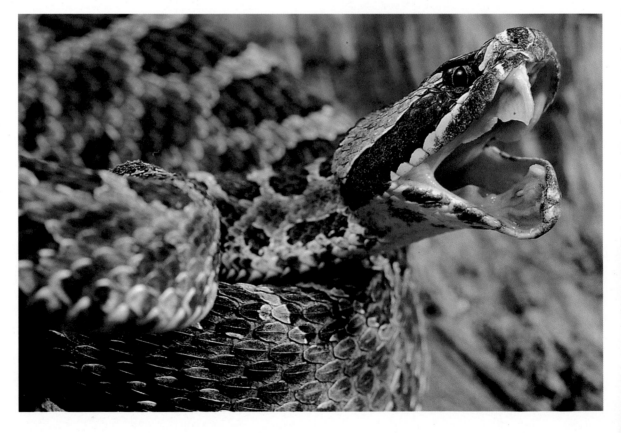

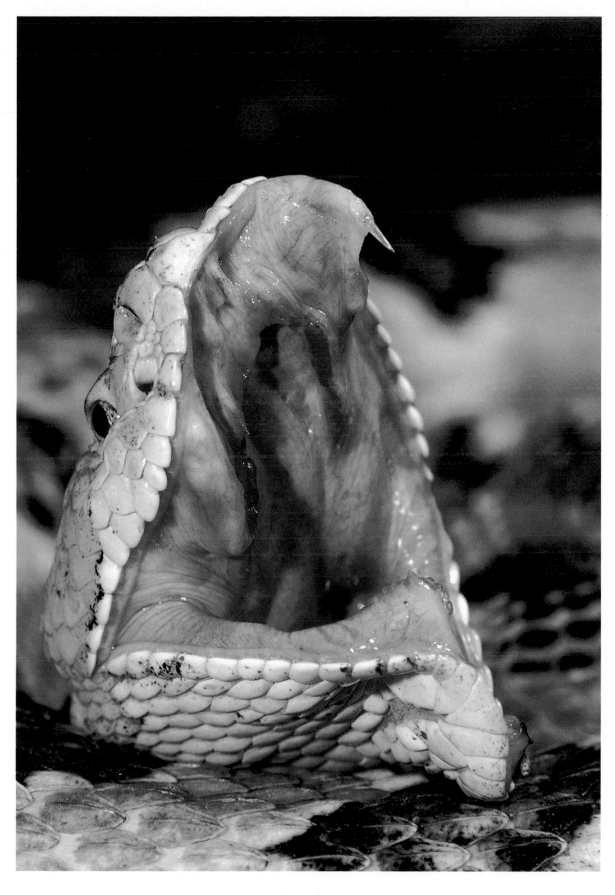

TIMBER
RATTLESNAKE.
In studio, Hoot
Hollow, McClure, PA.
200mm macro lens.
1/250 sec. at ƒ/16–22.
Kodachrome 64.

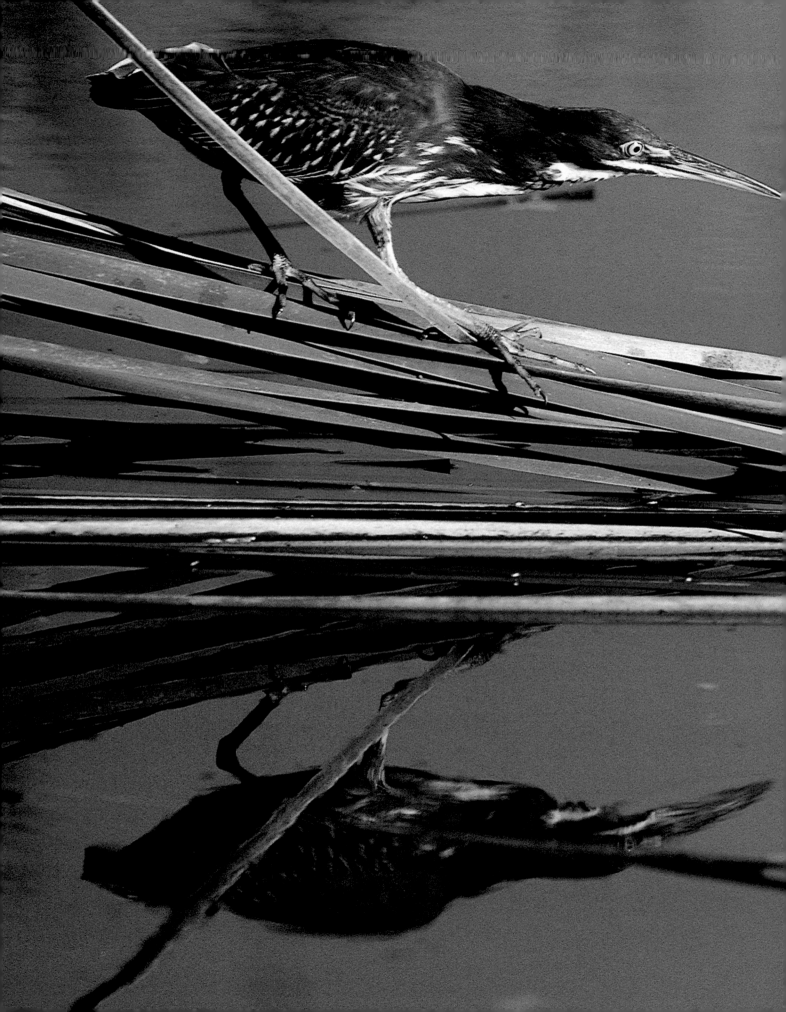

BIRDS

MASTERING THE BASICS

Because you can choose from more than 700 species, birds are an obvious subject for wildlife photography. They span the spectrum in terms of color, behavior, size, and choice of habitat. Some bird species are available to everyone, regardless of where you live. But you can most easily photograph certain other species in a single location or in a few select areas where, at times, the birds are incredibly tame. For example, great blue herons range throughout North America, including streams and lakes around my home in the Northeast. Nevertheless, it is almost impossible for me to photograph these birds in central Pennsylvania, yet I have a very easy time capturing them on film in southern Florida and the Everglades, where the birds are both abundant and habituated.

This is the reason why I often concentrate upon site-specific subjects, working with waders and shorebirds in Florida, grouse and swans in national parks in the West, and hummingbirds at established feeders near my home or in the desert southwest. Still, on trips I am rarely able to devote as many hours or days to a specific bird as I want to. Like me, you may find that you do your best work at home, where you are able to refine techniques and reshoot as you seek the perfect image.

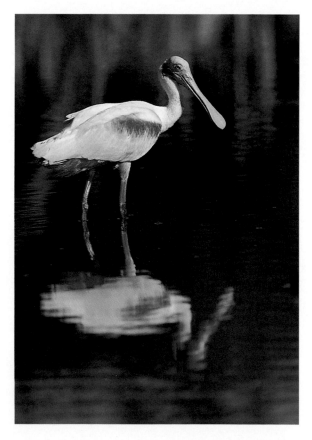

ROSEATE SPOONBILL. Mzarek Pond, Everglades National Park, FL. 300mm F2.8 lens. 1/250 sec. at ƒ/11. Kodachrome 64.

One of America's prettiest birds, roseate spoonbills are fairly common in southern Florida. I used the exposure equivalent of the "sunny f/22" rule for my exposure.

As you read through this section, you'll see that I haven't included many images of nesting birds. Those few nests I illustrate involved birds that were either habituated or were cavity nesters, and my presence was neither intrusive nor threatening. Photographers have an unfair advantage with nesters because the birds' instinct to provide for their young may force them to tolerate intrusions they would ordinarily avoid. I'm not concerned about a photographer having an advantage over a subject, but I do worry about the thin line that separates benign photography from potentially harmful photography that causes a bird to abandon its eggs or young. I think that nesting images have been overdone, so I feel that the likelihood of your shooting something unique is small. If there is a chance that your photography will cause nest failure, don't shoot—don't put the birds at risk.

Serious bird photography requires a great deal of equipment, as well as a variety of techniques. I frequently use blinds, either the quick-to-set-up L. L. Rue Ultimate Blind or ones that I've made out of plywood or cloth. However, because I expect that some of you will try techniques similar to mine, I haven't included examples that required elaborate blinds, flash equipment, or moving vegetation. It is important for you to master the basics of bird photography before you attempt more challenging techniques. First, of course, you must be able to attract potential subjects with bait or water lures, or know how to condition a bird over time.

Another fundamental skill that is critical for bird photography is working with flash. I use flash for a number of reasons; these include stopping the action of and capturing the brilliant colors of hummingbirds, illuminating owls at night, and filling in shadows in contrasty lighting conditions. On occasion, I use remote releases when I shoot with flash.

A basic bird-photography outfit must include a large telephoto lens. A 500mm F4 lens offering 10X magnification is perhaps the ideal lens for this type of photography because it focuses to approximately 15 feet and is fast enough for most lighting conditions. I use my 500mm lens for about 80 percent of my bird photography. Longer lenses, such as 700mm lenses, require careful handling, which is often a hassle. If a 500mm lens is too heavy or the price is too steep for you, consider one of the 400mm F5.6 lenses; these are lighter and less expensive. Of course, you'll need your other lenses, too, in order to effectively record birds on film. Over time, I've used almost every lens in my gadget bag depending on the bird and the shooting conditions.

MAKING COMPELLING PORTRAITS

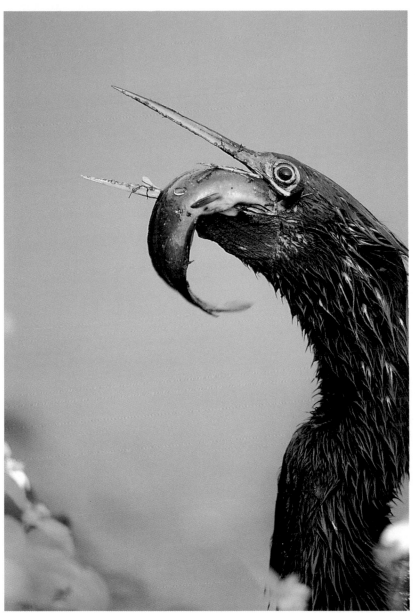

ANHINGA. Anhinga Trail, Everglades National Park, FL. 500mm F4 lens. 1/250 sec. at ƒ/4–5.6. Kodachrome 64.

The aptly named Anhinga Trail in the Everglades is probably the best location in the United States to photograph anhingas, which are odd-looking birds. Unlike its companions, this anhinga preferred to feed within a few yards of the trail. After catching a fish, this bird waddled on shore, dislodged the catfish from its bill, killed the fish, and then tossed it into the air to position it properly for swallowing. The closeup of this anhinga is dramatic and well composed. The bird's beak and eyes and the catfish are sharp because they are in the same plane of focus. I eliminated most of the distracting white flowers on the bank. White flowers and black birds don't mix well when an exposure is biased toward the darker subject.

Birds are colorful, familiar subjects that are too frequently seen from a distance. People rarely can get close enough to appreciate their detail, and this very elusiveness makes them appealing. Undoubtedly, this is one of the reasons bird photography is so popular. These challenging subjects reward your photographic efforts with color and detail that are surprising and often breathtaking. Images that reveal the intricacies of bird feathers, beaks, or feet are always effective; these parts are often ignored because average viewers take in the whole.

Another reason why bird portraits are a favorite among wildlife photographers is that birds exploit more niches and, consequently, sport more unusual physical adaptations than any terrestrial vertebrate group. If you simply think about the long bill of a hummingbird, the spatula-like bill of a spoonbill, and the powerful curved bill of an eagle, and extrapolate these variations to other bird features, you'll have an idea of the wealth of subject matter that birds provide.

To shoot a successful bird portrait, you must get close to your subject. If you are a beginner, consider zoos or rehabilitation centers; they are an easy way to get started in this field. National parks, wildlife refuges, and other areas where birds are accustomed to people are also good spots. I've had a lot of luck shooting along beaches where shorebirds, gulls, and sometimes even herons, ospreys, and pelicans have grown remarkably tame.

An effective portrait should do more than merely fill the frame. Sometimes, you may find that a bird's expression is compelling enough to fill the frame and produce a striking image. At other times, you may move in to include only a portion of the bird, or to back off so it can interact with its environment.

As you shoot, keep in mind that flash can be a bird photographer's lifesaver. Birds are active subjects, and they are most busy early or late in the day when ambient-light exposures are difficult to make with slow-speed films. But by stopping most of their motion, flash enables you to work in dim light. In addition to being ideal for such obvious subjects as birds nesting or foraging in thick, dark cover or owls at night, flash can preserve color by eliminating harsh contrast, softening deep shadows, and providing fill-in backlighting at midday. Flash can also add an eye highlight and enable you to shoot striking silhouettes.

For much of my field work, I use a teleflash system because flash-to-subject distances tend to be long. When shooting closeups, I often add a little fill or eye highlight simply by keeping the flash on the hotshoe mount. I base my exposure on the ambient light and dial down my TTL flash to a –2 or even –3 setting.

My favorite tidal-zone resident is the black oystercatcher, a gull-sized shorebird that uses its heavy bill to break into the hard-shelled prey it finds at low tide. One of the best places to find habituated oystercatchers is Point Lobos State Park, near Monterey, California. Even here, though, I usually need a day or two to find an oystercatcher that is tolerant—and close enough to photograph. And remember, the ideal time to visit these areas is just after low tide, when the rising seas reclaim the rocks and move shorebirds closer to the mainland. If you are in position, you'll be ready for the black oystercatchers, tattlers, black turnstones, and other unique birds that feed with the tides.

As mentioned earlier, you must be extremely careful when walking across tidal rocks. They can be unbelievably slippery. Both Mary and I have crashed hard on rocks while shooting tide-pool subjects. Proceed slowly, and carry your camera gear at your side, not over your shoulder, in order to lower your center of gravity. Then, if you lose your balance, you'll be less likely to fall. Test each step before putting all of your weight down, and stay on dry rocks wherever you can. The safest way to work in these dangerous areas is to let the birds come to you. This method will probably produce the best results as well. I move in to a reasonable distance and sit, hoping the birds will approach me as they feed.

For this subject-level shot, I set up my tripod at its lowest extension. This enabled me to sit comfortably while waiting for the black oystercatchers and to use my maximum-stability stance. Strong winds are common here, so anything you can do to secure your lens more firmly helps.

While shooting, I decided on this composition because I liked the way the slopes of the two rocks framed the bird; this draws your eye inward. Luckily, the cloudy-bright afternoon provided a pleasant rimlighting effect around the oystercatcher, so I didn't have to be concerned about the contrast bright sunlight produces.

Exposing a dark subject can be a problem unless you remember that black becomes gray when you meter it directly. Here, I based my exposure on a middle-toned rock that was outside the frame. I then opened up about half a stop. After recomposing the bird, I ignored the camera meter, which indicated an underexposure, and made this effective portrait.

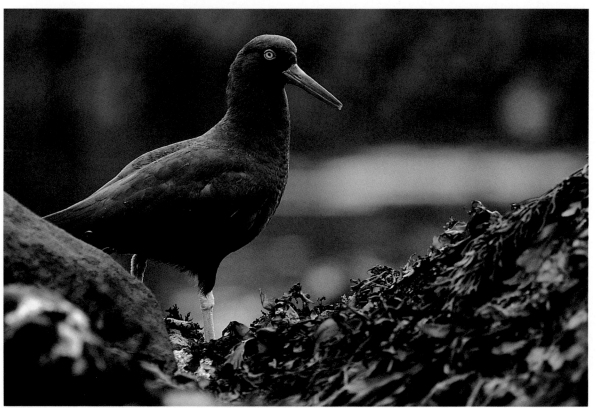

BLACK OYSTERCATCHER. Point Lobos State Park, CA. 500mm F4 lens. 1/250 sec. at *f*/4. Kodachrome 64.

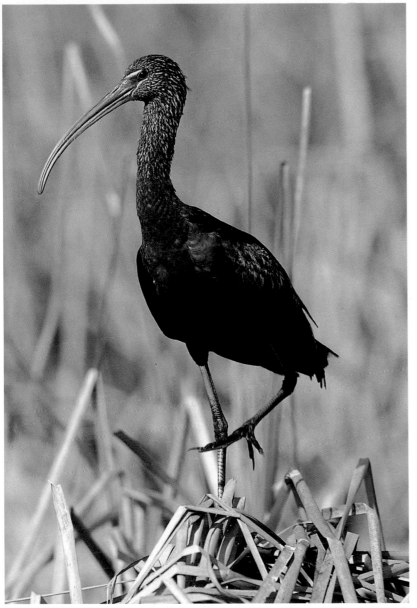

GLOSSY IBIS. Eco Pond, Everglades National Park, FL. 500mm F4 lens. 1/250 sec. at ƒ/5.6–8. Kodachrome 64.

I can always count on Eco Pond in the Everglades for great bird photography. My workshop members and I have photographed rare anis and colorful painted buntings, as well as the more common brown pelicans, ospreys, herons, and white ibises. One year, a trio of glossy ibises regularly stalked the shoreline for frogs and insects, providing us with the best shooting opportunity I've ever had with this species.

Since I was shooting close up, my only choice was to switch to a vertical format. In this picture, the bird's head is in the upper-left point of power, but that was merely happenstance. An actively feeding or preening ibis may have its head in a dozen positions in as many seconds, so your best bet is to concentrate on keeping your subject in focus while firing.

Because glossy ibises are dark birds, they are good examples of the "sunny ƒ/11" rule when photographed in bright sunlight. I ordinarily use this estimated exposure when a dark subject fills or nearly fills the frame. When the subject is smaller in size, I compromise by using the half-stop setting between "sunny ƒ/11" and "sunny ƒ/16."

I agonized over this exposure since this scene was very contrasty. I evaluated the various tonalities, which ranged from the ibis's black body and dark neck to the green background and bright cattails, and determined exposure accordingly. Because I selected the half-stop between ƒ/11 and ƒ/16, middle tones, such as the green cattails, and potentially bright hotspots, such as the dried, bent cattails, weren't severely overexposed. Although high-contrast scenes can make exposure determinations difficult, it is still important to shoot them. If you have any doubts, bracket the exposure. I've seen too many photographers struggle over the "right" exposure for so long that they miss the shot completely.

You can often observe little blue herons from slightly above as you stand on a bank or shoreline in southern Florida. Making subject-level shots is hard because these birds often feed in water only a few inches deep. Short of lying in mud or in very shallow water, there is no other way—and certainly no comfortable way—for you to obtain this view. In fact, I've often gone into the water to shoot water-level pictures of geese, swans, herons, and shorebirds. I've been known to use float blinds, wear chest waders, and lie prone along mud flats or shorelines with my elbows and chin stuck in ooze. Although these approaches are uncomfortable, they work.

The dam breast created a perfect vantage for a water-level view of the heron in very shallow water. Photograph by Mary Ann McDonald.

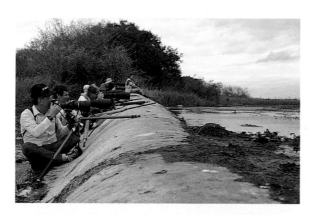

LITTLE BLUE HERON. Myakka River State Park, FL. 500mm F4 lens. 1/250 sec. at *f*/5.6. Kodachrome 64.

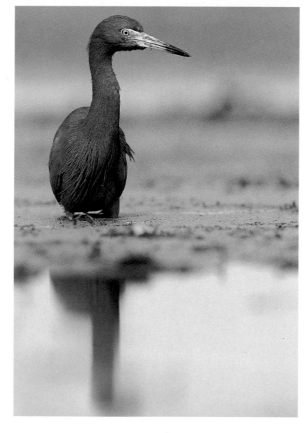

Fortunately, the water level along the shore of the Upper Myakka Lake was low and the dam breast was exposed. Fishermen and tourists regularly crossed the dam, thereby habituating the ibises, egrets, and herons that fed nearby. This created a perfect opportunity for the members of my photo tour to work almost at water level while remaining dry.

To reach this shooting position, all of us had to sit or kneel on the down-river side of the dam. This required positioning our tripods so that one or two legs rested flat on the dam, which is a difficult setup for most tripods. Fortunately, everyone in the group was using either a Bogen or a Gitzo tripod whose legs are nearly parallel to the ground when fully extended; this enabled us to aim right above the dam.

It is critical that the horizon be level in water shots. If it isn't, the image looks odd and unnatural because water never rests on an angle. To check, look at the back of your camera. If it appears to be level with the horizon, chances are the image will be, too. To ensure level horizons, I also use an architectural-grid focusing screen in all of my cameras; its inscribed lines provide an easy reference. Vertical compositions are more difficult to keep level, perhaps because the frame of reference is shortened. I usually check the horizon in all of my compositions, but this step is critical for vertical shots.

When shooting water scenes, you'll also find it useful to compose so that you don't arbitrarily cut off any reflection, or at least the important part of it. In this shot, the heron reflection just barely fits within the frame. If this reflection had been mirror-like rather than broken up by ripples, this tight composition wouldn't have worked. I would have needed more space both below the reflection and above the bird to balance the image.

I wanted to avoid centering the subject while keeping the water line level. By focusing manually, I was able to position the heron anywhere within the frame without worrying about a focusing sensor and the potential centering that results. Since focus is critical for closeups, I fired only when the bird's eyes and bill were parallel to the film plane to guarantee image sharpness.

Little blue herons are darker than middle tone, so an uncorrected spot-meter reading of the bird would have resulted in overexposure. Realizing this, I based the exposure on the water surrounding the subject's head. This agreed with an incident-light-meter reading that I'd taken from my position a few yards away from the heron. I needed a shutter speed of 1/250 sec. because the bird was moving. As long as I focused properly, I didn't wobble, and the bird didn't move too quickly, this setting would help to ensure image sharpness. Fortunately, this worked most of the time.

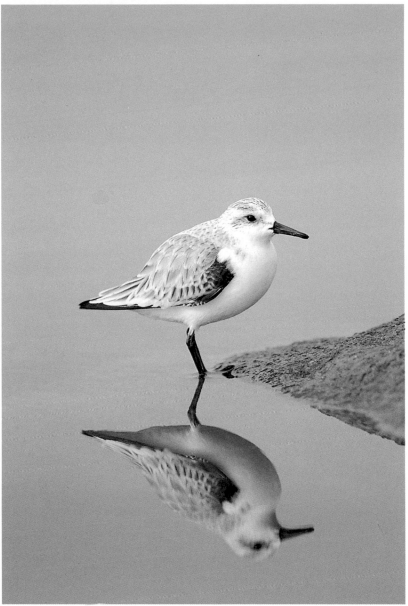

SANDERLING. Half Moon Bay, CA. 500mm F4 lens. 1/125 sec. at *f*/8. Kodachrome 64.

Sanderlings frequent the sea's edge on both North American coasts, probing and pecking for small crustacea in front of the crashing surf. Although these birds nest in the arctic and winter in South America, you can come across individuals along the United States coastlines any month of the year. I've had my best luck along popular beaches, such as those around Seventeen Mile Drive near Monterey, California, and Cape May, New Jersey, where the birds are habituated.

As sanderlings run along the beach, they resemble tiny wind-up toys. Despite this charming behavior, focusing on a rapidly moving sanderling certainly isn't child's play. The birds rarely stand still, so whenever I find an individual bird or a small flock resting I seize the opportunity.

I didn't immediately notice this sanderling's near-perfect reflection, but as I moved closer I discovered that I could catch the bird's reflection by changing my perspective. To do this, I had to back up and approach my subject from a different angle. This is noteworthy because photographers are often unwilling to back away after working so hard to get close, no matter what the reward.

Unlike the waiting techniques I use for black oystercatchers, the method I used for these sanderlings was somewhat more aggressive. I had to slowly approach this sanderling. Rather than stalk this bird, I decided to move slowly toward it because it knew that I was approaching. In general, you can't sneak up on a shorebird unless it is asleep and alone. You must proceed very slowly, take frequent breaks, and let the bird become accustomed to your presence. If you hurry, you probably won't succeed. Here, I moved forward by "walking" on my knees in order to keep low and to appear less threatening. Knee-walking is easy to do in sand, but I wouldn't want to try it on barnacle-encrusted rocks.

To determine exposure, I spot-metered the sanderling's back and then opened up half a stop. I considered the back feathers brighter than middle tone, but not white, and I reasoned that a slight overexposure would yield the correct tonalities. I used an aperture of *f*/8 to ensure maximum image sharpness. This required a relatively slow shutter speed, but this wasn't a problem because my subject was motionless and I braced carefully.

Owls make wonderful subjects. They're rarely seen, although they are probably as common as most species of hawks. Chances are, you'll see great horned owls or barred owls at night where you see red-tailed or red-shouldered hawks by day. I haven't found better areas than south and central Florida for consistent, easy owl-viewing. Barred owls are the more common of these two owl species, especially in hardwood hammocks in the Everglades and in the cypress swamps at Corkscrew Sanctuary. Unfortunately, barred owls rarely sit in

BARRED OWL. Mahogany Hammock, Everglades National Park, FL. 80–200mm F2.8 zoom lens. 1/8 sec. at *f*/8. Kodachrome 64.

Below you see two ways to illuminate a barred owl. Most of the time, using an on-camera flash produces redeye (bottom). The only exception is when the flash-to-subject distance is quite short. To eliminate the possibility of redeye altogether, simply hold a flash off-camera (top). With this setup, the shine from the owl's eyes reflects back to the flash and the camera at different angles. Naturally, this was what I did to get the shot of the barred owl surrounded by out-of-focus highlights.

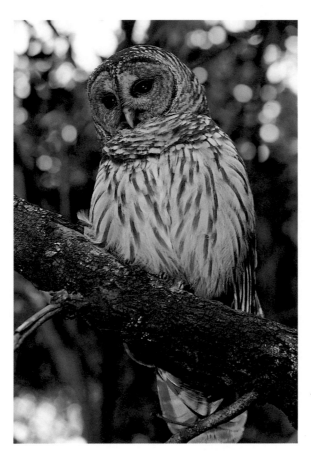

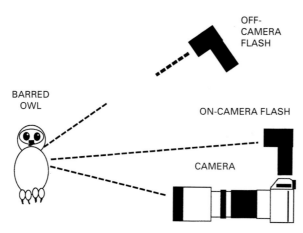

bright sunlight. Usually they are in deep shade where either a long shutter speed or flash is required. Fortunately, flash doesn't disturb an owl by day. The flash is usually too far away and the ambient light too bright to bother the bird. However, the effect of a flash can disturb you if you don't use it correctly! Flash images can be contrasty if the owl is bright and the background dark. If I'm photographing an owl during the day, I want, and prefer, it to look that way. I like the background details to be discernible.

Naturally, owls lend themselves to vertical compositions. For this shot, an aperture of *f*/8 provided sufficient depth of field for the owl without making the background appear busy. As it is, the out-of-focus highlights framed the bird. These highlights might have been distracting if I'd stopped down more.

When you use flash with owls, aperture choice is often dictated by the flash-to-subject distance, not by any compositional preference. For example, if this owl had been farther away, I would have needed a larger aperture because of the flash falloff. I would have had the option of closing down to a smaller *f*-stop for greater depth of field only if the owl were closer to me.

Flash units with larger GNs provide more choice in apertures than smaller flashes do. This is why I usually advocate buying the largest flash you can. However, a teleflash bracket offers an alternative. With a teleflash, I can make a flash with a modest GN (around 110 for ISO 64) into a very powerful flash because the Fresnel lens I use increases the GN by a factor of three.

Owls show red-eye when their tapetum (a colored, light-reflecting layer of cells behind the eye) reflects the flash's light back onto the lens. A flash, even a teleflash system, must be held off-camera to provide sufficient parallax to eliminate red-eye. The greater the distance from a subject, the farther off-camera the flash must be. To photograph this owl at a distance of 20 feet, I positioned my flash 3 feet off-camera.

The correct exposure for the light ambient background was 1/8 sec. at *f*/5.6. I set my aperture to *f*/8 so that the ambient exposure was one-stop underexposed. To find the required flash-to-subject distance, I divided *f*/8 into the GN (160). Next, I held my flash at the required distance, 20 feet, for an *f*/8 aperture. In this way, my flash exposure was correct, but the owl didn't stand out garishly from a black background.

Fill-flash is a worthwhile technique for critical situations. But don't expect to execute great fill-flash photographs on location if you haven't practiced or thought out the technique. Then, if you want to successfully photograph owls, head to Florida for some great photo opportunities.

Because red crossbills are rare migrants in my part of Pennsylvania, I was surprised to find a small flock in my neighbor's pine trees while I was out walking one morning. The birds seemed tame and allowed a close approach, so I headed back home to get my gear. When I returned to that spot, however, they were gone. The crossbills came back the next day, but once again I didn't have my equipment with me. Luckily, the birds were still there after I retrieved my equipment. By following them for an hour or so, I was able to get close enough to shoot some portraits.

Here, I had to center the crossbill to ensure proper TTL flash exposure. I would prefer having the bird a little lower in the frame in order to show more of its perch. Crossbills feed actively, so I was probably concentrating on focusing, not on the subject's placement. This is a common error. To use fill-flash for this shot, I made a spot-meter reading of the sunlit areas near the bird. Then after manually setting the exposure, I adjusted my SB-24's exposure-compensation dial to −1/3. This produced slightly less light than was needed for a middle-tone exposure, thereby toning down the flash. Still, however, the flash cast a soft shadow behind the crossbill.

During a two-week period, I saw the crossbills about eight times and tried photographing them on six occasions. I managed to do so only once. Photographic success depends not only on luck, but also on persistence. Whatever your subject, remember, if at first you don't succeed. . . .

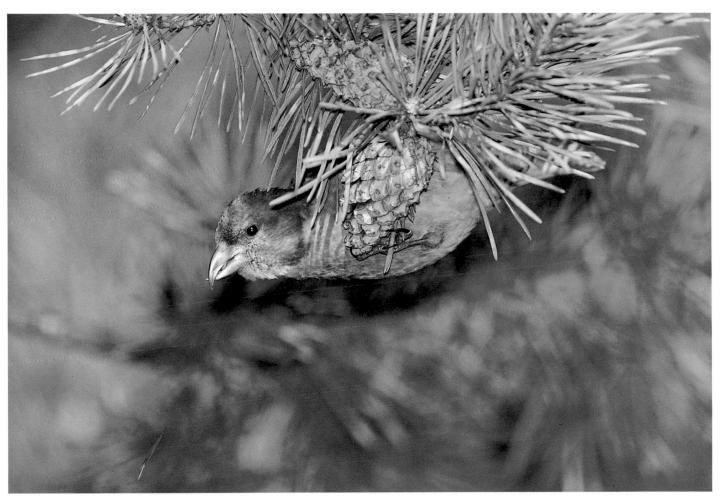

RED CROSSBILL. Hoot Hollow, McClure, PA. 500mm F4 lens. 1/125 sec. at f/4. Nikon SB-24 Speedlight and TTL teleflash at −1/₃. Kodachrome 64.

Hawks are difficult to photograph because they're habituated in few areas. As a result, most photographs of wild raptors are made either from a blind at their nest or, when the birds perch close to a road, from a car. Shooting at hawks' nests is risky, too. Most raptors nest in trees or on cliffs, so photographers need scaffolds, tree blinds, or ropes to get into position. Doing this safely demands great care and climbing expertise. This approach puts the birds at risk as well. If a blind is erected too quickly or if the birds have just started to incubate, they may abandon the nest.

Shooting from a vehicle is easier, but even this alternative makes getting very close to a raptor tough. If you decide to try this method, keep in mind that national wildlife refuges are among the best spots to find birds that are habituated to vehicles. Another option is to photograph captive birds in zoos, rehabilitation centers, nature centers, humane societies; you can also check with your district's game or wildlife-enforcement officer.

You can also work with birds used in falconry. This has two distinct advantages: you can take falconry birds outdoors to ideal locations, and you can distinguish them from truly wild birds. Cheating? Perhaps, but I think photographing a relaxed goshawk in captivity is much better than finding—and potentially disturbing— a nest in order to shoot closeups. Unfortunately, locating a falconer may not be easy. However, since falconry is a licensed sport, a local wildlife-enforcement officer may be able to direct you to one. Falconers love their birds, and, understandably, a falconer may not be initially receptive to your request. Offering enlargements in trade may get you in the door.

Tim Kimmel, a good friend of mine, is a falconer and an expert on goshawks. To photograph Princess, Tim's female goshawk, in my studio, we recreated a forest habitat. Working with diurnal birds in the studio is a challenge because making the set look natural is hard. Any studio setup involves creating a realistic impression with a minimum of props. Since most blue-sky backgrounds look artificial, I eliminate the need for a fake sky by adding enough props to convey the impression of looking into a forest.

Although I had a few days to get ready for this portrait of Princess, I was at a loss; I couldn't envision the scene. Then one day as I was driving, I noticed some big pine trees with strongly backlit limbs. Inspiration struck. I could "see" Tim's goshawk perched in the deep shade of the sweeping tree limbs. With this idea in mind, preparing the set was easy. I used a large poison-ivy vine, some pine boughs, and fall foliage to suggest a forest. I hung some 2 × 4s from the open studs in the ceiling of my studio and lashed limbs and branches to the wood. A sturdy tripod supported both the thick vine and the bird.

I needed three manual flash units for this shot. I positioned one flash close enough so that it provided strong backlighting for the maple leaves and the bird. I then placed the other flashes in front to evenly illuminate the goshawk and pine limbs. I determined exposure with a flash meter, checking each flash to figure out the lighting ratio.

I used a zoom lens in order to be able to quickly change compositions with my tripod-mounted camera. Tripods aren't absolutely necessary with flash since their short light bursts function like very fast shutter speeds. But when I don't use one, I spend too much time concentrating on holding the camera steady and maintaining my position instead of visually sweeping the edges of my images for clutter or other distracting elements.

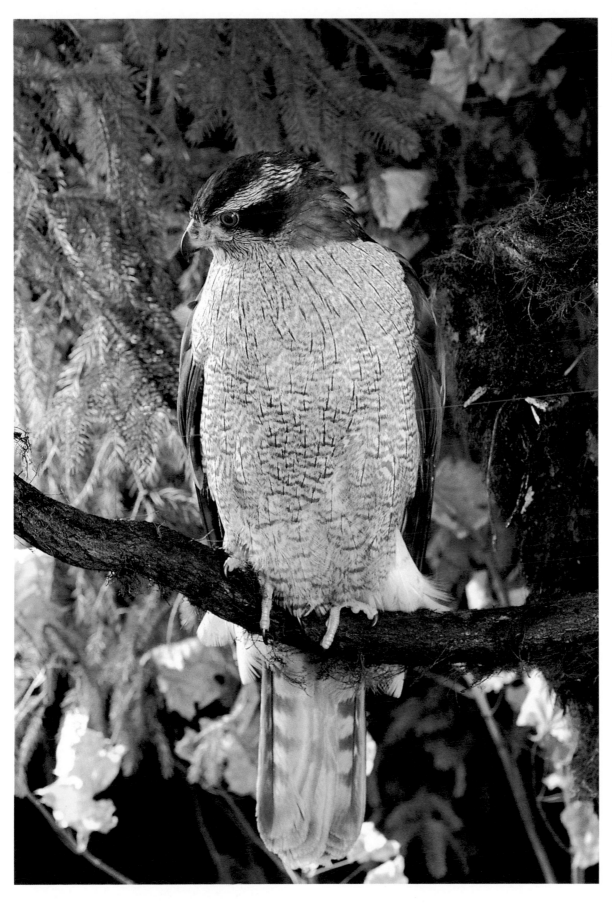

NORTHERN GOSHAWK.
In studio, McClure, PA.
80–200mm F2.8 zoom
lens. 1/250 sec. at f/8.
Three manual flash
units. Kodachrome 64.

The shoreline can be covered with hundreds of thousands of birds, but getting close enough to shoot portraits can still be quite difficult.

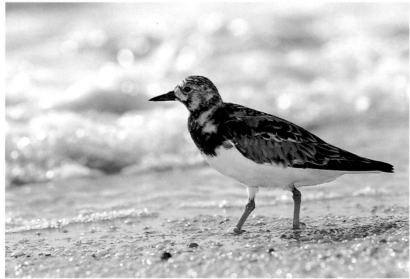

RUDDY TURNSTONE. Reed's Beach, NJ. 500mm F4 lens. 1/250 sec. at *f*/5.6. Nikon SB-24 Speedlight and TTL teleflash at −1/3. Kodachrome 64.

Shorebirds are common along all United States coasts, but you may obtain your best results near resorts. The birds often flock there in abundance and can be quite tame. For example, each year in mid-May, hundreds of thousands of migrating birds gather along the shores of the Delaware Bay to feed on horseshoe-crab eggs. By June, the birds are gone, and the shores of the lower Delaware won't be as crowded again until the following year's invasion. Red knots, sanderlings, dunlins, and ruddy turnstones, which are the prettiest, visit this important migratory-staging area in large numbers. At times they virtually blanket the beaches, luring photographers from all around the world to film the event.

Unfortunately, I suspect that many of them go home disappointed for a number of frustrating reasons. Millions of birds seem to be everywhere but where you are. And the birds are often suspicious around photographers and act very skittish. They are likely to fly off if disturbed, such as when a photographer walks toward a flock. In order to get close to the shorebirds, you must advance slowly and pause often. I often move forward on my knees.

Shorebirds are small; turnstones, for example, are a little smaller than robins. Nevertheless, shooting frame-filling shorebird portraits is possible, but you must be patient. I recommend lying down in the sand and waiting for the birds to come to you. This can take time, so I sometimes doze, face down, in the sand while I wait.

This image is centered because I wanted to make sure that my TTL-flash-metering area read the turnstone, not the background. Otherwise, the bird would be overexposed. I based the exposure on the ambient light, taking a reading off the bright sand and then opening up 1 1/2 stops. By dialing in a small, one-third-stop compensation, I helped to guarantee that this flash exposure wouldn't be unnaturally bright.

The beach faces west, which creates severe contrast problems when the shorebirds arrive in the late afternoon. Although backlit birds can be attractive, I wanted to show the turnstone's distinguishing marks. I needed flash to do that. A TTL teleflash eliminates the need for calculating an exposure based on continually changing flash-to-subject distances. Like most shorebirds, feeding turnstones move rapidly, far too quickly for a manual or precalculated exposure. A Fresnel lens is large and can act like a sail in windy areas. This, in turn, can cause camera shake, so I always use the fastest synch speed possible for the ambient-light conditions. I also ordinarily avoid using teleflash when it is windy.

BIRDS IN FLIGHT

Flying birds are among the most challenging of subjects because in most cases the difficult task of getting close to them is a matter of luck. Combine this with the need for a proper exposure, a pleasing composition, and tack-sharp focus, and the chances of getting a great shot are even smaller.

There is no question that the increasing sophistication of autofocus lenses has tilted the odds in the photographer's favor. Unfortunately, not all autosystems are equal; some are far superior for picking up, locking on, and tracking a moving subject. Systems that offer predictive autofocus, in which the lens continues focusing after the mirror flips up and the lens' focusing mechanism is powered by its own motors, are most likely to yield satisfactory results.

Don't despair if your camera doesn't have autofocus capability. You can still capture a flying bird on film in several ways. When you want to photograph a fairly easy subject in natural light, such as a gull hovering overhead waiting for bread to be tossed into the air, a manual-focus lens and quick reflexes may be all you need. You have two options when you focus manually. You can follow-focus, which allows you to keep pace with the movement or the travel of your subject. Your other option is to anticipate when the subject will pass into the sharp-focus zone and prefocus. When I prefocus, I snap the shutter the instant before I think the bird will be sharp. By doing this, I compensate for the unavoidable lag time involved as I react and as the mirror flips up prior to the shutter opening. To capture bird action that truly is invisible to the naked eye, I use flash.

SHOREBIRDS IN FLIGHT. Reed's Beach, NJ. 300mm F2.8 lens. 1/30 sec. at f/16. Kodachrome 64.

Periodically and without warning, shorebirds that congregate along beaches explode into flight. To capture the sense of motion and the mass of birds, I tried a very slow shutter speed for an impressionistic interpretation. I aimed at the birds flying off the beach, focused, and fired. Only a few birds were recognizable in the mass. With an aperture of f/16, I had plenty of depth of field, but image sharpness depended on successfully panning. That wasn't easy, as the birds flew away almost before I could start. Because of this, I fired motor-drive bursts, hoping to have at least a few reasonably sharp frames where the birds and my panning were synchronized.

With their iridescent plumage, hummingbirds are perhaps the most beautiful birds in North America and are found all over the continent. At least 12 species regularly visit the United States, and many of these frequent the mountain canyons of southeastern Arizona. At the Santa Rita Lodge in Madera Canyon, for example, you can see at least five species regularly, and even more when luck is on your side.

Hummingbird photography is easiest at feeders, but like many other photographers, I strive to work with birds in a more natural setting. For this shot, I wanted a frame-filling image of a flying hummer as it sipped nectar from a flower. Since several hummingbirds were visiting this feeder, I found it easier to disguise it than to wait for a bird to visit flowers I'd placed nearby. I disguised the feeder tube by splitting and taping an aloe flower to its end. Adding a few aloe stalks in the background provided balance; one flower in the corner of the frame looked awkward.

Naturally, focusing and composing are simplest when a hummingbird is still, but this generally occurs only when one is feeding or is perched. Between sips of nectar, a hummer may dart about, hover, and then swoop to a new position before diving back to the feeder. This action happens so quickly that in the time it takes for you to read this paragraph, a hummingbird may have fed and hovered twice!

I always focus manually on hummingbirds in flight because they rarely remain still long enough for autofocus to lock onto them. Even if the autofocus does work, I may not have time to recompose and avoid centering the subject. By focusing manually, I'm certainly challenged but I am also free to position the bird anywhere in the frame.

In preparation for photographing hummingbirds, Mary and I positioned a feeder, background, and flashes in the shaded area behind the room.

Photographing these small, swift birds poses another challenge. It is difficult to capture their iridescence without using electronic flash. Since light that reflects off the birds' plumage creates this rainbowlike effect, even the most resplendent hummingbird will look black if the light isn't right. With flash, it isn't too difficult to get the correct angle for bright colors. However, flash photography presents its own problems with exposure, synchronization speed, and ghost images. Low ambient light and flash sync speeds of 1/125 sec. or 1/250 sec. help to eliminate ghosting, but this combination can result in unnatural-looking black backgrounds. To avoid this, the flash or flashes must evenly illuminate the background and the hummer.

In this setup, I aimed three flash units at the hummer and a fourth at the background. I determined the lighting ratio with a flash meter. Matte board, which I used for the background, often reflects more light than an incident-light meter indicates. Accordingly, then, if the meter reads $f/16$, you can assume that your board will actually be reflecting an amount of light that calls for an aperture of $f/22$. If you want a working aperture of $f/16$, you must place the flash farther back until you obtain an $f/11$ meter reading at the board.

To eliminate problematic ambient-light ghosts, I placed both the feeder and the matte-board background in deep shade. Note, however, that a ghost could appear if you use two or more flash units with different flash durations. If one flash fires for a longer time than the other, it is possible that the hummer will move and blur with the second light. To avoid this potential problem, I always use flash units with identical flash durations.

Hummers may feed fearlessly quite close to you, but you'll have more luck if you give them some room. I achieved a comfortable working distance of about 9 feet by coupling both a PN11 and a PK13 extension tube with my 500mm lens. This resulted in some loss of light, so I opened up my incident-light meter's reading to $f/16$.

You might wonder why I didn't use a natural background for this photograph. For the most part, this is practical only when the background is close to your flash setup and is fairly flat. The varying depths among the trees, rocks, and other objects around this feeder rendered this impossible. Also, a naturally illuminated background would have produced a ghost image when the hummer inevitably moved during the exposure.

You can make a similar setup in your backyard. Just remember these two important points: ghost images and dark backgrounds can ruin your flash photographs, and your shutter speed won't matter if your exposure is based solely on flash.

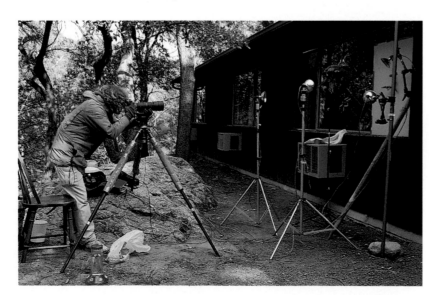

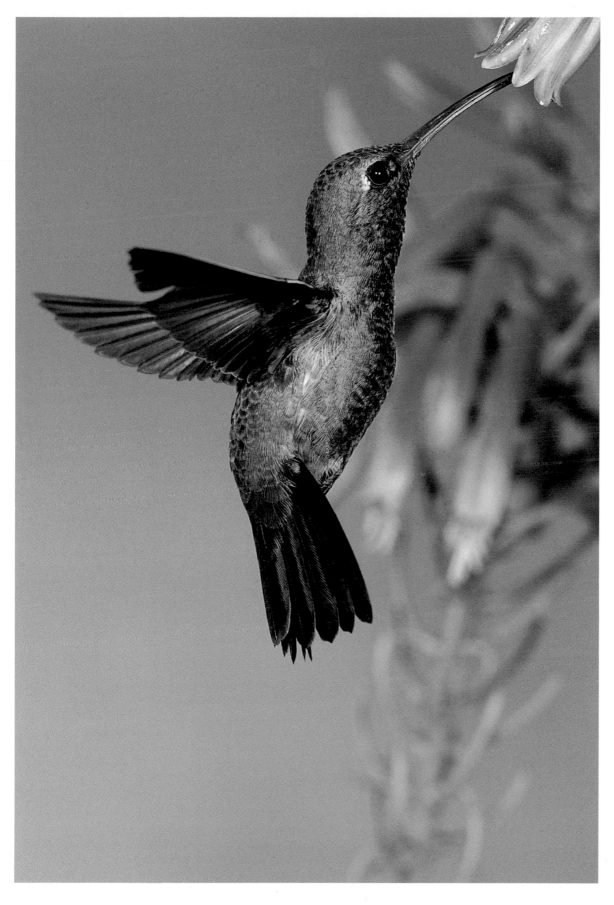

BROADBILLED
HUMMINGBIRD.
Madera Canyon,
Santa Rita Mountains,
AZ. 500mm F4 lens
with PN11 and PK13
extension tubes.
1/250 sec. at f/16.
Four manual flash
units. Fujichrome 50.

SAW-WHET OWL.
Central Pennsylvania.
100mm F4 lens. Bulb at
f/11. Four manual flash
units and Dalebeam.
Kodachrome 64.

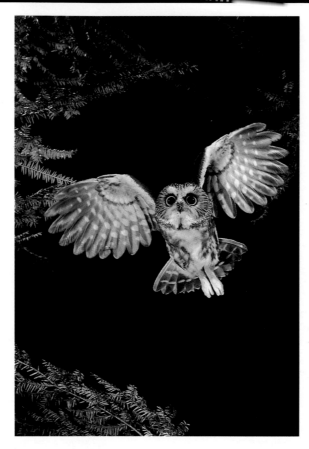

If you decide to try photographing a bird flying at night, keep in mind that even with a Dalebeam, good compositions are still a matter of luck. When I use one Dalebeam, I aim my camera toward the middle of the beam's path to make it more likely that the bird will fly within the frame. Sometimes I catch a bird half out of the frame, but short of using a second Dalebeam, this is the easiest way to get fairly consistent results.

Even in a flight cage, however, an owl has tremendous leeway, so trying to predict where it will fly is almost hopeless. To increase the chances of having this saw-whet owl fly where I wanted it to, I made a frame in the middle of the cage. Next, I surrounded the frame with black cloth that extended to the walls, floor, and ceiling, and provided the necessary background. The cloth had to be back far enough so the light the owl received was at least two stops brighter than the light that the background received, thereby rendering it virtually unnoticeable. I placed branches around the frame in order to direct the bird toward its center. To fly the length of the cage, the owl had to pass through this opening and the infrared beam I'd aimed there.

Next, I surrounded the frame with four Sunpak 611 flashes. I wired one flash unit directly to the Dalebeam, and the other three flashes to slave units. I placed one flash on either side of the frame, suspended another behind for backlighting, and aimed a fourth at the owl's belly. I dialed the flashes down to 1/16th power, providing a flash duration of approximately 1/6400 sec. At extremely brief flash durations, GNs are low. I positioned my two main flash units a little less than 3 feet from the spot where I expected the owl to pass. I calculated the lighting ratio by making separate readings with my flash meter and then took an overall reading to determine the required aperture, *f*/11.

With this arrangement, I set my camera on "B" to record the flashes when they fired. Most of the time, this was easy. Whenever the owl was on the "right" side of the frame, I simply tripped the camera with a remote release and kept the shutter open. Then when the bird flew through and broke the beam, the flashes fired and I closed the shutter. Sharp focus was easy because I'd wired the Dalebeam to a flash; the exposure was made as soon as the owl broke the beam. I simply prefocused upon that spot.

As you may expect, a flash firing in the dark may momentarily disorient an owl. To minimize this, I kept a 25-watt bulb aimed at the frame. This light wasn't enough to register any film ghosting when the owl flew by, but it was sufficient to prevent the owl's eyes from dilating wide. The rehabber and I didn't observe the owl becoming disoriented when the flashes fired.

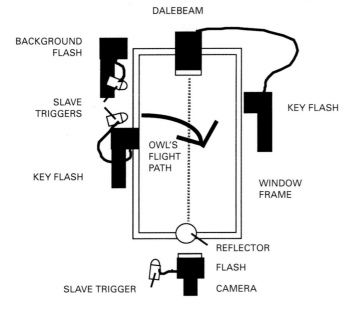

To capture a flying saw-whet owl at night, I used four flash units. I wired one flash directly to a Dalebeam and placed it on the right side of the window frame. I put the second key flash on the left side of the frame. I positioned the third flash to provide backlighting and aimed the remaining flash at the owl's belly. After setting the camera on Bulb, I made the shot when the owl flew from the back of the cage, through the window, and toward the camera, which I'd placed in front of the window.

USING PERCHES AND BAITS

One of the most appealing aspects of wildlife photography is the challenge involved in getting close to your subject without causing it stress or interfering with its natural behavior. Using common sense and knowing a bird's routine can combine to get you to the right place at the right time. This may simply require your traveling to locations where birds are habituated and ignore other people who are close by.

Birds are active subjects with incredible mobility. They are capable of investigating, seeking, and exploiting new food sources, perches, or hiding places as no other wildlife group can. Birds are also reasonably intelligent and can recognize food sources quickly. As such, you can shape a bird's behavior to some extent and can safely train a bird to perform for the camera.

The easiest way to shape a bird's behavior is to provide food or, with desert species, water. By doing so, you can condition a bird to fly to a particular area or perch. I like this method because it makes interesting closeups and frequently exciting action images possible, and my subjects benefit from cooperating with me since I give them food. Winter is an ideal time to shape most birds' behavior when you provide food at a feeder. Spring and summer, when adults actively seek food for their young, are also great times to bait birds. Working with birds in a nonstressful way is especially important during the nesting season. You'll learn that using a little common sense and knowing a bird's behavior together can enable you to get wonderful images.

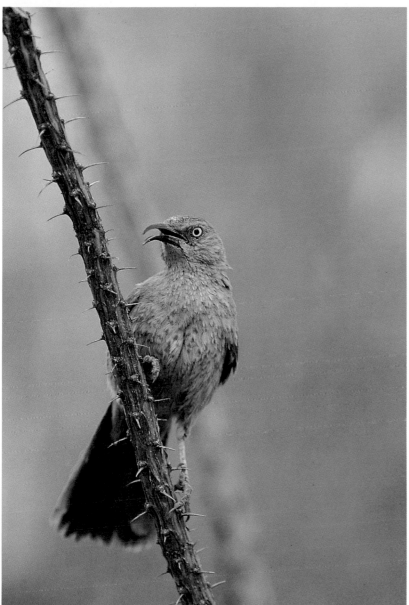

CURVE-BILLED THRASHER. Organ Pipe Cactus National Monument, AZ. 500mm F4 lens. 1/250 sec. at ƒ/5.6. Kodachrome 64.

In an attempt to attract birds while camping in the southwest desert, I placed several pans around my campsite. Next, I punched a tiny pinhole in an equal number of cans and suspended them over the pans. Naturally, when I filled the cans with water, it slowly dripped out through the holes into the pans, and the sound of the splashing drops and the ripples they created drew in birds. They were seeking relief from the glaring midsummer sun and intense heat. I made this shot of the thrasher in midafternoon on a cloudy-bright day when the typically harsh shadows of that time of day were absent. Selecting an aperture of ƒ/5.6 provided some depth of field without making the background too sharp. This picture is an exception to one of my rules. I usually shoot in only the angular light of morning or evening unless I'm using flash to fill in deep shadows.

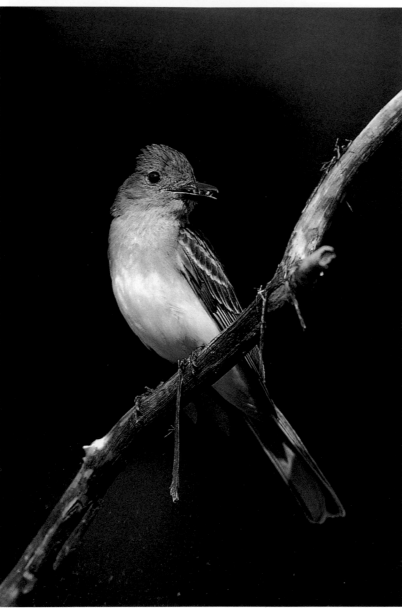

CRESTED FLYCATCHER. Hoot Hollow, McClure, PA. 500mm F4 lens. 1/250 sec. at *f*/8. Kodachrome 64.

In open areas, most birds will accept a new perch if is placed in a convenient location. But this may not work if plenty of natural perches are available. Still, you might have some luck if you observe a bird's routine as it approaches the nest and set up your blind nearby.

Even then, your troubles may not be over. Lighting conditions can be tricky with cavity nesters in a forest. For example, crested flycatchers nest in woodlands and orchards in boxes or natural cavities that range from 6 to 60 feet high. Fortunately, this pair of birds nested in a low bluebird box in my pasture. As a result, I was able to use a ground-level blind in good light. While watching the flycatchers, I noticed that both adults always perched upon an adjacent fence before flying to the nest. I suspected that the birds would use a natural perch if one were available, so I tied a branch to a tripod that was positioned about 6 feet from their box. They landed on the limb as soon as they returned.

By setting up a perch, I had control of the camera angle, the light, and the background. I am always particularly careful when it comes to backgrounds because I don't want any unsightly, distracting hotspots ruining my pictures. In addition, I try to keep the makeshift perch parallel to the film plane in order to maintain the same degree of sharpness throughout the prop. Next, I set up my L. L. Rue blind about 30 feet from the perch, slowly moving it closer until it was just 15 feet away. To avoid disturbing the flycatchers, I always waited until both birds left the perch before I moved the blind.

Placing the birds in the center of the frame provided masthead room for a magazine cover. Thanks to my all-matte focusing screen, I was able to use any area of the screen to determine sharpness. By focusing manually, I had a few extra seconds to compose the image and make exposures each time the birds landed.

Since I was shooting on a clear day, I was able to take advantage of an equivalent "sunny *f*/16" exposure. I used an aperture of *f*/8 to obtain extra depth of field and a shutter speed of 1/250 sec. to stop motion. Occasionally, however, a cloud covered the sun, so the "sunny *f*/16" equivalent didn't work. Whenever this happened, I took a meter reading off either the nearby birdhouse, which was also middle tone, or off a small gray card that I'd placed by the perch. I didn't meter off the birds because they were too small to completely cover the spot-metering area, and I worried that the dark background would bias the exposure.

BELTED KINGFISHER.
Hoot Hollow, McClure,
PA. 500mm F4 lens.
1/250 sec. at *f*/5.6–8.
Kodachrome 64.

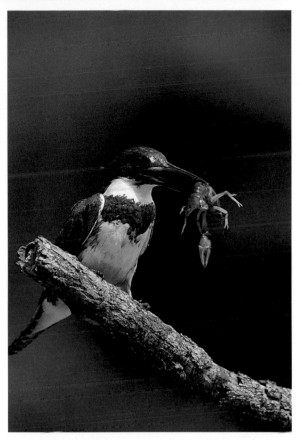

Photographing belted kingfishers demands preplanning, and being familiar with the birds' behavior can also help you to make great shots of them. Kingfishers dig horizontal burrows that are 3 to 15 feet deep and nest in steep banks. During the first summer that Mary and I lived in Hoot Hollow, Pennsylvania, a pair of kingfishers nested in our creek's 4-foot-high bank. Although flood waters washed out the nest twice, the birds dug another one each time. Nevertheless, I worried that the birds would choose a safer location far from our home.

The following spring, I built what I jokingly refer to as the world's largest birdhouse. When Mary and I had our frog pond excavated, I piled the earth high and landscaped it sharply in order to create a steep bank. I hoped that the kingfishers would choose this site, which was safe from washouts. As a final touch, I stuck a small dead snag in the pond where it would be within easy reach of my 500mm lens. When the birds returned, they headed for their old nest first. Later, they began a second hole farther downstream, and then a third in the bank I'd built. For a while, I wasn't sure which spot they would use; soon, however, they concentrated their activity at the bank and nested there.

Belted kingfishers are quite wary and are sensitive to even the slightest camera movement. Keeping this in mind while I worked, I moved my lens very slowly as I composed from inside my blind. My subjects often left before I was able to complete my move, but I felt that it was better to miss the shot than to have them not trust the blind.

Shooting at 700mm, I couldn't obtain the vertical portrait I wanted because the kingfisher perched squatly and was too wide for the frame. When I switched to my 500mm lens, the resulting image was stronger because the branch complemented the bird. Next, I had to decide between image size and shutter speed. Using a teleconverter produced a larger image, but it also increased the chance of soft images. At 700mm (14X), focus is critical, and the chance of registering camera or subject movement is higher because of the slower shutter speed required. My 500mm lens minimized this problem. One final point: whenever I can, I attach a Bogen Magic Arm to my camera when I shoot at 700mm for additional camera support. Working the Magic Arm inside the blind was awkward because I had to loosen it and then lock it into place again each time I recomposed.

Because kingfishers have contrasty tones, I based the exposure on the snag. I always made the readings before the birds arrived in order to avoid frightening them by moving my lens. Luckily, their rattling cry heralded their arrival, which gave me time to swing my lens back up to the perch before they landed.

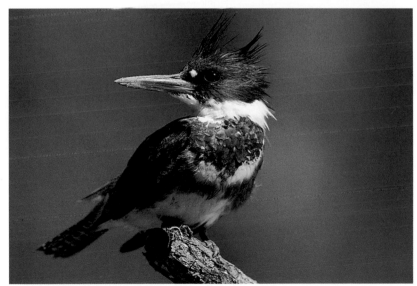

BELTED KINGFISHER. Hoot Hollow, McClure, PA. 500mm F4 lens with 1.4X teleconverter.
1/250 sec. at *f*/5.6. Kodachrome 64.

The eastern bluebird, which is one of the most popular songbirds, is also a wonderful photographic subject. Mary and I maintain a modest bluebird trail of bird boxes that boasts a number of successful nests each season. Ordinarily, however, I don't advocate photographing most bird species at their nests; uncovering nests that are hidden in thick cover may expose it to predators. Too many nests are destroyed in this way, and I don't think any photograph is worth that price. But this isn't much of a problem with box-nesting bluebirds because you don't have to expose their nests in order to shoot them. Most cavity nesters, in fact, are threatened only by photographers who clear away vegetation that may cover the nest hole and whose presence keeps away the adult birds.

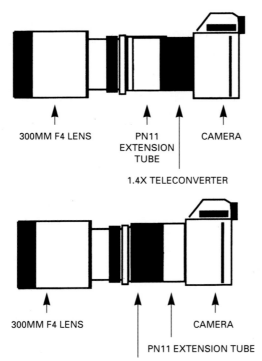

300MM F4 LENS PN11 EXTENSION TUBE CAMERA

1.4X TELECONVERTER

300MM F4 LENS CAMERA

PN11 EXTENSION TUBE

1.4X TELECONVERTER

After trying to photograph this bluebird with several lenses, I finally decided that using my 300mm F4 lens with a PN11 extension tube and a 1.4X teleconverter would produce the effect I wanted to achieve (top). Notice the order of these pieces of equipment; this determines how close you can focus. By placing the extension tube directly behind the lens, I decreased the minimum focus of the lens. The resulting image size was then multiplied by 1.4 when I placed the teleconverter behind the extension tube; this yielded a large image size and a short working distance.

If I'd reversed the order of the equipment by putting the teleconverter immediately behind the lens and then added the extension tube, I would have effectively produced a 420mm lens (300 × 1.4) and a slightly smaller image size (bottom).

Although I knew that photographing our bluebirds at their nest box would be easy, I wanted to shoot portraits of them on natural perches. To facilitate this, I began placing mealworms inside a nearby aquarium shortly after a pair of bluebirds adopted the newest box, which was just 40 feet from the door to our house. Then, beside the aquarium, I placed an old tripod that supported one of several branches I alternated every few days. Whenever I dropped mealworms into the tank, I shouted, "Hey, bluebirds!" I wanted—and hoped—that they would associate my voice with food. Because one bluebird was often perched close by when I approached the aquarium, I was confident that the birds would make the association after a number of repetitions.

Eventually, on cue, a male bluebird flashed to the fence line whenever I yelled out. As soon as I left, the bird flew to a branch above the tank, paused, and then hopped inside for an insect treat. And by the time the bluebirds' young had hatched, both adults knew that my presence meant "fast food" for their offspring. This experience taught me that conditioning works, even with wild birds. Naturally, though, I was also happy to see that the birds maintained their independence: they continued to hunt for insects rather than to wait for and to rely on my handouts.

At this point, I was able to start photographing the bluebirds. Frame-filling closeups of small songbirds require a fairly close working distance. As such, depth of field becomes very important. With short working distances and a wide-open lens, depth of field can be so shallow that only the bird's eyes are rendered sharp. Small apertures of $f/5.6$ and $f/8$ provide the depth of field required to increase the sharpness of the entire subject.

Luckily, I was able to position the branches whatever way I wanted when making this shot. I achieved the best results when the branch was parallel to the film plane because the sharply focused branch enhanced the composition. Choosing the more effective format was also important. An upright bird lends itself to a vertical format, while a branch extending across a horizontal frame can look boring. In this shooting situation, I thought that holding my camera vertically produced a stronger image than a horizontal orientation did. I preferred the way the lines of the bird dominated the shorter lines of the branch in the vertical shot. As such, I shot horizontally only when I added an interesting-looking branch that complemented the image.

Although the bluebirds were conditioned, I used a plywood blind; I didn't want to prevent the birds from feeding. My plywood blind is heavy, which makes setting it up a bit hard; however, it is stable in all but the strongest winds, and it is cooler than many of my

cloth blinds. Some blinds, including this plywood one, are difficult to work from if you don't raise your tripod centerpost high enough so that your lens reaches the lens porthole in the blind. This reduces tripod (and, therefore, lens) stability, which in turn increases the chances of soft images. To minimize this problem, I always raise the tripod legs as high as I can before resorting to the center column.

Over time, I moved my plywood blind quite close to the aquarium and used progressively shorter lenses. I started with a 500mm F4 lens with a 1.4X teleconverter (for an effective focal length of 700mm). Next, I switched to a 500mm lens, and ended with a 300mm lens with a 1.4X teleconverter and a PN11 extension tube (for an effective focal length of 420mm).

At short working distances, the combination of a prime lens, teleconverter, and extension tube determines how close you'll effectively be working and how large an image you'll achieve. For the closest working distance and largest images, I placed my PN11 extension tube behind my 300mm prime lens. Next, I multiplied the image obtained by this close-focusing 300mm lens with my 1.4X teleconverter. If I'd done the opposite and placed the teleconverter behind the lens first, thereby producing a 420mm lens, and then added the extension tube, I would have ended up with a slightly smaller image size. In essence, I would have decreased only the working distance of the 420mm lens. Both combinations result in the same light loss. This principle works with any extension-tube-and-teleconverter combination, not just with a Nikon PN11 extension tube and 1.4X teleconverter. Try this with your closeup gear.

Mary and I had a lot of fun working these bluebirds. In addition to making some outstanding images, we also helped the birds through a very taxing time of year. And conditioning a bird to a food source is a great alternative to disturbing birds at their nests, and can work with almost any bird species.

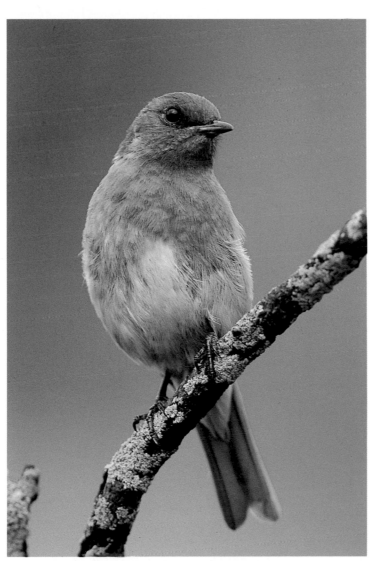

EASTERN BLUEBIRD. Hoot Hollow, McClure, PA. 300mm F4 lens with 1.4X teleconverter and PN11 extension tube. 1/125 sec. at ƒ/5.6. Fuji Velvia at ISO 40.

Like all jays, Florida scrub jays are bold, inquisitive, and often quite tame. Unfortunately, habitat loss has threatened this species' survival; they frequent thick scrub-oak woodlands that are being cleared to make room for more golf courses and shopping centers.

Mary and I regularly visit a scrub-jay colony located near a retirement home. Fed daily, the jays are so conditioned that some always appear as soon as we arrive. If the birds haven't eaten yet, they'll mob us in search of peanuts and sunflower seeds. During one of our visits, Mary and I found a group of people hand-feeding the jays. Our huge lenses certainly weren't necessary that day because the birds were almost within arm's reach. To record their proximity, we decided to place a peanut on Mary's lens. Within seconds, a scrub jay landed on her teleflash bracket. To capture this moment, I quickly composed several images using a zoom lens. Here, I positioned Mary and the jay at opposite points of power, which balances this image nicely.

For the humor in this picture to work, Mary's expression was very important. If she'd simply looked at the camera and smiled, this would be just an ordinary snapshot. Fortunately, Mary is a ham and quite expressive, and in the minute or so that the scrub jay remained on her flash bracket, she adopted a number of facial expressions and poses. Here, we tried to convey the frustration a photographer feels when a subject becomes too cooperative. I think we succeeded.

Consider including people in your wildlife images. Editors are always looking for photographs of people enjoying the outdoors. And in slide shows, shots of people interacting with wildlife or the environment adds interest and a sense of place or scale. Although events can happen so quickly that you have little time to think, it is essential that you always remember what it is that you want to convey. If you find something humorous, record the scene that way. If you have a choice, shoot candidly; this will let you capture natural expressions and poses. Most people freeze up in front of a camera and look stiff. If, however, you must photograph posed subjects, try relaxing them by talking, cracking silly jokes, and/or providing immediate feedback when your models do something that looks good. Use your best judgment—and whatever seems to work for a particular subject. Then if you are lucky, you'll get a great shot.

Finally, if you photograph people and hope to publish your pictures, make sure that you obtain signed model releases as you shoot. This will save you plenty of headaches if the photographs are published. In this case, I married the model!

SCRUB JAY.
Southwest Florida.
80–200mm F2.8 zoom
lens. 1/250 sec. at *f*/8.
Kodachrome 64.

INTEGRATING SUBJECTS AND ENVIRONMENTS

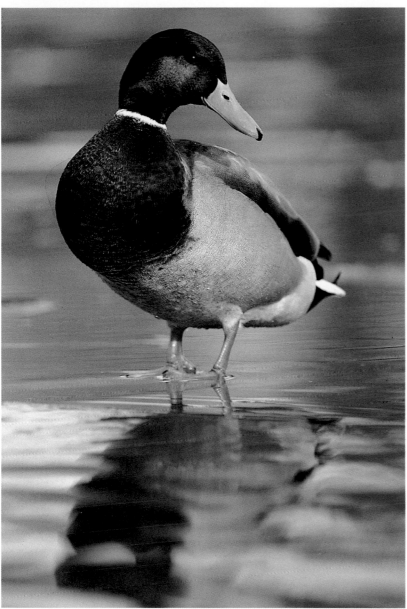

MALLARD DRAKE.
Allentown, PA. 300mm
F2.8 lens. 1/125 sec. at
ƒ/5.6. Kodachrome 64.

To get as low as possible to photograph this mallard drake, I placed my tripod's legs flat on the ice and lay prone on the ledge. This gave me a near-subject-level perspective. Because mallards have dark heads and breasts and light gray bodies, they are contrasty subjects. Fortunately, this bird's bill and feet were middle tone, as was the surrounding gray-brown water, which I based my exposure on. Although I was using an F2.8 lens, I stopped down to f/5.6 for better depth of field.

Photographers are often so concerned with getting close enough to birds in order to shoot frame-filling images that they neglect the importance of the birds' habitats. But some of the most memorable and powerful images I've ever seen effectively integrate a wildlife subject and its environment. To effectively combine a subject with its surroundings, you need to distance yourself from the immediacy of the encounter so that you can see exactly what is possible. I've often been guilty of concentrating solely upon my subject and ignoring a wonderful habitat image. In addition, observing workshop and tour participants has shown me that my experience isn't unique.

Perhaps one of the reasons for this is that most bird portraiture requires using a telephoto lens, whose limited angle of view focuses your attention in too restricted an area. Then as you concentrate on a bird, you may often find yourself ignoring all other elements in the image. How many times have you thought you had a frame-filler only to find that the image occupied just a small, centered portion of your frame when your film was returned?

For environmental shots, then, you must consider the whole scene, both through the viewfinder and with the naked eye. This comparison may jolt you into the realization that a great shot is possible with a 200mm lens; you can include, for example, the tree, sky, or reflections that surround the bird. Through a long lens alone, however, you may see only the main subject. I realize that these opportunities aren't always obvious, perhaps because of the closeup mindset people often adopt when photographing wildlife. Don't make that mistake yourself.

Trumpeter swans are common permanent residents on Yellowstone National Park's many rivers. Local swan numbers are augmented each winter by migrants drawn to the park's open water. These migrants are less trusting than the resident birds. Remember this when you shoot because winter is a stressful time, so you shouldn't pressure these wary birds. If some of the swans appear nervous, leave them alone; there will be others, and some of these will be permanent residents accustomed to people.

On one of my winter photography tours, my students and I encountered a group of swans huddled against the distant bank of the Madison River. The air was biting cold despite the overcast sky, and the river was misty, making the swans barely discernible against the gray-white background. You may encounter similar shooting situations at almost any city pond or wetland during the winter months if snow is present.

This image's special ethereal quality is a result of the mist and snow and the minimal non-white areas. Snow, mist, and swans all reflect more light than middle tone, and a reflected-light reading based on any of these would have underexposed the shot. I wanted this scene to be lighter than middle tone, which required overexposure.

I made an in-camera spot-meter reading from the whitest snow (to the left of the center swan) and overexposed that area by a full f-stop. Coincidentally, the water in this photograph looks almost middle tone, but by determining my exposure by opening up off white, I knew that the water would look natural regardless of the exposure.

Although photographers often think in terms of the "rule of thirds," you don't have to divide every composition this way, as this picture shows. This "rule" is only a suggested guideline. But you must always keep in mind that shorelines can ruin compositions by either dividing a scene in an awkward manner or dividing a subject in half. It is usually best to avoid this, although that may not be possible if your subject is close to the opposite bank.

Here, I divided the frame by having the swans and water occupy the lower fourth of the frame. For this image, I got down low, as close to the snow-covered riverbank as possible. I didn't disturb the swans; I was more than 150 feet away. These graceful creatures frequently swam by, leaving distracting heads or tails projecting into the frame. I could do nothing but wait until those along the edge either left or swam completely into the frame.

TRUMPETER SWANS. Madison River, Yellowstone National Park, WY. 500mm F4 lens. 1/125 sec. at *f*/4. Kodachrome 64.

I suspect that most photographers use lenses with focal lengths of 200mm and less when shooting scenics. I do, too, but I usually carry a 300mm lens and a 1.4X teleconverter in case I want to make tight closeups as well. Fortunately, I had my equipment with me when a killdeer landed at this pool.

During the workshops Mary and I run, participants often ask beforehand what gear they should bring along. My usual answer is, "As much as you're comfortable carrying." You never know what equipment you'll need when you shoot in the field. When you gather your gear, keep in mind that a telephoto lens will emphasize important details in scenics. Conversely, with cooperative subjects, a wide-angle lens will yield unique perspectives that incorporate their habitats. If you have both types of lenses with you, you won't miss any pictures.

Unlike a closeup, in which the subject dominates the image, a scenic, in which the subject appears small in its habitat, can prove to be a challenge: it can be hard to make this type of shot interesting. As a result,

I immediately consider the points of power in the "rule of thirds" grid when I shoot scenics. I said "consider" because I may find that this approach isn't appropriate for a particular composition. Chances are that it will be, but remember, I use the power points only as a guide.

The "rule of thirds" grid worked well for this shot of a killdeer. The line of travertine leads diagonally from the lower-left to the upper-right points of power. The dark shadows in the opposite corners mirror each other and enhance the scene. My 300mm lens provided both a sufficient image size for the killdeer and the tight cropping needed to emphasize the landscape.

I stopped down to $f/8$ in order to achieve some depth of field. Fortunately, I didn't need more; if I'd wanted more depth, the resulting shutter speed may have been too slow to effectively capture this subject. As I fired, the killdeer flexed its wings, holding them motionless above its back for a brief instant. I was lucky. At 1/125 sec., the shutter speed I used here, the wings would have blurred if they'd still been moving.

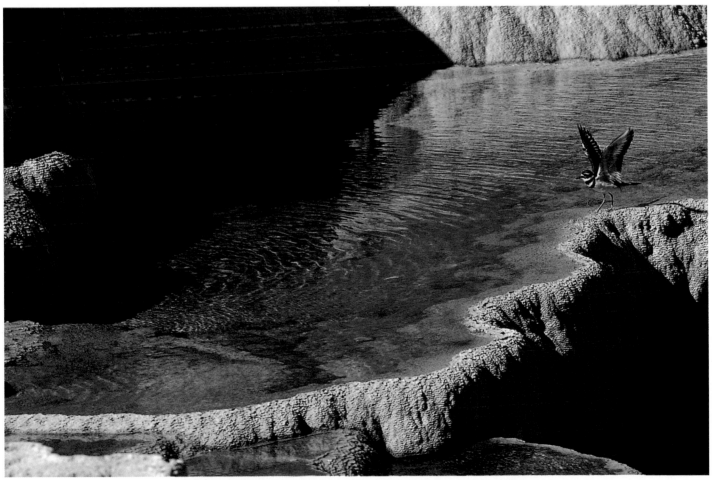

KILLDEER. Mammoth Hot Springs, Yellowstone National Park, WY. 300mm F4 lens. 1/125 sec. at $f/8$. Kodachrome 64.

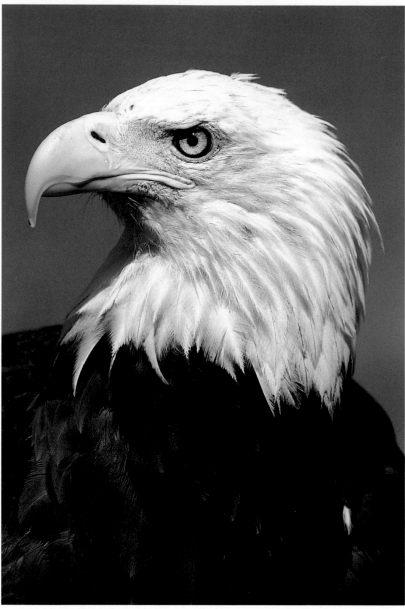

BALD EAGLE. Seattle, WA. 500mm F4 lens. 1/500 sec. at ƒ/8. Kodachrome 64.

Few bird portraits offer as much commercial appeal as shots of eagles do. I don't know anyone who doesn't enjoy photographing eagles; unfortunately, however, opportunities to do so are often quite rare. Although it is difficult to get frame-filling headshots of a wild bird, it is relatively easy to do so with a captive eagle. Finding a subject isn't hard either because most zoos and many rehabilitation centers have at least one.

And I've had wonderful cooperation at most zoos and rehab centers once I met and talked with the bird handlers. I usually follow up my shoot by sending enlargements of the birds I photographed to the handlers. I urge you to do the same even if you don't intend to return to that zoo or center. This gesture is a common courtesy and will smooth the path for other photographers who may follow. Chances are, you'll benefit, too, at the next zoo or rehab center you visit.

More difficult than locating a captive eagle, perhaps, is getting the right lighting or background for an attractive portrait. In some cases, a bird handler cooperates and places a perch where the photographer wants it. I wasn't this lucky. After I spent almost an entire afternoon at a zoo waiting for the right light, one of the zoo keepers decided to put the eagle back in the shade. Up until this point, I'd managed to snap only a few frames.

When photographing large birds, I like to include a portion of the body for a "bird bust." Hawks and eagles lend themselves readily to this with their upright stance. These closeups can, however, suffer from a lack of sharpness since depth of field is usually quite shallow, especially when I shoot at a wide-open aperture setting. Here, I closed down to ƒ/8; I wanted enough depth to render the bird's beak and eyes sharp. As such, it was essential for me to keep the side of the eagle's head parallel to the film plane. If the bird had faced me, either its beak or its eyes wouldn't have been sharp. I needed to use my longest telephoto lens in this shooting situation because I wasn't able to control the working distance. Luckily, this lens provided a very limited angle of view and minimized the number of distractions behind the eagle.

Each autumn, at least 2,000 bald eagles congregate along Alaska's Chilkat River to feed upon spawning coho salmon. This annual event draws hundreds of photographers who hope to make the definitive bald-eagle portrait. But weather conditions in southeastern Alaska conspire against photographing the birds. This part of the state receives as many as 300 days of precipitation each year. And on a clear day in November, the shooting window is limited to about six hours of usable light. Furthermore, the road that runs parallel to the Chilkat River faces southwest, thereby requiring photographers to shoot toward the sun.

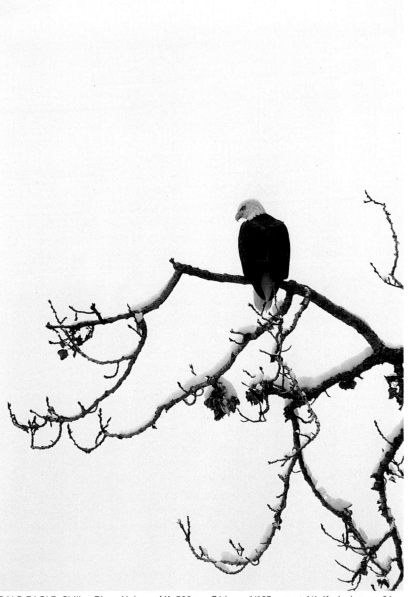

BALD EAGLE. Chilkat River, Haines, AK. 500mm F4 lens. 1/125 sec. at ƒ/4. Kodachrome 64.

Another problem is that because the area is so popular, many of the eagles' prime roosting and perching spots are off-limits. As such, photographers and birders are restricted to the viewing areas located along the road and the river's closer bank. Fortunately, the eagles are reasonably habituated, and those perched near the viewing areas permit people to get fairly close to them. Good shots—in fact, even great shots—are possible, but they require extraordinary luck because both the birds and the weather must cooperate.

Although I have closer shots of Chilkat bald eagles, this image is one of my favorites. Perched on a twisted snow-covered branch, this eagle reminded me of an Asian painting. Placing the bird off-center provided some negative space, which, in turn, reinforced that impression. Birds on high perches require you to pay special attention to composition. If you approach your subject, your shooting angle will increase and will result in a less pleasant view. Long lenses help, but sometimes there is a practical limit to this magnification. You must decide whether to move closer or make do with the image size you have. Here, I kept the smaller image.

When a bird appears fairly small in the frame, clutter can pose another problem in terms of composition. For example, when making this portrait, I noticed a network of distracting branches to the right of the eagle. I cropped them out of the image by framing the bird against the sky.

Satisfied with the composition, I fully extended my tripod in order to decrease my shooting angle. This introduced potential image shake, which is always a problem when I use slow shutter speeds and long lenses. It is particularly troublesome when I can't use my maximum-stability stance. To eliminate camera shake in this shooting situation, I locked up my mirror, used a cable release, and attached a Bogen Magic Arm to the camera body. Clamped to a tripod leg, the Arm helped to reduce vibrations.

Next, I determined exposure by taking a spot-meter reading of a section of forest with amounts of light and dark areas that were equivalent to those of the desired composition. This constituted a crude gray card. The spot-meter reading was about $1^{1}/_{2}$ stops less than the setting my camera indicated when I focused on the eagle, but the bright sky behind the bird accounted for this difference.

Bald eagles are fairly common in a number of areas around the United States and Canada. You may have better weather and a longer shooting window than you do when you work near the Chilkat River in Alaska. The *National Photo Traveler* bulletin lists many of these sites and includes maps and the best times to shoot (see page 143).

Bald eagles are scavengers that feed on dead fish and carrion. In the western United States, for example, bald eagles feasting on road-killed deer is a common sight along the highways. And in Alaska and Florida, eagles commonly feed on dead or dying fish.

I made these bald-eagle shots while working on a project about vultures. I'd been told about a landfill where garbage-eating vultures were accustomed to vehicles driving by. That was true, but unfortunately the birds looked awful perched amidst paper, cardboard, and other litter. After two days of "stalking" the vultures from my car, I gave up; it was impossible to eliminate the garbage. I decided to shoot elsewhere. Fortunately, the vultures bathed in a water impoundment nearby in the afternoon. The background was free of litter, and through my long lens the area looked like any stretch of Florida coastline. As luck would have it, eagles visited the area, too. I realized that if could get an image here, I would have something special.

While the vultures cooperated wonderfully, none of the eagles fed close enough for tight compositions. Flight shots posed another challenge because I had to provide room in the frame for the birds' wings. This was difficult because the birds' speed and direction changed continually, and I could never be sure which direction a bird would come from.

I needed a blind while shooting at the impoundment because the eagles and vultures weren't accustomed to a person standing outside a car. I started out simply with a portable blind, which I placed near some dead fish. I was comfortable, sitting on a stool and reading a paperback while I waited, but the blind didn't work. In time, I figured out that the vultures and eagles overhead saw me through the thin slits in the blind's roof. At first,

I wasn't sure whether it was my being inside the blind or the blind itself that spooked the birds. It was me; within a half hour of my leaving the blind one afternoon, vultures swarmed my baits.

At this point, I decided to make some changes. I closed the blind tight, sealing off all the "windows," or openings, the birds could use to spot me. Although the vultures returned, the eagles didn't, and I wondered whether they were more cautious. Faced with a travel deadline, I had to try something else. As a last-ditch effort, I dug a pit blind in the impoundment's sandy wall. I carved a seat, backrest, and holes for my tripod legs, as well as a narrow shelf for my extra equipment. Next, I covered the blind with a sand-colored fabric and added some branches and rocks to keep the wind from lifting the cloth. I then scattered bait at a number of spots that were different distances from the pit blind. This would vary my compositions and give the birds a choice if they were suspicious of the blind.

Luckily, the pit blind worked. Vultures appeared within half an hour. Then about an hour later, the first eagles flew by, signaling their presence by their haunting cackle. Eagles are aggressive, and when these birds arrived at the impoundment, they swooped in and scattered the more timid vultures. Although this action was hard to capture on film, it made for the most exciting images I shot that day.

I used a 500mm F4 lens and a 1.4X teleconverter. Camera shake wasn't a problem since I kept the tripod low and was able to brace my elbows against the walls of the blind for additional support. Determining proper exposure, however, proved to be difficult. Immature eagles (and vultures) are darker than middle tone, and the adult birds' heads are much lighter. I metered the water and used that setting for the immature eagles and vultures, and then closed down half a stop for the white-headed adults.

For the shots of the birds in flight, I prefocused above the hoped-for landing area. Then when a bird entered my field of view, I fired. The birds' movements were so swift that all I could do was react.

A well-concealed pit blind provides an interesting perspective for many elusive subjects. They work well with subjects where foreground vegetation isn't a problem. Keep in mind, though, that pit blinds are damp and dirty, so you must be careful that grit doesn't fall onto your equipment. Because pit blinds are very dark, I cut a small window in the roof of mine in order to have some light to read by. Many wildlife photographers advocate being alert and ready every second, but I find this waiting so tedious that I grow impatient.

Here you see the fish I used for bait. My blind is tucked into the sandy slope in the distance.

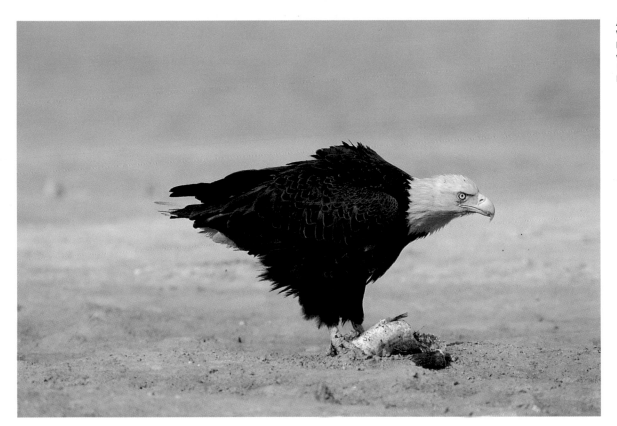

ADULT BALD EAGLE WITH FISH. Southwest Florida. 500mm F4 lens with 1.4X teleconverter. 1/250 sec. at f/5.6–8. Kodachrome 64.

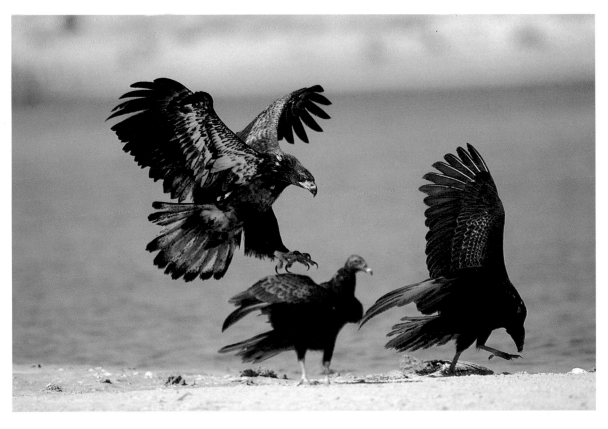

IMMATURE BALD EAGLE IN FLIGHT. Southwest Florida. 500mm F4 lens with 1.4X teleconverter. 1/1000 sec. at f/4. Kodachrome 64.

My good friend Frank Schneidermeyer and I were hiking toward a rocky beach in search of tide-pool macro subjects when a wandering tattler flew by and landed on some distant rocks. I'd never photographed this species before, which is a Pacific Coast migrant, so I immediately started shooting as I moved in. At the same time, a large wave crashed against the rocks, framing the bird in a wall of water. I missed that particular shot, but it looked wonderful. Luckily, another even larger wave followed, and I fired just as it began curling down toward the bird. An instant later, the tattler flew away.

Since the bird was so small, I made sure that I positioned it near a point of power on the "rule of thirds" grid. When the first wave hit, I noticed that it didn't quite reach the top edge of my frame. Anticipating this problem as the second wave crashed, I raised the frame slightly. This creates the impression of an even larger wave, which adds to the scene's drama.

I based my exposure on the crashing waves, reasoning that this very bright area was the most important element in the picture. After making a quick reading, I opened up by one *f*-stop. This kept the water white and made all other exposure values register darker. The tattler was too small to consider when I determined exposure.

As with the killdeer shot, I was ready for whatever photo opportunities presented themselves here by carrying all the gear I might need. Macro gear is necessary for shooting at tidal pools, but by having my telephoto lens along I was able to capture this fleeting moment. Later on, after Frank and I left the beach, I cleaned my lenses. This is critical when you work near salt water. Even on a calm day, you'll find the front element of your lenses speckled with potentially corrosive salt spray. Use a skylight or 1A filter on your smaller lenses as extra protection under these conditions. The tiny decrease in image quality is offset by the importance of keeping your lenses free of damaging corrosives.

WANDERING TATTLER. Point Reyes National Seashore, CA. 300mm F4 lens. 1/250 sec. at *f*/5.6. Kodachrome 64.

APPROACHING NESTING BIRDS

I've stressed the vulnerability of nesting birds and warned you about the dangers photography poses to them. Of course, not all photo opportunities are harmful to these subjects. The following methods will allow you to photograph easily accessible nesting birds without causing them any stress.

Photographers can have an unfair advantage when working a nest, potentially pushing the limits of a bird's instinct to overlook dangers or warnings it would ordinarily heed. To avoid this, I use various methods that represent minimal risk to the nesting success of my subjects. Some approaches involve habituated birds, while others are simply the result of chance encounters like those you may have been lucky enough to have had. I've incorporated practically every wildlife photography trick and technique that works,

from remote releases to photo blinds. The method I used depended on the species and the circumstance. In every case, however, my chief concern was the welfare of my subjects, and I hope that you'll follow my example.

Signs of stress vary according to species, but in some ways recognizing them almost boils down to using your common sense. If a bird refuses to fly into a nest and only lands in nearby trees, circles overhead and calls, dive-bombs either you or your camera setup, or engages in distraction displays, you can be sure your presence is bothering your subject. A guaranteed way to be absolutely sure that you're causing stress is to determine if you feel pity for the bird—which you should if you're observing a bird that won't come all the way into its nest. If so, back away or stop shooting.

OSPREY. Coastal southwest Florida. 500mm F4 lens. 1/500 sec. at ƒ/5.6–8. Kodachrome 64.

Along the Florida coasts, many ospreys nest close to homes or highways, where they've grown accustomed to people. I came across perhaps the best nest I've ever seen only a few dozen yards off the highway near a popular south Florida beach. Since it was early in the nesting season, I suspected that the male might attempt to mate. I positioned the female in the lower portion of the frame, leaving adequate room to include the male if he landed or if he feinted a pass and flew by. As luck would have it, he landed on the female and bunched his sharp claws into fists. This position isn't very stable, so the male keeps his wings outstretched and flaps them continuously to maintain his pose and balance. This action provided me with exciting shooting opportunities.

Killdeers nest on open ground, often far from the nearest water, laying four well-camouflaged eggs in an inconspicuous, pebble-lined depression in the earth. It is very easy to miss the nest; frequently, the only clue that a nest is nearby is the killdeers' distraction display. Called the broken-wing act, adults lure predators or photographers away from the nest by crying piteously and dragging an "injured" wing upon the ground. If you see this type of behavior, watch your step; otherwise, you are likely to step on eggs or newly hatched chicks. Stop and search the area immediately around your feet. If you don't spot the nest, retreat by the exact route you came. Return about an hour later, and scan the area with binoculars for the incubating adult.

Each year killdeers nest on my neighbor's large gravel driveway. The birds are quite used to people walking within 20 yards of the nest. Unfortunately, I needed to be closer to shoot, so I placed a blind nearby. Photographing ground-nesters from a traditional blind creates a perspective problem because you tend to look down on the birds when shooting closeups. To work at bird's-eye level, I used a different blind, one I jokingly call "the coffin blind" because of its odd shape. As the packing box for my situp board proved, anything that provides concealment can work. Unfortunately, the box wasn't long enough to cover my legs, and they stuck out the back. Luckily, the birds didn't mind since my legs were usually facing away from the nest and were motionless, the critical factor.

Working inside my coffin blind at ground level required a special camera support because the blind was too narrow for my tripod's legs. Depending upon how much height I needed, I used one of my short, homemade mini-pods, or I stacked a couple of beanbags into a pile. Lying prone and arching my back to look through my viewfinder strained my back. To alleviate that stress, I propped a few beanbags beneath my chest and stomach for support. If you're thinking of using a ground-level blind—or any blind for that matter—spend a number of minutes test-driving it for comfort. That way, you'll avoid hours of agony once you are inside and it is too late to make changes.

Ground-nesters are among the easiest birds to photograph, but they are also quite vulnerable to disturbances. These killdeers were so tame that they returned to their nest as soon as I disappeared inside the blind. Some birds won't come back, however, so you'll need a decoy assistant to accompany you to the blind. Since birds can't count, they'll return to their nest as soon as your helper leaves. A suspicious bird may return to the nest even if you don't enlist the aid of a decoy, but will do so much more slowly than it would if you used an assistant. This time factor is dangerous for the eggs or the young, especially if they're exposed to the direct sun.

Some ground-nesters use thick cover, and you can't see their nests without disturbing the vegetation. I urge you to leave these nests alone because you'll be exposing them to predation. Other ground-nesters, such as terns and skimmers, are colonial, and approaching them can cause tremendous damage if this exposes the eggs or young to hungry gulls.

NESTING KILLDEER. McClure, PA. 500mm F4 lens. 1/250 sec. at ƒ/8. Kodachrome 64.

Most heron rookeries are in remote areas where few people wander. These breeding colonies are very sensitive and easily disturbed, so it is best to leave them alone. In fact, I urge you to avoid rookeries or nesting colonies where birds aren't habituated because the adults may abandon their eggs or young if disturbed. But there are some exceptions. You can find safe alternatives where your photography isn't a threat to wildlife in the southern United States.

Florida is home to a number of such locations. In late spring, Sanibel Island's Ding Darling National Wildlife Refuge and Everglades National Park's Anhinga Trail and Shark Valley Trail host colonies of yellow-crowned night herons. And at the alligator farm in St. Augustine, various egrets and herons nest a few yards from the boardwalk.

A rookery in southern Florida provides nature photographers with good photo opportunities. It is located on a small island in the middle of a municipal park. Although the nesting herons, egrets, cormorants, and anhingas are isolated, they are still close enough to the surrounding shoreline to make shooting easy.

I made this shot of four great blue herons while working in this colony. I wanted to shoot a family portrait in which the birds were not only large, but also in reasonably sharp focus. Achieving this effect can be difficult to do with a long telephoto lens. Here, the three birds in the plane of focus are sharp, while the features of the fourth bird, which is in the zone of apparent sharpness, are discernible but not critically sharp.

As you can see, one of the adult birds is only partly in the picture. This isn't troublesome, however, because the bird's outline doesn't begin to complete its form. If the heron's tail had been cut off and the back and belly lines had started to converge, your eye would have sought completion of the outline. As the bird appears here, though, the lines extend outward without a hint of convergence. The repetition in this image helps, too; the first heron suggests the shape of the second adult.

A lens/converter combination of 700mm produced the largest possible image size. However, this came at a cost in terms of potential image degradation due to camera shake, improper focus, or subject movement. I am very conscious of focus when using long lenses; I double-check sharpness with the focus-confirmation dot on my Nikon 8008S or F4 cameras whenever I can. To eliminate camera shake, I use a fast shutter speed and a cable or remote release when there is no wind to shake the lens. I also use the mirror lockup on my F4 for motionless subjects, but this solution is impractical with continually moving subjects, such as these herons.

If I can, I'll double-support my camera/lens combination for increased stability when I shoot at an effective focal length of 700mm. Although using two tripods, one for the lens and the other for the camera, works, I find this very cumbersome when I need to change or adjust a composition. A Bogen Magic Arm does almost as well, and by releasing tension on this accessory, I can recompose easily.

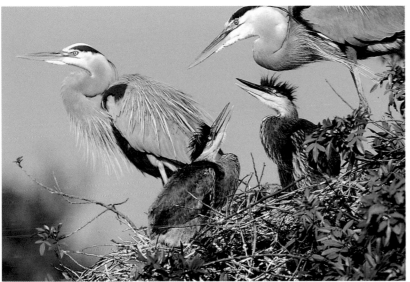

GREAT BLUE HERON NEST. Southwest Florida. 500mm F4 lens with 1.4X teleconverter. 1/250 sec. at ƒ/5.6. Kodachrome 64.

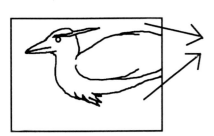 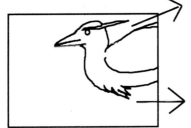

INEFFECTIVE FRAMING WITH CONVERGING LINES EFFECTIVE FRAMING WITH NONCONVERGING LINES

As you can see in this shot of great blue herons, one of the birds is only partially in the picture. This framing is acceptable, though, because the subject's lines won't converge if you imagine them extended beyond the edge of the frame (right). However, if the heron's back and stomach lines had begun to converge in the image, you would naturally want to see more of the bird (left).

Unlike the cup-shaped nests of many other bird species, the nests of wood thrushes are fairly easy to shoot without disturbing the surrounding vegetation. A friend and I were exploring some trails when we accidentally flushed this wood thrush from her nest. One of the four eggs in it belonged to a cowbird that had parasitized the nest with a single egg. Cowbirds don't raise their own young; they lay their eggs in other birds' nests. This allows a female cowbird to lay more eggs in a single season than she would be able to if she incubated and reared her own young. Most host birds don't recognize the cowbird's egg as an interloper and incubate it as one of their own. When it hatches, the baby cowbird often pushes the other eggs or the step-siblings out of the nest, resulting in the host raising only the invader.

My friend and I left the cowbird egg in the nest, letting nature take its course. When we returned later, we moved carefully in order to photograph the incubating adult as she sat tightly on her nest. For this picture, I shot at near-subject level. Depth of field wasn't critical because the nest and the bird were approximately in the same plane of focus.

Since subject movement wasn't a concern, I used my camera's mirror-lockup feature. Like many other incubating birds, this wood thrush "froze" to avoid detection. If the bird had moved, its motion would have alerted a predator (in the bird's eyes, this would have been me). If I'd looked away even momentarily, the bird may have exploded off the nest, flying away so quickly that it would seem to vanish.

If the bird flies off, you should leave the area, and you shouldn't try shooting the nest again. The parental bond to the nest can be weak, so the bird may desert it. However, this is less likely to happen a few days after the young hatch, when the parental bond is strongest. If you must photograph a particular nest, you should consider working it only after the eggs hatch and the young are a few days old. Also, don't cut or remove any vegetation that conceals the nest. If there are branches in the way, tie them back while you are there, and untie them when you're finished shooting each day. Although you'll disturb the birds each time you do this, you'll protect the nest from predators when you're finished shooting for the day. In these situations, you should also consider setting up a blind in order to make behavioral shots.

But the best strategy for photographing any incubating bird that you encounter is to use a telephoto lens and to work from one predetermined spot. Don't approach too closely. Otherwise, if you shift position after focusing your attention on the bird, you are quite likely to cause it to flee. Nest photography has been done and redone innumerable times before, and your chance of obtaining truly unique images is overshadowed by the possibility that your actions may result in nest failure.

WOOD THRUSH ON NEST. Delaware Water Gap National Recreation Area, PA. 300mm F4 lens. 1/30 sec. at ƒ/5.6. Kodachrome 64.

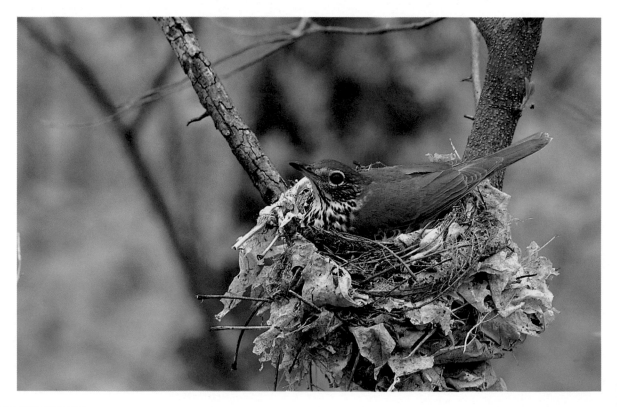

Tree swallows nest in cavities, using abandoned woodpecker holes and bird boxes located near the edges of wood lots or in completely open fields. The tree swallows near my home aren't very habituated, and whenever Mary and I walk by them, they practically part our hair with their dive-bombing attacks. For mutual peace of mind, my wife and I always use a blind when we photograph our swallows.

Tree swallows feed their young hundreds of times a day. Adults don't linger as the young wrestle one another for possession of the opening. Since I have little time to compose carefully, I make sure that I am ready to shoot before the adults return.

I have a number of options when working with tree swallows. Sometimes I compose horizontally in order to catch an adult the instant before it lands. This requires fast reflexes. Keeping the shutter half-depressed, I fire as soon as the bird appears. If I am lucky, I'll record the bird in flight. For closeups, I generally flip to the vertical format, thereby providing enough room for the adult's wings in case the bird flaps them to maintain its balance. Usually I have a second or two to check focus or to fine-tune the composition, but even then, things happen fast. In this image, the adult has its foot inside the mouth of one of her young. I must confess that I didn't notice this when I made the picture.

I select fast shutter speeds when photographing tree swallows. In addition to stopping the motion of the birds' wings, which you expect, these speeds freeze the movement of the birds' heads, which can be quite rapid when the swallows are feeding. Ordinarily, I'll focus on the young birds' eyes if they wait at the hole.

If, however, I notice the young stretching farther to greet the adult, I'll prefocus on that spot and wait.

Whenever I work with tree swallows, I move my blind into shooting position over a two-day period. I've found tree swallows to be very tolerant of a blind, but I would rather not risk moving in so quickly that the birds hesitate to return to the nest. To further reduce the chance of stressing the birds, I use 300mm or longer lenses for nest photography.

As you shoot, watch the young birds' reactions and movements. They show their excitement as soon as an adult flies into view. Action is imminent, but this warning sign gives you enough time to get ready. Start using your blind as soon as the young appear at the hole. In general, they do this a few days before fledging. If you wait too long, you may miss the feeding shots. The adults eventually stop visiting the nest and begin to tease the young from the nest with food.

Mary and I are fortunate to have plenty of open land near our home to erect birdhouses. You may not. If you want to photograph tree swallows or other cavity nesters, consider placing bird boxes in open fields or meadows near your home. If you need to do this on someone else's property, ask the landowner for permission and explain your intentions. Chances are that you'll get a positive response.

Keep in mind that different species have different nest-box requirements. Check with a good bookstore; your local nature center; or your state's fish, wildlife, or game commission for birdhouse plans. If you don't want to build your own birdhouses, you can purchase boxes at many feed stores and nature centers.

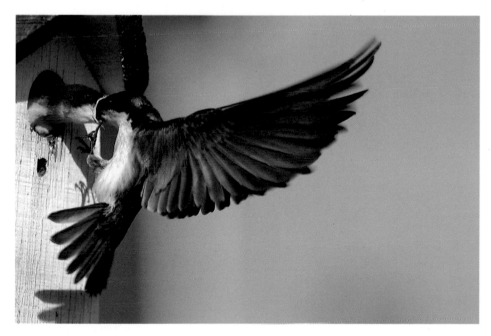

TREE SWALLOW. Hoot Hollow, McClure, PA. 300mm F2.8 lens. 1/1000 sec. at ƒ/4. Kodachrome 64.

Red-shafted flickers nest in holes or cavities in trees, buildings, and fence posts. Most of the nests I've seen have been too high for me to shoot without using a scaffold or tree-stand blind. One day, however, my friend Bill Sailer spotted this nest just 5 feet off the ground, an ideal height since we didn't have any tree-climbing gear with us. Unfortunately, we didn't have a blind either. Operating our cameras from a nearby shooting position was impossible because this could have prevented the adult flickers from feeding their young. Luckily, we had electronic remote releases, which enabled us to photograph the birds up close while observing them from a distance.

But using a remote release is unpredictable. Your subject may be out of focus, poorly framed, or even missing when you trip the shutter. I know this from experience. When Bill and I used our remotes here, there was a short delay between the time I depressed the switch when a flicker landed to when the camera fired. This delay was usually long enough for a bird to tip in to feed the young, leaving only its back end visible. Occasionally I was lucky, and I got off a shot before the adult dipped inside.

Setting up while the flickers were on one of their 20-minute foraging trips, I composed to allow enough

RED-SHAFTED FLICKER, TAIL VIEW. Gallatin National Forest, MT. 500mm F4 lens with 1.4X teleconverter. 1/500 sec. at ƒ/5.6–8. Nikon SB-24 Speedlight on TTL teleflash at –2. Kodachrome 64.

room for the entire bird. This wasn't easy to do; I didn't have a reference point because no birds were present. I was faced with another problem, too. I wasn't able to measure the nest hole as a size reference because I feared that the young flickers might panic and prematurely fledge. So I estimated the bird's position in the frame as I composed the scene.

Focusing was a problem, too. However, since the flickers always approached from behind the tree, I focused on the back of the hole first, and then refocused slightly forward, hoping that the flickers would be within this plane of focus. The ƒ/11 aperture I selected increased my chances of success.

I was using a Nikon 8008S camera and a special MC-4A remote cord that plugs into the camera's electronic-release jack. The other end of the cord has two banana plugs that I spliced to 80 feet of two-strand electrical wire. To complete the circuit, I simply touched the two wire strands together.

Next, I based my exposure on an in-camera reading of the tree bark and set my SB-24 Speedlight's exposure-compensation dial to –2. This setting lessened the chances that my TTL flash would overexpose the flicker when I composed off-center. An SB-24 flash on full power produces just enough light for an ƒ/5.6 aperture with ISO 64 film at a flash-to-subject distance of 20 feet. To increase the effective GN of the flash by a factor of three, I used a Fresnel lens on a teleflash bracket, which gave me more than enough light and a faster recycling time.

Remote photography results in many frustrating challenges and plenty of poor slides, but it can also yield surprising gems. In theory, a Dalebeam would have minimized many of the problems I encountered while making this shot. But even if I'd had one with me, I wouldn't have had the time to slowly condition the flickers to the clamps, wires, and flashes that I would have needed. Without appropriate conditioning, the birds may have abandoned their nest.

In addition to the Dalebeam, you can use a databack with a trap-focus feature for remote work. This programs a camera to fire only when a subject appears in focus. This approach could have worked here if I'd aimed the camera so that the sensor was positioned over the bird's body. In practice, however, trap focus often doesn't work well. If your subject remains stationary within the sensor's range, the camera will continue to fire until the roll of film is completed. And if this happens, the flash, which fires repetitively, won't have enough time to recycle. The first image may be fine, but subsequent images will be progressively more underexposed as the flash fires before it recycles.

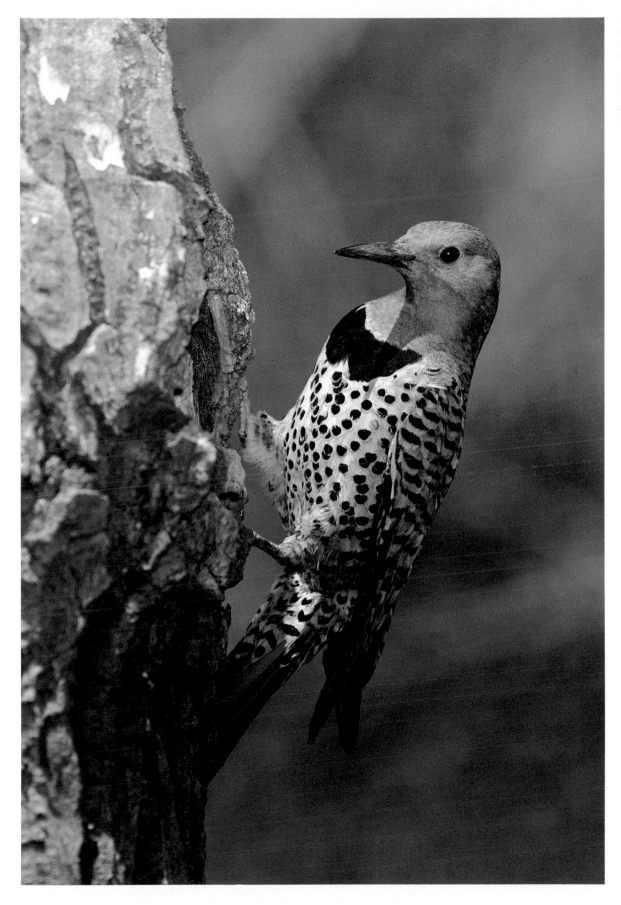

RED-SHAFTED
FLICKER. Gallatin
National Forest, MT.
500mm F4 lens with
1.4X teleconverter.
1/500 sec. at f/5.6–8.
Nikon SB-24
Speedlight on TTL
teleflash at –2.
Kodachrome 64.

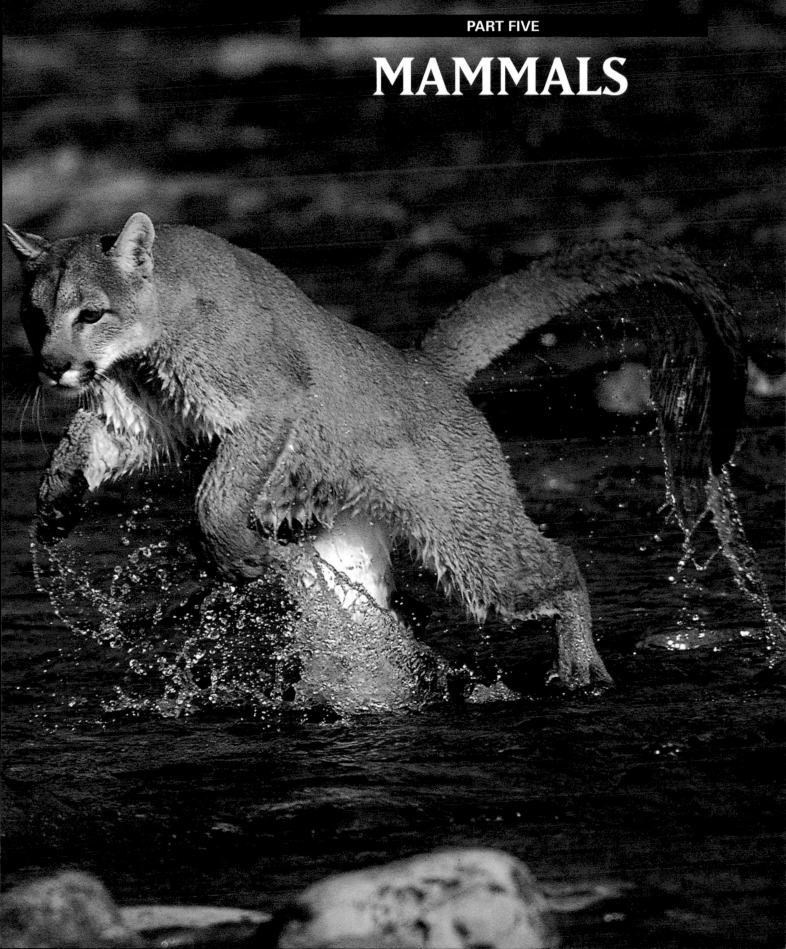

MAMMALS

FINDING SUBJECTS TO PHOTOGRAPH

COYOTE. Yellowstone
National Park, WY.
600mm F4 lens.
1/500 sec. at ƒ/5.6.
Kodachrome 64.

*This habituated
coyote hunted close
to the road and
was completely
oblivious to the
dozen photographers
who attempted to
photograph it as
it approached.*

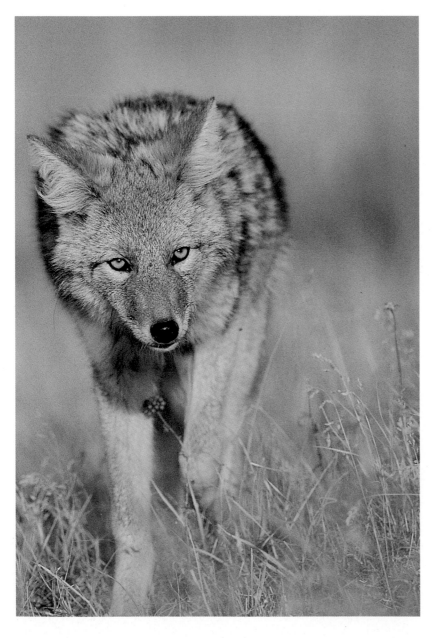

Although amateur and professional photographers shoot millions of exposures of deer, elk, and moose in the national parks each year, they neglect the majority of mammals. It is easy to understand why. Most are rabbit size or smaller, and many, either because of game seasons or their own habits, are quite elusive.

I do most of my mammal photography in three general areas: at national parks and wildlife refuges, where large herbivores are protected; in my backyard and studio, where I can work with some of the smaller species; and at commercial-shooting facilities, where I photograph predator "models" in natural habitats.

The use of predator models may disappoint those who believe every wildlife photograph is made in the wild. While doing all of your wildlife photography in the field is possible, your chances of success are abysmally slim. Most American predators are uncommon or rare, and nocturnal or very shy.

In my 25 years of visiting prime predator habitats in every section of the United States, I've seen about six wildcats. My luck isn't atypical either. I've spoken with excellent Western photographers who live where cougar, bobcat, or lynx are common, and their experiences mirror my own. Regardless of the captions, most photographs of American wildcats show captive or trained models. If you want to photograph predators, you'll have to decide whether or not you would like to work with captives. I think that these subjects are too beautiful to ignore.

I do some of my most exciting work, however, in my own backyard or at parks I visit frequently in order to shoot in different light and weather. In my yard, I can work on habituation or shaping behavior, so that a squirrel or chipmunk feeds from a particular perch or crosses a special path.

On rare occasions, I photograph mammals in a studio setup. Deer mice, voles, moles, and shrews are furtive creatures I rarely see, so my only chance to record them is via a setup. Small mammals require work, not only in terms of the photography itself, but also in terms of their care and maintenance. If you decide to attempt to photograph these creatures, I urge you to plan ahead. Small mammals have fast metabolisms and eat surprisingly large amounts of food. Know the diet of your subject and have the appropriate food available before you obtain the animal. Create an escape-proof set, shoot quickly, and release your subject as soon as you can at its point of capture—unless, of course, that is inside your home.

I use lenses with focal lengths of 300mm or longer when photographing large wild animals. Even when habituated, deer and other big mammals can be dangerous. By keeping your distance, you'll not only be safer but also less likely to stress your subject. Fast lenses are especially useful since many mammals are most active at dawn and dusk. For wildlife models, such as cats and wolves, I opt for lenses with focal lengths around 300mm. And when working in my studio with shrews or mice, I use either a 100mm or 200mm macro lens. Flash is required for nocturnal animals and for setups. Remember, though, red eye may result when you use an on-camera flash; to prevent this unnatural eye shine, I generally hold a flash unit off-camera.

EFFECTIVE MAMMAL PHOTOGRAPHS

*When I discovered
this spotted ground
squirrel feeding along
a back road, I stopped
to make the usual
record shot. Luckily,
the squirrel eventually
cooperated by adopting
one of the funniest
animal poses I've ever
seen: the exhibitionist,
sans raincoat. The
subject is both small
and centered, two
characteristics typical
of an uninteresting
composition. But this
picture works because
the subject's pose is so
comical. Ordinarily, I
would suggest placing
a small subject in a
point of power and
letting the habitat play
a more important
role. This approach
wouldn't work here,
though, because the
clutter of vegetation
and hot rocks doesn't
add to the image.*

Like the faces of adults, children, and pet dogs and cats, the faces of wild mammals can be expressive, and successful mammal portraits capture these looks of serenity, alertness, anger, or curiosity. This requires more than exercising discretion when making closeups; it also demands patience and acceptance, so that the animals react in a natural way.

Unlike people, however, mammals also convey expressions via nuances of their entire bodies, not just their faces. A poised limb, a subtle tenseness of the shoulder muscles or back, or a furtive dip of the head and neck can reveal a mood or an emotion. In its simplest form, though, mammal portraiture involves making images that clearly illustrate the animal. These straightforward pictures have validity, too, depicting form and function so that viewers can study and appreciate them. The most effective way to make both types of mammal portraits is to shoot closeups, which usually requires using a telephoto lens. Because many mammals are cautious and some are dangerous, working with a long lens reduces your chance of getting into trouble.

In addition to telephoto lenses, I need a great deal of patience to create successful portraits. Many of the larger mammals, including elk, moose, deer, and bighorn sheep, are classified as game and are hunted in parts of their range. As a result, they are wary, so finding cooperative subjects in truly wild areas can be frustrating. Fortunately, in protected areas many of these animals, as well as innumerable nongame species, relax and become quite tame, or at least cooperative enough to eventually accept a strange

human nearby. Only when this happens can a patient photographer enjoy success and expect to capture the natural poses and expressions that characterize a good mammal shot.

Patience may not come easily for you. It certainly doesn't for me, especially when I'm not sure I'll be rewarded for my efforts. To help pass the time required for my subject either to appear or to accept me, I'll cheat by reading books, sleeping, or photographing other subjects. Sometimes, if I must approach an animal, I'll appear to wander about aimlessly, or I'll sit or lie down, hoping that my real intention, getting closer, isn't obvious.

Sometimes nothing works, and that, perhaps, is when patience really counts, when you're willing to keep trying despite your failed attempts. This may call for trying a new method, traveling to a new area, or simply accepting the fact that this time the animal won, and that hopefully sometime, somewhere, you'll be lucky enough to encounter and photograph the subject you seek. If you can acquire that mindset, you'll enjoy your wildlife photography more and, ultimately, become more patient, too.

Mammal images made with flash are as challenging as those made in natural light alone. As mentioned earlier, flash can produce an unnatural eye shine when the light reflects off a nocturnal animal's tapetum. You may have noticed this effect if you've ever driven at night and your car's headlights have shone into the eyes of rabbits or deer, thereby producing an eerie red glow. Using an on-camera flash, via either a hotshoe mount or with a teleflash system, is likely to cause this red-eye effect; the only exception is when the mammal is quite close. Whichever type of on-camera flash is in use, the parallax is too little for the reflection not to be recorded by the lens. To avoid red eye, then, you should hold the flash off-camera.

Exactly how far a flash must be held away from the lens depends on the flash-to-subject distance. If this is small, 3 feet for example, you need to hold the flash unit only 6 to 8 inches away. But if the animal is 20 feet away, a gap of 15 or more inches may be required.

Of course, you can use flash creatively to produce wild, unnatural eye shine that enhances an image. A green glow accenting the face of a bobcat or cougar or the weird red eyes of a cottontail, may intensify an otherwise mundane portrait. Ordinarily, I try to capture an authentic look when shooting with flash and avoid the red-eye effect. But if this is the look you want, just make sure that this unnatural glow is a deliberate choice, not an unwanted surprise or accident.

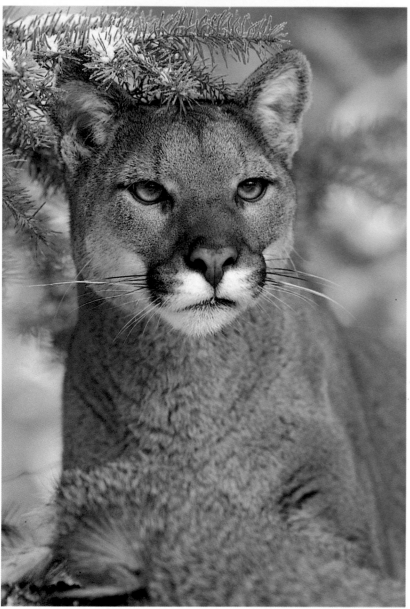

COUGAR. Wild Eyes, MT. 300mm F2.8 lens. 1/125 sec. at f/5.6–8. Kodachrome 64.

Like other North American wildcats, cougars are wary, elusive creatures that have learned to avoid people. I've seen only two in the wild, which I had absolutely no chance to photograph. Nevertheless, my files contain many frame-filling portraits, action sequences, and poses of cougars in natural habitats because, like most other professional photographers, I use wildlife models. A few places scattered across the United States give photographers a chance to work with tame predators in natural habitats. For example, when Mary Ann and I lead workshops in Montana, we take the participants to Wild Eyes, whose owners, Brent and Robin Allen, have provided our groups with incredible shooting opportunities.

I didn't want to alienate anyone with a potentially grisly image of this cougar feeding on a mule deer (purchased at a state auction of poached animals) so I framed tightly. As such, I was able to include only a small portion of the deer, which is barely noticeable. The cougar's intense eyes rivet your attention. The lighting was perfect, just bright enough to provide good depth of field without casting harsh shadows. Usually, a cat's hooded eyes appear dark or black in bright sunlight. The vertical format nicely followed the cat's lines and let me position its face at a strong power point.

At this close working distance, I didn't shoot with the lens wide open. If I had, only the cougar's eyes would have been sharp. Stopping down to f/6.3 gave me adequate depth of field to include the cat's entire face in the zone of apparent sharpness and still use a sufficiently fast shutter speed.

I love to wander the woods looking for wildlife, but I entertain no unrealistic hopes of ever photographing a North American wildcat. If you want to photograph magnificent predators, consider working with wildlife models. This is rewarding photographically—and a great deal of fun, too.

The grizzly bear could be considered North America's most dangerous animal. This powerful omnivore moves so fast that it can cover 100 yards in a three-second dash. The grizzly bear's presence evokes the primeval wilderness. Consequently, it is a much sought-after subject. Today, its range within the lower 48 states is limited to the areas within and surrounding only two national parks, Glacier and Yellowstone; however, the animal's range is fairly widespread in Alaska and much of northwestern Canada.

On one of our fall tours to Yellowstone National Park, Mary Ann and I heard about a pair of young grizzlies that fed along the roadside of a high pass. So the next morning, my wife and I drove into the high country hoping to merely catch a glimpse of the animals. To our complete surprise, the bears were about 100 yards off the road. Over the next few hours, they foraged at various distances, sometimes grazing unconcernedly only a few dozen yards from the roadside and from the dozens of people who watched this unusual event.

The young bears fed with their heads down, offering few opportunities for attractive poses. Occasionally, one raised its head to survey its surroundings, and during those brief windows of opportunity I fired. Here, I decided that a vertical format best accommodated the large image size.

The light level was low, and I needed a fast film speed. Ordinarily, I push Kodachrome 200 to ISO 250 because I like the deeper color saturation. This film is grainy, but in this shooting situation, this feature complemented the bear's rough texture. Even then, my fastest shutter speed ranged between 1/125 sec. and 1/250 sec., so I had to time my shots to coincide with the moments when the bear was still.

Photographing dangerous animals from a safe distance requires long lenses. For this shot, I used my 500mm F4 lens. I could have used a 1.4X teleconverter to increase the lens' working focal length by an extra 200mm, for a total of 14X magnification for the distant shots, but I couldn't afford the resulting light loss and slower shutter speeds.

I want to stress that these young bears approached the dozens of people along the road; no one approached the bears. Also, this shooting opportunity was practically unprecedented in Yellowstone, and it is quite likely that it won't happen again. If you hope to photograph grizzly bears, go to Alaska. The number of bears is high, and there is less of a chance that a bear will become a threat and have to be destroyed. Denali and Katmai National Parks, Pack Creek, and McNeil River Sanctuary are well-known locations where grizzlies or their cousins, the brown bears, are common.

Although I hope many of my examples motivate you to make similar pictures, this photograph is certainly the exception. I don't recommend photographing grizzly bears in either Yellowstone or Glacier National Parks. There are too many people and too few bears, and too great a chance that an encounter will end in tragedy. Every few years, a "photographer," anyone with a camera, is injured or killed. Even bears that simply become habituated to people get into trouble, resulting in their translocation to more remote areas or worse. Leave the photography of Yellowstone and Glacier bears to luck, and assume that you'll never make a good grizzly image in one of the national parks in the lower 48 states.

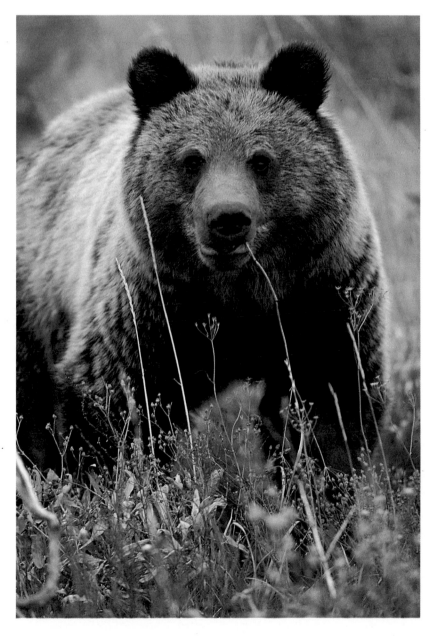

GRIZZLY BEAR. Yellowstone National Park, WY. 500mm F4 lens. 1/1250 sec. at ƒ/4. Kodachrome 200 at ISO 250.

Pikas are great subjects. These high-country dwellers live on rocky cliffs and slopes throughout the Western United States. I've encountered them in a number of prime wildlife-photography locations, including Denali, Mt. Rainier, Yellowstone, and Rocky Mountain National Parks.

These little brown animals are active year-round, even during the winter when their diet of grasses and other vegetation is buried under snow. At this time of the year, pikas feed on the dried greens they stored throughout the summer. With this information, finding pikas isn't too difficult. During the summer months, pikas carry grasses and other vegetation to one or more haystacks stashed beneath a boulder. If you can find a haystack, you'll eventually see a pika when it returns with more material. Read about your subjects before you are in their territory, so that you can recognize opportunities as they arise.

Mary Ann, my friend Bill, and I were driving through Yellowstone when we stopped at a talus slope. This rocky slope was a perfect pika habitat. Soon we heard the animals' high-pitched piping calls. We spotted a pika a few minutes later. This well-camouflaged, stone-gray animal was running across the rocks.

Pikas pop in and out of view fast, so you may find yourself centering the animal in the image because you are caught up in the excitement of seeing one in your viewfinder. Don't fall into this trap. Aware of this problem, I made a special effort to position the pika at a point of power whenever I had one in view. An all-matte grid screen helps in this shooting situation because you can use any area of the screen for focusing.

Here, making a successful image required only that I wait patiently. I wouldn't have waited hours if I hadn't known a few facts about the pika's diet. Sitting about 20 feet from a path this pika followed to one of its haystacks, I braced my tripod securely between boulders. I positioned it high enough to allow me to rest my elbows either on the tripod legs or on my knees in my maximum-stability stance.

On earlier shooting expeditions, I tried using my camera's autofocus mode with pikas but was unhappy with the results. I wasted too much time recomposing after aligning the animal within the focusing brackets. In time, I discovered that it is simpler to focus manually, as well as more effective. I can frame the image anyway I want when a pika pops into view.

Determining exposure was easy on this perfect "sunny $f/16$" day. Remember, however, that the "sunny $f/16$" rule works only if the sunlight falls directly over your shoulder onto the subject. Naturally, by midmorning, the light had changed position. I lost about half a stop because of this new angle, which my in-camera meter reading of middle-tone rocks in the same light confirmed.

PIKA. Yellowstone National Park, WY. 500mm F4 lens. 1/250 sec. at $f/5.6$–8. Kodachrome 64.

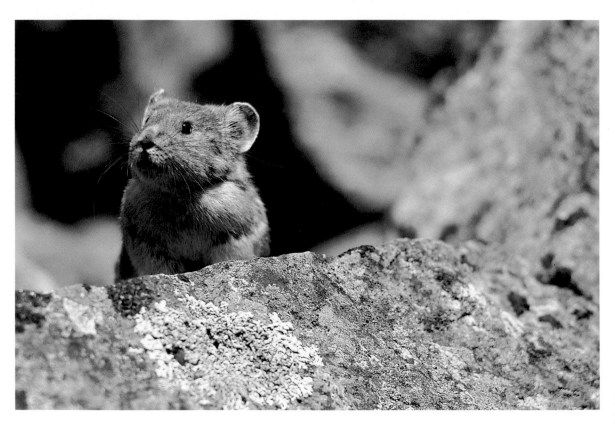

Badgers are open-country animals that feed on rodents they unearth by digging into their prey's burrows. They are primarily nocturnal, although it is possible to find one during the day that won't mind your presence. Although I've seen a few wild badgers, I've had my best luck using models; these guarantee successful images without stressing or harming my subjects in any way. I think this is a very attractive alternative. Another advantage that photographing a wildlife model offers is compositional freedom. Over time I've photographed this badger from every angle I could think of and with every lens I own.

Badgers are aggressive, but a distant portrait doesn't reflect this. A closeup, on the other hand, can capture this trait. I made the closeups shown here two very different ways. For the wide-angle shot, I was quite close to the badger's burrow; I was assured that the animal wouldn't bite when it lunged to within 12 inches of my camera (and my fingers!). I kept my left eye closed and looked through the viewfinder with my right eye, so the animal didn't appear very large in the viewfinder.

As a result, the situation never seemed as dangerous as it might have had I seen the badger at its actual size. The wide-angle lens included the habitat and the distracting bright sky in the image. Placing a split ND filter on the lens would have reduced the sky's brightness, but this wasn't possible under the circumstances. Consequently, I wasn't happy with the resulting image.

Although contrast wasn't a problem when I used the telephoto lens, obtaining critical sharpness was. To get close, I added a PN11 extension tube, but this dramatically decreased depth of field. In order to solve this problem, I had to position myself so that the badger's nose, teeth, and eyes were in roughly the same plane of focus.

People often get into a rut when shooting particular subjects, assuming that there is just one "best" lens or one "perfect" angle. If you have the time and opportunity, try different lenses for a new look. But don't attempt to use a wide-angle lens for a shot of a truly wild badger!

BADGER. Wild Eyes, MT. 300mm F4 lens with PN11 extension tube. 1/125 sec. at f/8. Kodachrome 64.

BADGER. Wild Eyes, MT. 24mm F2.8 lens. 1/250 sec. at f/5.6. Kodachrome 64.

Both regal and graceful, elk are one of my favorite large-mammal subjects and are common sights at one of my favorite wildlife destinations, Yellowstone National Park. In fact, I've had innumerable chances to photograph elk engaged in various behaviors in a number of ways there. I made some of my favorite shots, however, under the most challenging shooting conditions I've ever encountered. Perhaps this illustrates the need to, and the productivity that results from, shooting at the edge of light—the outer envelope, if you will. Light and atmospheric conditions can combine to create truly magical photographic moments. In Yellowstone, these peak times are most likely to occur during the colder months, when geothermally heated water pumps steam into the frigid air. During the spring and fall, these conditions may exist only in the first moments of dawn, when the air is cold.

I saw bull elk at a small roadside thermal pool in Yellowstone on a number of occasions. Unfortunately, each time the elk either ran off or fed too late in the day, when the light wasn't good for shooting. On the best day I've ever had in the park during the winter, I encountered four bull elk feeding at a thermal pool while I still had enough light to shoot in.

Magical conditions like this attract you to a scene, regardless of the subject matter. And although it is always tempting to include everything you see in your picture, slow down, assess exactly what it is about the scene that appeals to you, and incorporate those elements into your picture. Remember, a viewer won't know if you saw four elk or only one as long as the image works.

While making this shot, I tried compositions with different numbers of elk. I used my zoom lens for the ease in framing that it provided. What attracted me so strongly to this thermal pool, however, wasn't the number of elk but the scene's moody quality. Mist rising from the pond first enveloped the elk and then gradually parted to reveal their outlines.

The light was low, so I kept my tripod legs at their minimum height in order to increase my stability. Determining exposure proved to be a real nightmare. The mist, the elk's body, and the elk's head and neck, all required different light readings. Ordinarily, when I shoot fog or mist, I take a meter reading off the fog and open up half a stop or a full stop, depending upon conditions. For this picture, I made a spot-meter reading off the elk's body and then opened up about a third of a stop from that reading.

ELK. Yellowstone National Park, WY. 80–200mm F2.8 zoom lens. 1/60 sec. at ƒ/2.8. Kodachrome 64.

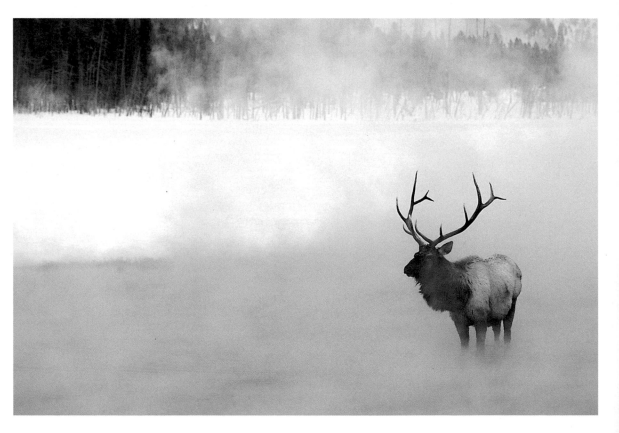

ELK. Yellowstone National Park, WY. 80–200mm F2.8 zoom lens. 1/60 sec. at ƒ/4. Fujichrome 100.

Sometimes I'm asked why I return to areas to shoot or to run workshops because it seems natural that I would just be shooting the same subjects over and over again. This isn't the case. Subjects change continually, and even the same animals are seen under completely different environmental conditions.

The year after I photographed the elk in the mist, I came across a few of the same bulls at one of my favorite Yellowstone locales, which I call "the magic forest." This area isn't marked on a map; Mary Ann and I christened the spot because of the incredible beauty it offers on icy-cold winter mornings. On this particular day, a bull elk literally materialized out of the forest's mist.

While composing this scene, I positioned the elk in the upper-left point of power and turned my camera vertically in order to take advantage of the foreground's natural frame. Placing the elk high in the frame eliminated the background limbs and trees. A slight breeze was kicking around the steam, and as I fired the mist rolled in, masking sharp details. I didn't have much time to think about my exposure. I metered the snow and opened up one ƒ-stop, letting the darker values of the elk and the bare limbs fall as they may. I got off only one shot. The mist intensified; when it cleared, the elk was gone.

Because Nikon's 80–200mm F2.8 lens lacks a tripod collar, switching from horizontal to vertical is inconvenient. Without this collar, I have to flip the tripod-head platform to a vertical position. This alters the camera perspective and can result in lost images as I struggle to recompose. Lenses with built-in tripod collars rotate to vertical on their axes, thereby changing the composition without changing the perspective. To get around this, I've equipped my Nikon 80–200mm lens with a Forster's bridge mount that mounts directly to a tripod. This accessory enables the lens to rotate on its axis. And, just as important, the add-on collar also reduces the stress this heavy lens exerts on the camera mount. In fact, without the collar, I would have missed this shot.

Porcupines spend most of their time huddled in trees chewing on leaves or bark, so you can easily overlook them while searching for wildlife-photography subjects. And for the most part, I've seen porcupines only at night or dead on the road. The few I've seen alive during the day were so high up in trees or in such thick cover that I wasn't able to photograph them. My best porcupine subjects, however, were "models" that didn't try to seek cover.

From a distance, porcupines look more like balls of fluff than like large rodents. But closeup, porcupines are quite interesting. In order to concentrate on the face of this unusual creature, I used a 300mm lens at minimum focus. I also placed the animal's face in the lower-right point of power.

I based the exposure on an in-camera reading of the adjacent tree bark. After setting the aperture, I used a TTL teleflash both to brighten the porcupine's face and to highlight the animal's black eyes. Otherwise, without flash, its eyes would have merged with its dark fur.

I wanted to decrease the intensity of the flash by two f-stops, so I set my Nikon SB-24 Speedlight's exposure-compensation dial to −2. This kept the flash from overexposing the porcupine and made its face middle tone.

Fill-flash adds sparkle and highlights to dark subjects, but you need to use some exposure compensation when photographing them. If you don't, the TTL flash sensor will overexpose for black. Some flash units, however, don't have built-in exposure-compensation dials, so you have to trick the sensor. In that case, I suggest taking your ambient-light reading in the manual-exposure mode, setting the shutter speed and aperture accordingly, and then doubling the film-speed setting on your camera. Keep the original aperture and shutter speed, regardless of what the camera now indicates. Then when the flash fires, the TTL flash sensor thinks it is exposing for a faster-speed film and emits less light than is needed to make the dark tone gray. As a result of this underexposure, your dark tones remain dark.

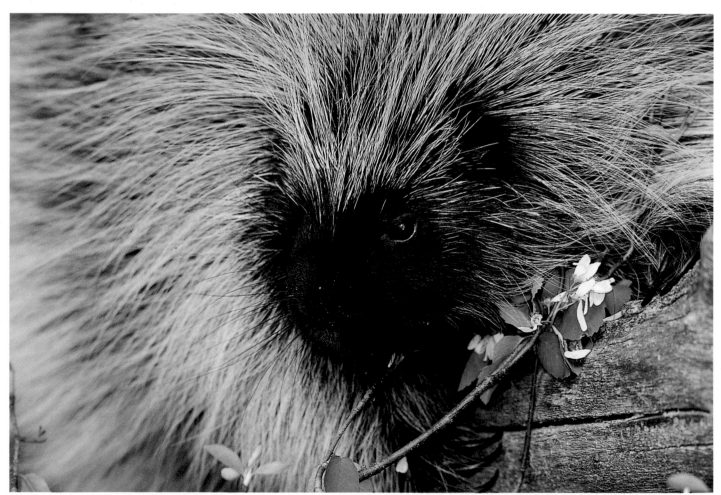

PORCUPINE. Wild Eyes, MT. 300mm F2.8 lens. 1/250 sec. at f/5.6–8. Nikon SB-24 Speedlight on TTL teleflash at −1. Kodachrome 64.

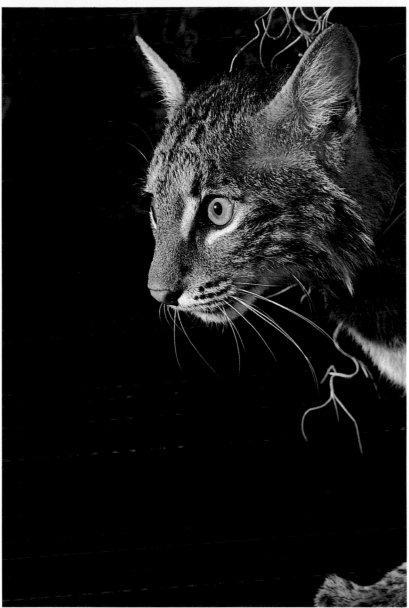

BOBCAT. South Florida. 80–200mm F4 zoom lens. 1/90 sec. at f/11. Three manual flash units. Kodachrome 64.

The only times I ever saw wild bobcats were in the Everglades at night, and these were impossible to photograph. Predator calling can draw bobcats during the day, but this technique is illegal inside national parks where their populations are probably highest. Some acquaintances have had luck attracting bobcats in unprotected areas by using "woodpecker-in-distress" or "crying-rabbit" audiotapes, but this strategy takes patience, plenty of stops, and long waits per calling session. Mainly, however, it takes a great deal of luck.

Ironically, my first opportunity to work with a bobcat took place near the Everglades in southern Florida. Unfortunately, I wasn't able to photograph the house pet outdoors because the owner was concerned that the cat might run off, and with a highway nearby and a winter deer-hunting season in progress, we didn't want to take that chance. I still wanted to take advantage of this opportunity, so I recreated the animal's habitat in its owner's living room. I photographed the bobcat on its favorite perch, a VCR. Since the unit abutted a wall, the placement of my props and flash gear was severely restricted. To suggest a southern swamp, I draped a short log across the VCR and a branch over the top of it. Then I hung some Spanish moss from the branch and used a black cloth as the background.

The tiny set imposed another limitation: I wasn't able to make full-body shots. I decided to work on closeups instead, including just enough of the moss or the log for realism. I selected a medium-length zoom lens because I wanted to be able to make quick compositional changes as required.

Two Sunpak 611 manual-flash units, placed on either side of the cat, provided the frontlighting. Another Sunpak unit created the rimlighting needed to set the cat apart from the background. I estimated the necessary flash distance for full illumination of the set, and then checked the exposure with a flash meter. The 1^1/$_2$-stop difference between the bobcat's perch and the black background was enough to make the background appear black in the final image.

You may have a similar shooting opportunity with a friend's pet raccoon, kinkajou, or opossum. Sometimes, though, the shooting conditions aren't perfect, and your first thought might be that successfully photographing the animal is impossible. Don't give up; you can get the results you hope for provided you include the right props and illuminate the set creatively.

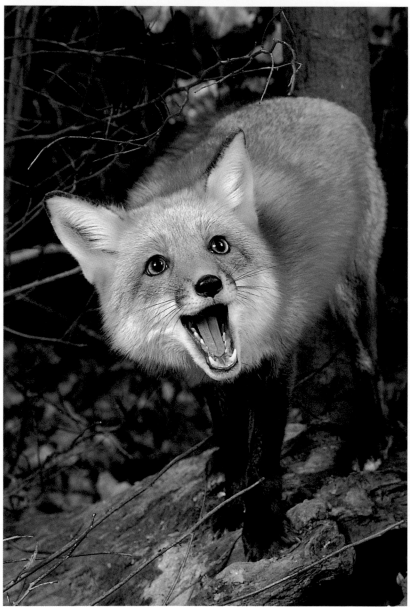

RED FOX. Eastern Pennsylvania. 80–200mm F4 zoom lens. 1/60 sec. at ƒ/11. Three manual flash units. Kodachrome 64.

Many years ago, before I started photographing wildlife models at established facilities, I decided to get my own photography model. I bought a four-week-old red-fox pup from a local furrier and raised the animal like a family pet. I owned a tolerant Labrador retriever, and the fox pup followed it everywhere. The pup didn't do the same with me.

The experience, in retrospect, was a nightmare, and one I wouldn't recommend. I was so concerned that my tame fox might run off and be killed that I rarely took it out to photograph it, which was the reason I purchased the fox in the first place. Furthermore, I spent much more time raising the animal than actually photographing it, and this was time that I could have used far more productively.

However, I got some good shots of this "wild" pet. I did my best work in my studio, where I recreated the red fox's habitat. It was easy to lure the fox onto the log I used; all I had to do was to place small tidbits of food on it. The fox grabbed the treat, looked to me for more, and waited.

My flash units had modeling lights that enabled me to figure out the lighting ratio. I aimed two flashes at the log and placed a third behind the leaves in the background for backlighting. Next, I made separate exposure readings for the log and the background in order to determine the lighting ratio since I wanted the backlit leaves to be slightly brighter than the fox.

ENVIRONMENTAL PORTRAITS

Because many mammals are large, you can back away fairly easily in order to include both your subject and its environment in your picture. And this compositional choice may tell more about the animal than any closeup would. By giving the subject room within the frame, you can suggest where it lives, how it copes with physical barriers or with weather, and how it can make itself virtually invisible.

Avoiding a tight portrait of a mammal requires discipline because most photographers have an almost overwhelming urge to fill the frame with their subject. Admittedly, backing away once you've worked in close is very difficult, especially if doing so required a great deal of effort. Of course, this won't be a problem if you're carrying a zoom lens or a short-focal-length lens with you. In general, however, I try to make my environmental shots before I get close to my subject. This way, I won't be changing to a short lens when I could be recording the most intimate expressions with my long lens, nor will I have to back off and give up what is often hard-earned ground.

That said, I don't make environmental portraits arbitrarily. I look for elements either in front of or behind the animal that will add to the scene. For example, fall foliage accenting a hillside, clouds or a bright sky that frame a silhouette, or foreground clutter that suggests camouflage or habitat prompt me to think environmental shot, not portrait. And sometimes a broad view can rescue an otherwise mundane scene. I can render contrast or clutter that may be readily apparent in a tight closeup insignificant if I back away. I try to be objective and ask myself if the mammal can stand alone as an interesting image. If it can't, I'll consider the elements that surround the subject and evaluate their potential benefits. If I can't come up with any, I'll probably pass on the shot.

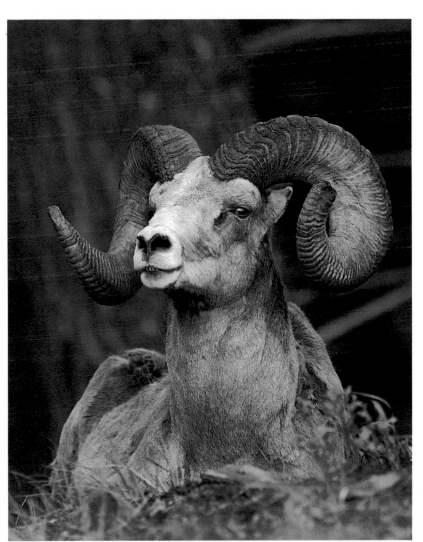

BIGHORN SHEEP RAM. Yellowstone National Park, WY. 500mm f-4 lens. 1/60 sec. at f/5.6. Kodachrome 64.

By late spring in Yellowstone, bighorn sheep seek higher ground, so locating them takes considerably more effort. In addition, they are less attractive at this time of year because they shed their winter coats in unsightly clumps of wool. Obviously, finding a good-looking specimen is hard. One year, I encountered a herd of about a dozen rams in various stages of molting. The sheep sat completely in the shade where the contrasty, high-noon light wasn't a problem. For this environmental portrait, I needed enough depth of field to adequately cover the ram without including too much background detail. By using my depth-of-field preview button and rotating the aperture ring, I determined that f/5.6 provided the best combination. This setting required a relatively slow shutter speed of 1/60 sec., so I had to wait for the ram to stop chewing before I fired.

MOOSE. Firehole River, Yellowstone National Park, WY. 500mm F4 lens. 1/125 sec. at *f*/4. Kodachrome 64.

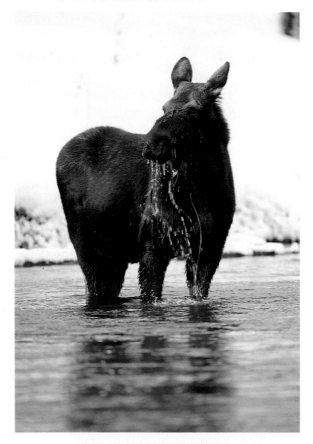

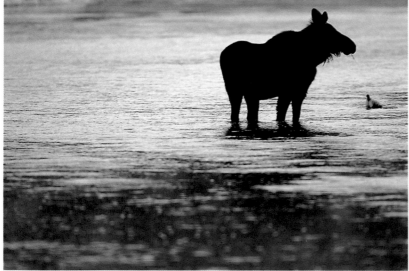

MOOSE. Firehole River, Yellowstone National Park, WY. 500mm F4 lens. 1/250 sec. at *f*/5.6. Kodachrome 64.

Moose are fairly common fixtures along the many rivers and ponds in Yellowstone National Park during the summer, but they're seen far less often during the winter. This moose, framed in sharp silhouette by a cloudy-bright sky reflected in the Firehole River, was the first one Mary Ann and I ever saw in the park in the winter. This location offered the best conditions we could have hoped for because the river had only dark and middle tonalities. The contrast between the bright snow and the dark moose would have made shooting exposures on land difficult.

As I assessed the situation, I ruled out my first idea, to position the moose on a lower-left point of power; I quickly realized that this made the moose face a cluttered shoreline. Ordinarily, compositions work best when the subject looks into the frame. But by placing the moose in an upper-right point of power, I eliminated the clutter and any other potential background distractions caused by the far shoreline. The image was now composed solely of light and dark patterns. The moose looking out of the frame creates an interesting sense of dynamic tension; however, it was very important for me to leave room in front of the animal, so that it wouldn't look cut off. With the moose framed this way, though, viewers may wonder what drew its attention.

A 500mm F4 telephoto lens provided a sufficiently large image size and excluded the background clutter. A lens with a longer focal length would have produced a tighter silhouette, but I didn't have one with me, and I didn't want to add a 1.4X teleconverter. Furthermore, the light was relatively low, there was a slight breeze, and my tripod's snow base wasn't especially steady. As a result, the light lost through the use of a teleconverter would have called for a slower shutter speed, and I would have been pushing the limits of a working focal length of 700mm.

Determining exposure was easy because I recognized the nature of the contrast in this scene. I simply metered the brightest area, the water reflecting the sky, made it middle tone, and then overexposed by one stop. This lightened the water's tonality at the same time that it kept the moose dark. As the vertical image illustrates, the moose is too dark for both it and the snow to be pleasantly exposed. Obtaining some detail in the moose overexposes the background because color-slide film's exposure latitude is too limited for the four-stop difference between the two.

Obviously, it is helpful if you can recognize contrast readily and compose accordingly. Frequently, in high-contrast situations, the easiest kind of shot to make is a silhouette. I often shoot silhouettes when working with birds and animals against bright skies or bodies of water.

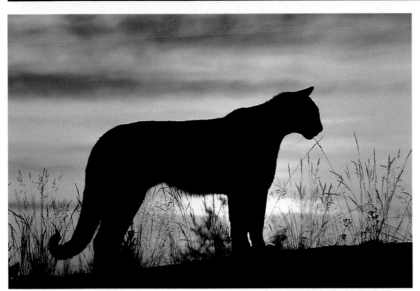

COUGAR SILHOUETTED AGAINST CLEAR SKY. Wild Eyes, MT. 80–200mm F2.8 zoom lens. 1/250 sec. at ƒ/5.6. Kodachrome 64.

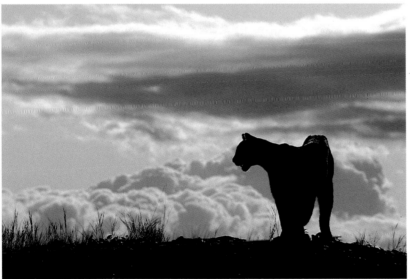

COUGAR SILHOUETTED AGAINST STORM CLOUDS. Wild Eyes, MT. 80–200mm F2.8 zoom lens. 1/125 sec. at ƒ/22. Kodachrome 64.

Using wildlife models provides you with the chance to position a subject wherever you would like one to be. And if you are lucky, the animal will cooperate and you'll get the image you envisioned. On an early-morning workshop shoot, the group wanted to photograph a cougar silhouetted at sunrise. We awoke to a sky filled with stars, but as we drove to the site clouds gathered around the eastern mountains. Fortunately, the clouds stayed low and the sun brightened—just as we'd hoped they would.

For a clean silhouette, I had to avoid any merging of subject and background. To prevent this, I kept low enough so that the cougar's legs cleared the horizon, and I shot only when the cat wasn't aligned with a tree. Remember, you can't make a silhouette against a silhouette.

In order for this shot to be successful, the cat had to be at the edge of the ridge. But getting the cougar there and having it stay there created quite a challenge for Brent and Robin. Then all of us had to remain still once the cat was on the ridge because any movement on our parts could have distracted the animal off the rocks. For this reason, I selected an 80–200mm zoom lens. I knew that it would enable me to make quick composition changes from a fixed shooting position.

Determining exposure for this sunrise shot didn't prove to be a problem. For both images, I intentionally overexposed by about one stop off the reflected-light reading of the sky. For the first picture, I metered the clear sky; for the second shot, I used the mid-range of the background clouds.

I hadn't planned to make the second image. We were nearly finished shooting when I noticed that dramatic clouds had gathered beyond the ridge. An idea came to mind, so Robin and Brent coaxed the cougar back onto the rocks. Here is where previsualization comes in handy. I could see both the cat and the clouds with my naked eye, but the clouds seemed to disappear when I looked through my telephoto lens. Noticing this, some of the workshop participants weren't inclined to shoot at first, but they changed their minds when they closed down to a small aperture and looked through their lenses again using their depth-of-field preview buttons. With the increased depth of field, both the cat and the clouds were clearly visible.

Silhouettes are fun to make. You simply need to remember that you must keep the subject's outline clean and distraction-free. Consider the endless possibilities, and get out there and shoot!

Each fall, scores of elk congregate on the lawns and in sage meadows surrounding Yellowstone National Park's headquarters. But the large hotel, administrative buildings, picnic tables, parked cars, and hundreds of tourists seemingly always in view combine to render this area uninspiring. Making quality images of the many elk found here seems to be impossible.

The last time Mary Ann and I were at Yellowstone, all of these background details frustrated us. Our attempts to shoot natural-looking photographs made us continually shift perspective as the elk moved and new obstructions popped into the background. We endured this for over an hour, following the harem bull as he rounded up his cows. Finally, we got a break. The bull lay down in natural cover as deep-blue shadows slowly masked the hillside in the background.

My 600mm lens provided the tight framing needed to eliminate the buildings on either side of the elk. And lying prone gave me the low angle required to maximize the contrast between the elk and the background. For an even lower perspective, I flipped the tripod head into its vertical slot for a drop of another 3 or 4 inches, then rotated the lens within its collar for the required horizontal shot.

The restricted background made including all of the elk's antlers impossible. Here, however, this is effective because the antlers' lines lead outward, and the contrasty light visually fragments the antlers themselves.

I'm always concerned about image sharpness when I use my 600mm lens since my camera detects even the slightest tremor at 12X magnification. Wanting to reduce the effects of camera shake, I knew that I had to achieve maximum stability. So I braced both elbows into the lawn, pressed my forehead against the camera body, and, gripping my camera firmly, gently squeezed off my frames.

Determining exposure was my second worry. First, I metered a patch of light-green grasses like those visible in the lower-right corner. Next, I opened up half a stop to bring up the light color of the grasses. I reasoned that the darker values on the elk's face would then fall naturally into place.

As this picture proves, making outstanding images is possible even under very trying circumstances. Long lenses help isolate important details, and luck certainly plays its part as well. Mary Ann and I always urge our tour participants to "live right and think positive" so that luck and cooperative subjects will come our way during the workshop. Although "living right" is open to interpretation, thinking positive isn't. If you can see opportunities when they are seemingly absent and can make the most of any shooting situation, you'll be able to get great images.

ELK. Yellowstone National Park, WY. 600mm F4 lens. 1/125 sec. at ƒ/4. Fujichrome 100.

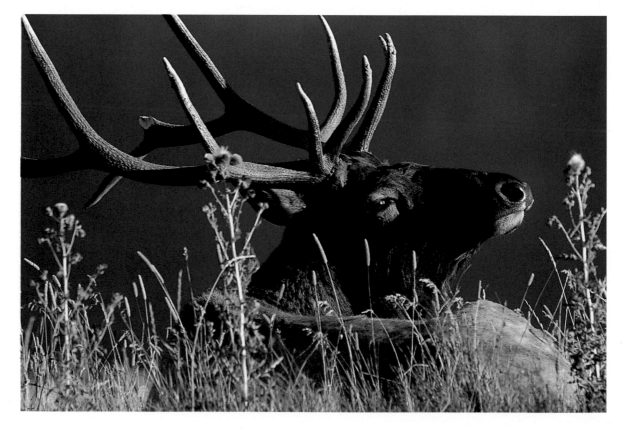

I haven't spent as much time shooting in the far north as I would like to. Although I've seen only two wolves in this region, on a snowy day in the western Yukon, you can find wolves here. Alaska's Denali National Park is probably the best location to see wild timber wolves, but seeing wolves and photographing them are entirely different matters. Shooting quality wolf photographs from a Denali tour bus is quite difficult.

Fortunately, you can take advantage of the wildlife-model option. Unfortunately, however, photographing captive animals isn't as easy as you may think. I liken the experience to photographing "wild" deer in a park or refuge; the animals may be tame, but they are also free to move off if they choose.

While preparing a teaching program for one of my workshops, I noticed that many of my predator portraits were too clean. Captured in near-perfect light, the subjects filled the frame, unobstructed by brush or grasses. But this isn't how you usually see a predator in the wild. Recognizing this discrepancy, I hoped to convey the furtive natures of predators by photographing a timber wolf in thick cover. I tried a variety of compositions incorporating vegetation and selective focus; these ranged from full-frame portraits to "small-animal-in-habitat" shots. This image, which is one of my favorites, works well because of its subtlety. The wolf is only partially visible, but its eyes, which are clear and in sharp focus, draw your attention.

Using a long telephoto lens on a fast-moving subject is difficult at close working distances. While I was working, the wolf rarely stood still for more than a few seconds, which barely gave me enough time to frame and focus. You might think the autofocus mode would have helped, but the surrounding leaves and branches would have tricked the autofocus sensor and caused more tracking than time allowed.

For fast-action subjects, I keep the ballhead on my tripod very loose. This enables me to follow an animal almost as easily as I can when I handhold a small lens. In this shooting situation, the limiting factors were finding my subject within the telephoto lens' limited field of view and snapping the wolf's eyes into focus before it moved off. Actually, using a tripod proved to be helpful here because I didn't have to concentrate on bracing myself, which I would have had to do if I shot handheld.

As I learned, it is important to review your work periodically, especially if you have many images of the same subject. Be objective. Check to see if they're all composed the same way, or always shot in the same light or with the same lens. Although it is easy to get locked into one technique and/or into one way of looking at a subject, think about how you could have photographed these subjects differently. I continually try to reevaluate and to shoot subjects in new ways. Sometimes this reassessment produces a real winner, but at the very least, it keeps photography interesting!

TIMBER WOLF. Wild Eyes, MT. 500mm F4 lens. 1/125 sec. at ƒ/4. Kodachrome 64.

As popular game animals go, wild deer are wary. You can usually photograph habituated deer in protected areas, such as state and county parks, private estates, and suburban developments with large tracts of land. Even then, however, you have few chances for great pictures because the deer are most active between dusk and dawn. I've never made a good photograph of a whitetail buck in an area open to hunting, although I am sure this is possible. I shot this image in a 5-acre deer pen. Although this is a lot of territory in which to look for shy deer, I was lucky. Shortly after sunrise, a pair of whitetail deer fearlessly investigated me.

Ironically, the bucks walked in too close for proper framing with my 300mm lens. I had to back up to fit one buck in a horizontal composition. But as I did this, I centered the buck's head and aligned it with a tree. Although the relatively wide-open aperture of f/2.8 rendered the tree out of focus, it was still distracting. If I can, I avoid centering an animal's body or head. When the buck looked toward me, I shifted far enough to the left to place its head on a power point. Luckily, my movement didn't disturb the deer.

Mobility is important when following deer. Using a gunstock or a monopod can increase your freedom of motion, but I think you end up sacrificing sharpness.

I usually mount my camera on a tripod in these situations. Deer are subject level with most standing photographers, so I keep my tripod's legs folded together at full extension as I follow my subjects. This lets me set up a shot without wasting time or motion.

The exposure was challenging because the light was very low and the deer was backlit. I metered an area composed of out-of-focus tree trunks and pine limbs. This was brighter than the deer's body and consequently emphasized the rim-lighting. Metering the deer might have been technically correct, but the final image wouldn't have looked natural.

With the slow shutter speed, both the deer's movement and the vibration of the camera's mirror could have caused blurred images. However, if the deer had stood still, subject movement wouldn't have been a problem. I've used shutter speeds as slow as 1/4 sec. on motionless deer. Here, mirror slap was more of a concern, so I used a shutter speed of 1/30 sec. to negate this vibration. To further dampen the camera, I tripped the shutter by hand while bracing myself firmly against the camera back. If I hadn't used my body weight as a shock absorber and had used a cable release instead, vibrations could have ruined the image.

WHITETAIL DEER.
Private Preserve, PA.
300mm F2.8 lens.
1/60 sec. at f/2.8.
Fujichrome 100.

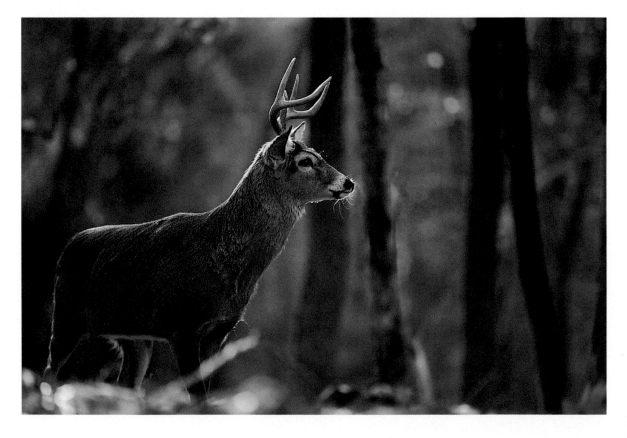

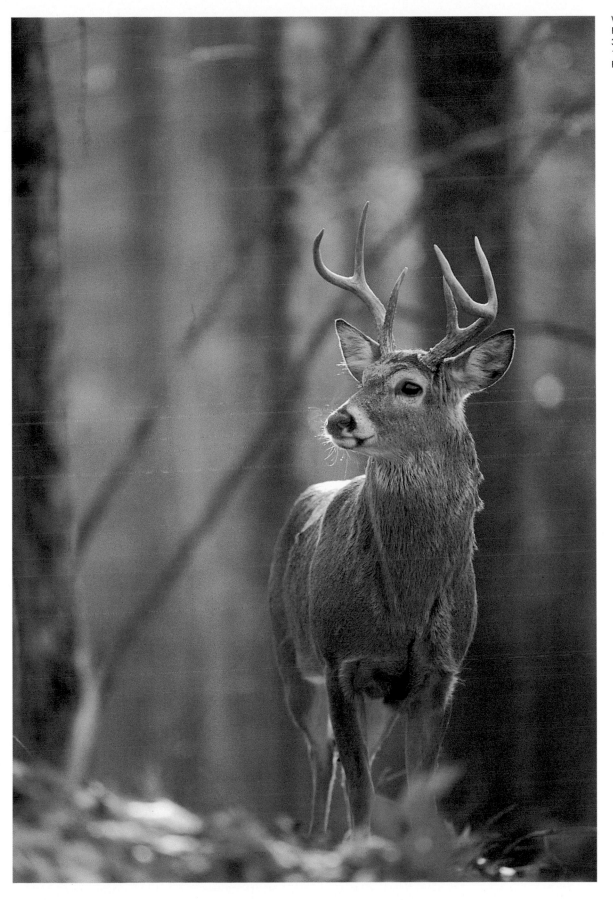

WHITETAIL DEER.
Private Preserve, PA.
300mm F2.8 lens.
1/60 sec. at f/2.8.
Fujichrome 100.

CAPTURING MAMMALS IN MOTION

Photographing mammals in action requires fast shutter speeds, panning, or flash. Fast speeds are mandatory for capturing decisive moments, such as a cougar in mid-leap or a pair of elk locking antlers and wrestling across a wet meadow. Fast reflexes come in handy, too, because you need to recognize and react to that critical instant when the image is magic.

Panning, where a moving camera follows a subject's movement, is an effective way to convey motion. This method implies speed through blur. Panned images don't necessarily capture a critical, frozen-in-time instant. Instead, a pan may imply a continuous motion if both the subject and background are blurred. You can make pans at fast or slow shutter speeds. The results differ in terms of the sharpness of the subject and the background; the subject's speed determines

this. For example, a slow-moving animal can appear to be moving fast if panned at a slow shutter speed. Conversely, a galloping animal can appear to be frozen motionless if panned at a very fast shutter speed. I find most panned images are effective when there is at least some blur in the background to convey a sense of movement. A razor-sharp animal still appears to be moving when the background is blurred.

Perhaps panning is more accurately described as a way to imply motion since using flash most definitely stops all motion. It also reveals postures and behaviors the naked eye can't record. Because many flash units offer extremely short flash durations, you can freeze an animal's leap, flight, or run and render it sharp on film. I find this capability very useful, and the resulting mammal portraits can be immensely appealing.

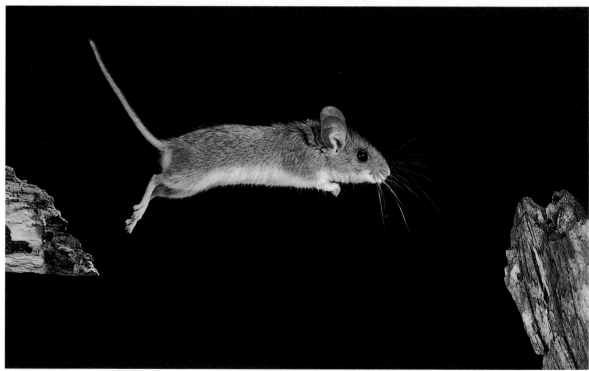

WHITE-FOOTED MOUSE JUMPING. Hoot Hollow, McClure, PA. 200mm F4 macro lens. 1/250 sec. at f/22. Three manual flash units and Dalebeam. Kodachrome 64.

To capture this mouse in mid-leap, I had to confine my potential subjects to an area where I could use a Dalebeam-tripped camera-and-flash setup. I built a cage out of three old storm windows, which provided the sides, and a black-painted board, which provided the back wall. A fourth storm window served as the top. I taped a feeding tray along one of the glass walls about 15 inches above the cage floor. I suspended a horizontal limb at the left side of my frame and secured an upright limb onto a movable wooden block at the right side of the frame. The mice climbed the vertical limb to jump across to the branch leading to a feeding tray.

I then set a Dalebeam on the glass top and aimed it at a reflector on the cage floor. I covered it with an open-ended aluminum can so the only way a mouse could trip the beam would be to jump across my target area. I aimed two Olsen High Speed Flash heads at the front glass at a 45-degree angle and suspended a third flash head above and behind to backlight the branch. Small leaps of 8 to 10 inches yielded the best shooting ratio with the Dalebeam.

SOUTHERN FLYING
SQUIRREL GLIDING.
Hoot Hollow, McClure,
PA. 80–200mm F2.8
zoom lens. Bulb at
f/11. Four manual flash
units and Dalebeam.
Kodachrome 64.

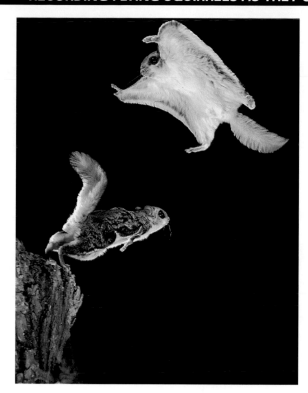

To get this image, I conditioned the flying squirrels to feed at a second site that I made next to their usual feeder. I started by placing a bait log about a foot from their feeding tray. Every night, I moved the log farther away, requiring the squirrels to hop, jump, and finally to glide to the new bait. However, the squirrels glided to the log from different angles. To standardize their path, I placed a jumping board on the original tree.

Because I was using only one Dalebeam, the squirrels were able to trigger my equipment whenever and wherever they crossed the infrared beam's path. To increase the chance that a squirrel would be with in the frame when I fired, I aimed the beam straight down a few inches in front of the landing area. Next, I positioned each flash to illuminate the area from a slightly different angle, thereby ensuring that I would have adequate lighting both in front of and below the squirrels. Placing another flash on the opposite side of the log provided backlighting.

I determined the lighting ratio with my flash meter, giving less exposure to the squirrel's white stomach and more to the backlight. Consequently, the flash distances varied. Once I'd figured out the ratio, I made a final reading with the Dalebeam and the four flash units to obtain the right f-stop. I used high-speed flash units with durations of 1/10,000 sec. on full power and about 1/20,000 sec. on half-power. I chose the half-power setting to freeze the squirrel's flight; a slower flash duration may have blurred the image.

Remember, you can wire Dalebeams either to the camera, where there is a slight delay because of the mirror and shutter, or to a flash, where there is no delay. By connecting the Dalebeam to a flash unit, I was able to use several cameras at once to obtain multiple views. I set each camera on "B" and then locked it open via an electronic release. After the flash fired, I closed all of the camera shutters.

How did I get two squirrels in this shot? I'm not completely sure, but it happened in one of two ways. I may have been slow in closing the shutter after the flashes fired, and in that time another squirrel may have jumped back toward the tree, crossed the beam again, and fired the flashes for the second image. Of course, if both squirrels had crossed at exactly the same point, the two would have merged. It is also possible that two squirrels were in the air and crossed the beam at exactly the same time. This explanation is a bit less likely, but plausible.

If you decide to work with these subjects during the day, you need to connect the Dalebeam to the camera, not to the flash, and must account for the resulting delay in firing.

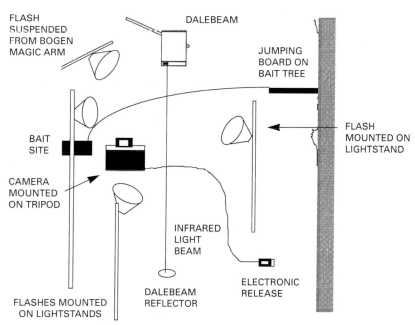

Arranging the lighting setup for this shot of flying squirrels initially took me about three hours; in time, and with a great deal of practice, I got this down to an hour or so. My first step was to hang the Dalebeam from a Bogen Magic Arm and aim the Dalebeam downward, a few inches in front of the spot I expected a squirrel to land. Next, I illuminated the landing area with three flash units mounted on lightstands and set at different angles in order to guarantee adequate lighting in front of and below the subject. Finally, I added another flash, which was suspended from a Bogen Magic Arm, for backlighting. And although the results you obtain when working with a Dalebeam are always a surprise, I never anticipated recording two flying squirrels in a single image.

When you work with wildlife models, you discover that action can be fast because they still exhibit all their natural behaviors. In this shooting situation, several wolves alternated between playing together and running between their owners. The animals ran by me a number of times, thereby providing me with many chances to pan. For this shot, I had two goals: I wanted to fill the frame with a running wolf to convey its speed and to keep the image sharp while panning.

Attaining my first goal was relatively easy, but achieving image sharpness while panning was much more challenging. Using the predictive-autofocus, or

track-focus, feature on my Nikon F4 certainly helped. To imply motion, I tried several shutter speeds, all of which were slow enough to produce some blur in the background, as I followed the wolf.

Panning accurately when you use a long lens is hard. Because of the weight and magnification of my 300mm and 500mm lenses, I usually mount them on a tripod when I want to pan a subject. Although this can compromise smoothness if the tripod head sticks during the pan, it also lessens the chances of the vertical wobble that handholding produces. And while I find that handheld pans with shorter lenses are almost as smooth as tripod pans, I am more likely to see wobble. To pan with my camera mounted on a tripod, I loosen both the panoramic knob and the tension knob on the ballhead so the lens essentially just rests on the tripod. This gives me a full range of motion without having to worry about lens weight.

Whether you handhold your camera or use a tripod, it is critical to get your subject in the viewfinder before you fire and to follow it afterward. When I focus manually, I try to prefocus on the spot where I expect the animal to be, although sometimes I must focus as I pan. That isn't easy. Tracking the animal before I shoot is just as important when I use my camera's autofocus mode. Following a subject within the autofocus brackets usually isn't too difficult, but animals often end up being centered in the image when panned with most autofocus systems.

Most cameras with predictive autofocus are able to pick up and maintain focus as an animal running parallel to you approaches and passes your target point; I've had fairly consistent results with my 300mm F4 lens. Most cameras require specific settings in order for this track-focusing feature to work. With my Nikons, I must set the autofocus switch to "C" for continuous mode, and put my motor drive on "Cl" for continuous, low speed. If I forget to do one or the other, the autofocus works but doesn't track the subject.

A smooth pan should produce sharp images of the animal's head and body, although the legs, hips, and shoulders may be blurred. This is because the legs always move faster than the body, and the hips and shoulders travel vertically as the animal bounds along horizontally. Since there is no way to know what you'll get with a fast-moving animal, I usually fire motor-drive bursts. Sometimes I am lucky, and a few of the frames are sharp.

Practice panning whenever you can. Photograph bicyclists, joggers, and even cars to master the technique. This is an invaluable skill that I've used with numerous subjects, from wildebeest, lions, and cheetahs in Kenya's Masai Mara Game Reserve to mallards and Canada geese at a city lake.

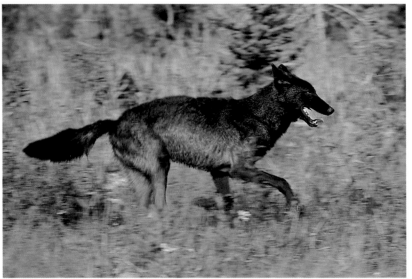

BLACK TIMBER WOLF RUNNING. Wild Eyes, MT. 300mm F4 lens. 1/250 sec. at *f*/11–16. Fujichrome 100.

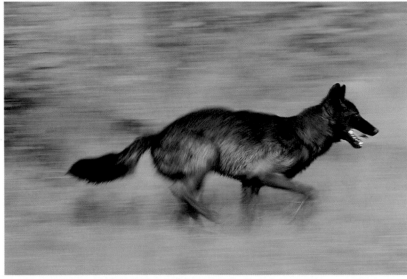

BLACK TIMBER WOLF RUNNING. Wild Eyes, MT. 300mm F4 lens. 1/30 sec. at *f*/22–32. Fujichrome 100.

APPENDIX: SUPPLIERS

Contact these suppliers for the equipment and services mentioned in this text:

Concept Developments, Inc.
1123 South 6th Street
Brainerd, MN 56401

For the Stabilizer Quick Shot, a shoulder/monopod system that is ideal for action sequences, especially with shorter lenses.

Forster's Photo Accessories
HC1, Box 1378
Blakeslee, PA 18610

For bridge mounts for Nikon's 80–200mm F2.8 lens, and also for longer telephoto lenses.

L. L. Rue Enterprises
138 Millbrook Road
Blairstown, NJ 07825

For Rue's ultimate blind, photo vest, Groofwinpod, and other accessories. Rue's catalog is the most complete source of esoteric gear for the outdoor photographer.

Joe McDonald's Wildlife Photography
RR #2, Box 1095
McClure, PA 17841

For photography workshops, tours, and safaris throughout the Unites States and abroad.

National Photo Traveler
P.O. Box 39912
Los Angeles, CA 90039

For a bulletin that covers specifics on selected destinations throughout North America.

Nature's Reflections
P.O. Box 9
Rescue, CA 95672

For the teleflash bracket and for Fresnel lenses.

Protech
5710-E General Washington Drive
Alexandria, VA 22312

For Dalebeams and remote cords, such as the MC4A, and for various electronic cameras.

Really Right Stuff
P.O. Box 6531
Los Osos, CA 93412

For quick-release plates for Arca-Swiss monoballs, focusing sliders, custom clamps that interface with the teleflash system, and other plate accessories.

The Saunders Group
21 Jet View Drive
Rochester, NY 14624

For the Lepp II Macro Flash Bracket, which is useful for TTL closeups with two flashes.

Tiffen
90 Oser Avenue
Hauppauge, NY 11788

For split, neutral-density, enhancing, and skylight filters, and for other lens accessories.

Wild Eyes Wildlife Models
894 Lake Drive
Columbia Falls, MT 59912

For predator photography with trained subjects, including both American bears, cougars, bobcats, lynx, wolves, foxes, and more.

INDEX